AMERICAN CHRONICLES:
THE ART OF
NORMAN ROCKWELL

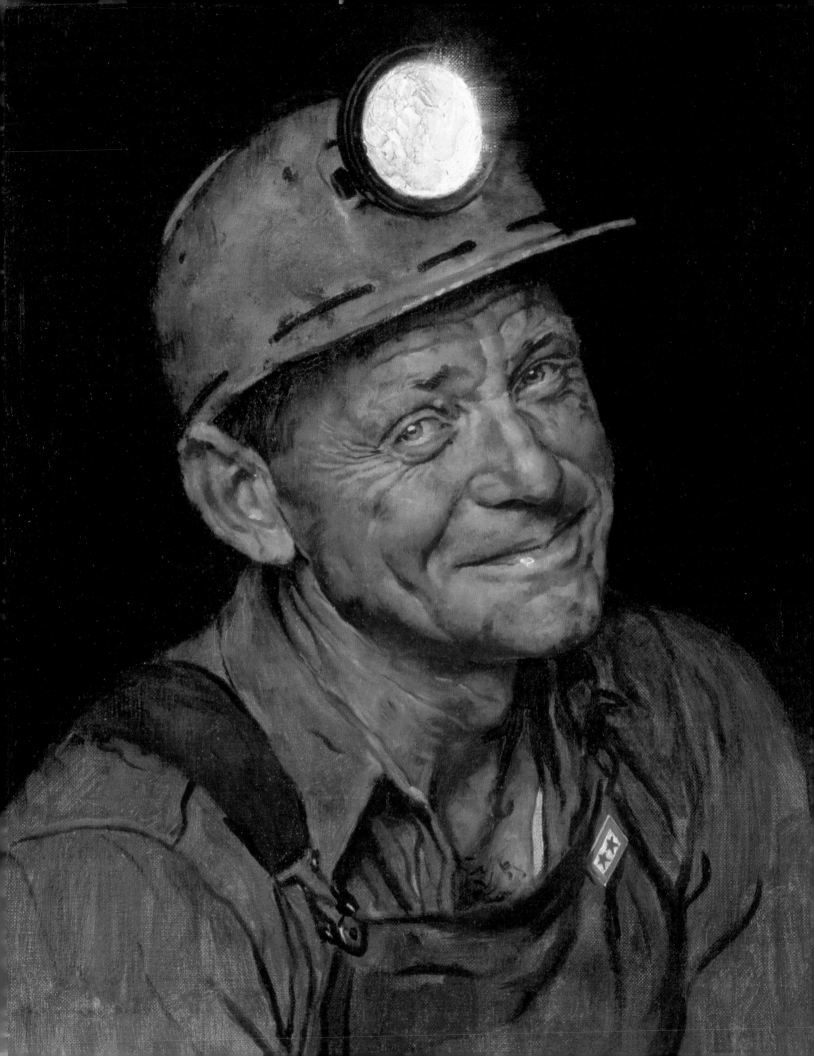

AMERICAN CHRONICLES: THE ART OF NORMAN ROCKWELL

by Linda Szekely Pero

A NORMAN ROCKWELL MUSEUM Publication

Stockbridge, Massachusetts

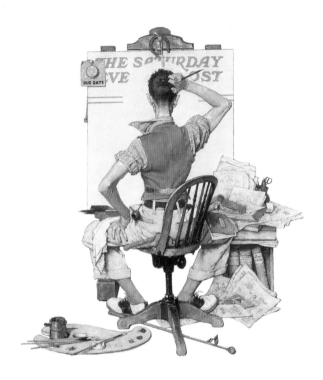

American Chronicles: The Art of Norman Rockwell
has been made possible by Fidelity Investments through the Fidelity Foundation
and by a grant from the National Endowment for the Arts, American Masterpieces Program.
Generous publication support has been provided by the Henry Luce Foundation.

Additional sponsorship has been provided by The Curtis Publishing Company &
The Saturday Evening Post and by The Norman Rockwell Estate Licensing Company.
Conservation support has been provided by the Stockman Family Foundation.

American Chronicles: The Art of Norman Rockwell
by Linda Szekely Pero
is a Norman Rockwell Museum Publication.

Distributed in 2007 by Norman Rockwell Museum
PO Box 308, 9 Glendale Road, Stockbridge, Massachusetts 01262
www.nrm.org

Library of Congress Control Number: 2007939129
ISBN: 978-0-9615273-2-7 (Hardcover); ISBN: 978-0-9615273-3-4 (Softcover)
Cover: *No Swimming*, 1921. Title Page: *Mine America's Coal*, 1944

Designed by Rita Marshall. Edited by Wren Bernstein and Kimberly A. Rawson
Production by Stephanie Haboush Plunkett and Kimberly A. Rawson
for Norman Rockwell Museum
Printed by Excelsior Printing Company

First printing 2007
Second printing 2010

ACKNOWLEDGMENTS

On behalf of the Director and Board of Trustees of the Norman Rockwell Museum, I wish to express sincere appreciation to Fidelity Investments through the Fidelity Foundation, the National Endowment for the Arts, and the Henry Luce Foundation, generous sponsors who have made this catalogue possible. In addition, sponsorship by The Curtis Publishing Company and *The Saturday Evening Post*, The Norman Rockwell Estate Licensing Company, and the Stockman Family Foundation has helped to bring this first compendium of Norman Rockwell Museum art and archival collections to fruition.

We are very grateful to the Rockwell family for their continued support in all of our endeavors, and would especially like to thank Norman Rockwell's three sons, Jarvis, Peter, and Thomas, for their innumerable contributions to the Museum since its inception.

Congratulations and accolades to Linda Szekely Pero, the Curator of Norman Rockwell Collections at the Norman Rockwell Museum and the author of this book. Her insightful catalogue entries reflect her deep and unrivaled understanding of Norman Rockwell's life, art, and iconography, acquired over nearly twenty-five years of dedication and intensive study. Rita Marshall, the gifted designer of this elegant volume, has created a timeless tribute to Rockwell's art. Associate Director for Marketing and Communications, Kimberly A. Rawson, graciously moved the many aspects of this project forward with assistance from Wren Bernstein, our expert editor, and from Gerould Harding and the outstanding staff of Excelsior Printing Company, whose commitment to excellence is clearly evident.

American Chronicles: The Art of Norman Rockwell has also been made possible by dedicated staff of the Norman Rockwell Museum, whose efforts have been vital to the success of this project. Special thanks to Norman Rockwell Museum Director Laurie Norton Moffatt, whose scholarship, vision, and long-time commitment to preserving Norman Rockwell's legacy is unsurpassed. We are honored to present this multi-dimensional view of a significant twentieth-century artist who has had a singular impact on society and visual culture.

Stephanie Haboush Plunkett
CHIEF CURATOR
NORMAN ROCKWELL MUSEUM

CONTENTS

Acknowledgments · 5

Director's Foreword · 8

SECTION ONE **NEW YORK** · 27

SECTION TWO **VERMONT** · 97

SECTION THREE **STOCKBRIDGE** · 143

The Artist's Process · 207

The Artist's Studios · 229

Exhibition Chronology · 256

Chief Curator's Afterword · 264

Checklist · 266

Image Credits · 270

Catalogue Contributors · 272

NORMAN ROCKWELL MUSEUM: COLLECTIONS IN CONTEXT

Norman Rockwell (1894–1978) was a force in twentieth-century American art. For sixty-five years, he chronicled American life on the covers and pages of the nation's most prominent journals, creating an unparalleled legacy. He is best characterized by his genius for celebrating the commonplace—for ennobling the ordinary to reveal the extraordinary. "Commonplaces never become tiresome," Rockwell wrote. "It is we who become tired when we cease to be curious and appreciative." Perhaps his greatest gift is the ability to see what is special in moments others take for granted. Throughout his career, Rockwell transformed images of everyday life into humorous and insightful vignettes with universal appeal, making his more than 4,000 works a window into twentieth-century life.

Few artists have made such a singular impact on art and society as to merit a museum in their name. Norman Rockwell Museum in Stockbridge, Massachusetts, holds the world's largest and most significant collection of works by Norman Rockwell and includes more than 700 paintings, drawings, and studies. The artist bequeathed his Stockbridge studio to the Museum, complete with furnishings, easels, brushes, art books, reference materials, mementos, and ephemera. More than 150,000 photographs, letters, and other biographic research papers are housed in the Norman Rockwell Museum Reference Center. The Museum's mission is to study and communicate with a worldwide audience the life, art and spirit of Norman Rockwell in the field of illustration. We present a contextual view of Rockwell, whose iconic paintings continue to reflect American culture, society, and traditions.

Norman Rockwell, *Boy With Baby Carriage.* Cover for *The Saturday Evening Post,* 1916.

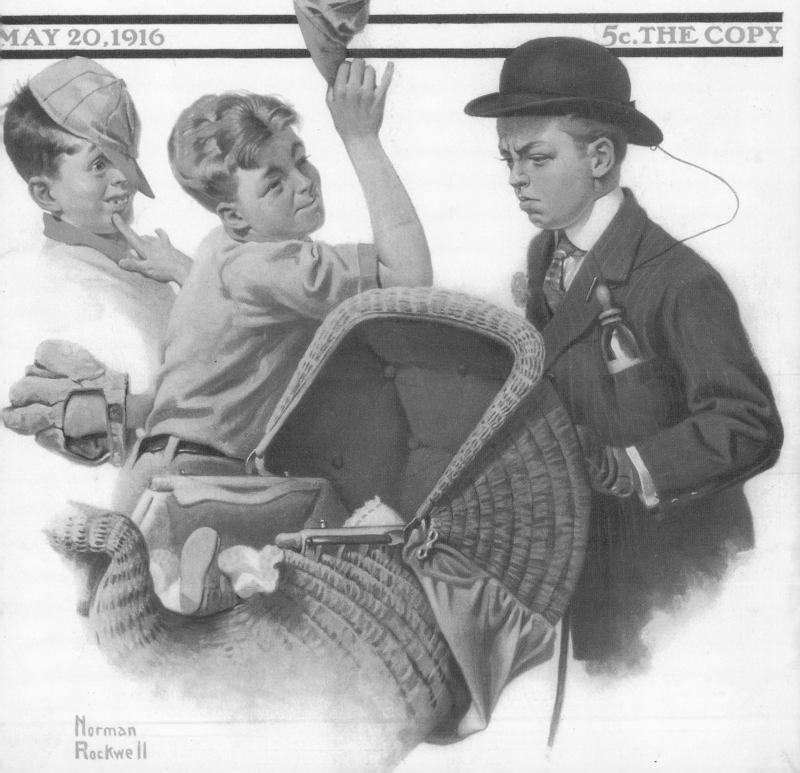

THE SATURDAY EVENING POST

An Illustrated Weekly
Founded A_____ __28 by Benj. Franklin

MAY 20, 1916

5c. THE COPY

Norman Rockwell

Born in 1894 in New York City, Norman Rockwell entered the profession of illustration at the time of the New York Armory Show of 1913, when modernism began to take hold in America. Educated at the Art Students League of New York in the classical traditions of Western painting, Rockwell went to Europe to study the moderns and was an admirer of both Picasso and Pollock. When he launched his career, illustrators were trendsetters with celebrity status. Rockwell hit his stride as an artist during the Cubist movement, creating what were considered to be unfashionable, narrative paintings during the age of Futurism, Abstract Expressionism, Minimalism, Dadaism, and Surrealism, and ended his forty-seven-year career at *The Saturday Evening Post* during the Pop Art era of the 1960s. His career continued for another decade, during which he painted documentary journalism for *Look* magazine until photography and television started to usurp the illustrator's role.

Rockwell held his first job at age eighteen as an illustrator and art editor for *Boys' Life*. He painted his first *Post* cover at twenty-two, and by the age of thirty was a nationally-known figure profiled in popular magazines of the day. By the 1940s, Norman Rockwell had become a household name and his images were eagerly awaited by an admiring public. When his career ended during the 1970s, he was considered by some to be artistically outmoded, yet he had achieved the status of an elder statesman, receiving the Presidential Medal of Freedom in 1977—the highest civilian award in the nation. Rockwell had a finely-honed sense of what his audience, who saw their lives reflected in his artwork, wanted to see.

Rockwell's paintings convey human shortcomings as well as ideals of freedom, democracy, equality, tolerance, and decency, but his visual reflections on populism and patriotism suggest above all for goodness to trump evil. The adjective "Rockwellian" evokes an image of an idyllic America of a simpler era, though it is also used cynically to convey a sense of hopeless naïveté. "I can't paint evil sorts of subjects," the artist commented. His paintings shine a light on our highest aspirations.

Family life, attitudes toward childhood and old age, growing up, marriage, birth, and parenting are the stages of life that provided Rockwell with infinite material. The ever-quickening pace of society

was depicted in imagery that conveyed the evolution of communication and transportation technology. From the introduction of the telegraph, electricity, radio, magazines, telephone, trains, and the automobile during the first half of the century, to television, airplanes, computers, space travel, and the growth of the urban metropolis in the latter half of the century, America was a nation on the move, and its history was told through Rockwell's pictures. Other societal changes such as post-war prosperity, women in the workforce, access to health care, and the civil rights movement are also chronicled in his art.

Compelled to work in his studio seven days a week, he produced an oeuvre of nearly four thousand images, including eight hundred magazine covers, advertising campaigns for more than one hundred fifty companies, and hundreds of story illustrations. He was extraordinarily prolific and his images were ubiquitous. Seen by millions of viewers, his work helped to make the medium of illustration as potent and powerful as the Internet is today, if not infinitely more poignant and persuasive. Norman Rockwell's impact on popular culture and his ongoing influence on generations of American illustrators cannot be overstated.

NORMAN ROCKWELL MUSEUM

Norman Rockwell Museum grew out of popular demand in Rockwell's home town of Stockbridge, Massachusetts. He moved to Stockbridge in 1953 from Arlington, Vermont, to seek medical treatment for his wife Mary at the Austin Riggs Center, a private psychiatric hospital. Stockbridge is a beautiful New England village where gracious homes line the Main Street that he painted in careful detail in the great tradition of town limners (*Home for Christmas*, 1967). The Rockwells were warmly embraced by the citizens of the town where he was to spend his last twenty-five years. Stockbridge has a distinguished history of famous citizens, and the artist joined a community where privacy was respected and fame understood.

The decade that followed was one of personal tumult and sadness. Mary's illness worsened and, six years after moving to Stockbridge, she passed away. Rockwell was devastated. Yet it was during these

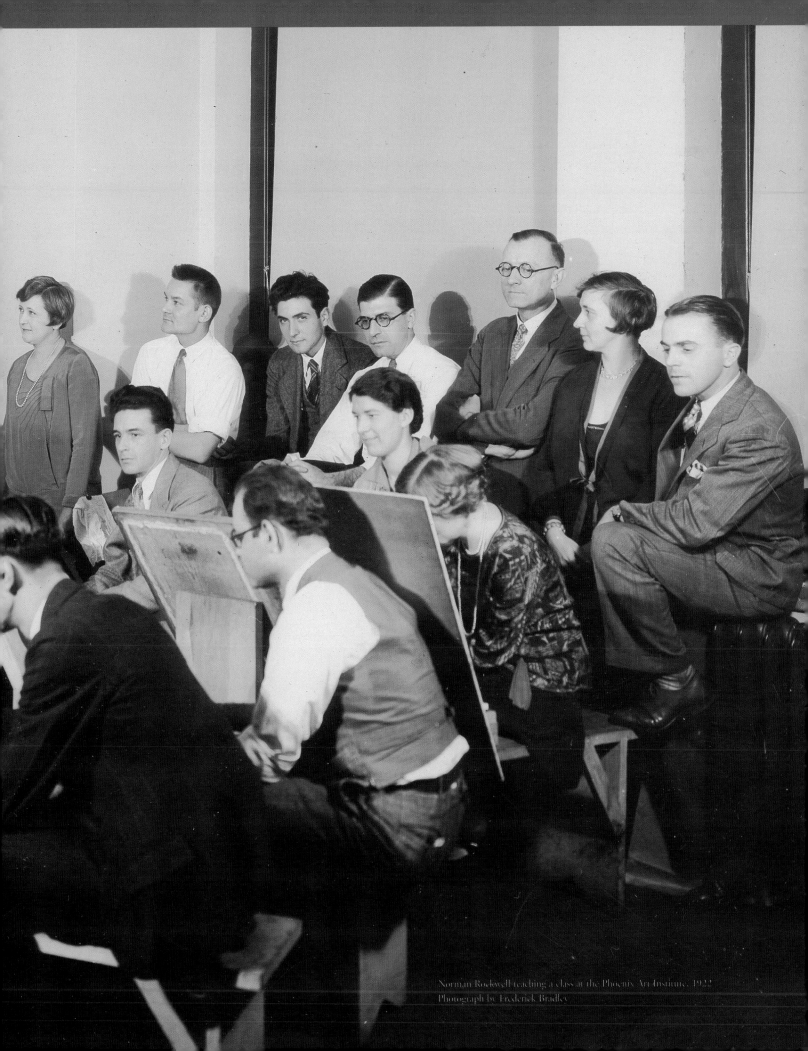

years that Rockwell completed some of his most iconic scenes of childhood and domesticity, such as *Girl at Mirror* (1954), *The Runaway* (1958), and *Marriage License* (1955), as if to conjure a tranquility that was missing in his life. Paintings from this decade form the nucleus of Norman Rockwell Museum's collection.

In 1967, a group of Stockbridge citizens, among them Norman and Molly Rockwell (a retired English teacher, poet, and activist whom Rockwell married in 1961) joined in a community effort led by Norma Ogden, Patricia Deely, and Rosamund Sherwood to preserve The Old Corner House, a two-hundred-year-old Federal Period house that was threatened with demolition on the historic Main Street. When The Old Corner House opened to the public in 1969, Rockwell agreed to lend some of his paintings to attract visitors to the restored home. For a short while, the organization functioned as the Stockbridge Historical Society and exhibited the town's historical artifacts. But word quickly spread about the original Rockwell paintings on display. The Old Corner House was soon identified primarily as a center for the exhibition of original Rockwell works.

AN ARTIST MUSEUM

Museums dedicated to the work of an individual artist, as well as artists' homes and studios, are becoming more widespread in the United States. Unlike museums of generalized subject matter or encyclopedic collections, museums, homes, and studios with comprehensive collections of an artist's work and papers offer an intimate and in-depth examination of an artist's life and creative workspace. These specialized institutions provide for deeper understanding of the artist's creative process and sustain research and scholarship of important artistic figures. They present, study, and preserve the life and work of an influential individual, often placing the artist in the larger context of his or her genre or art movement. Cataloguing projects, scholarship, archival research, and the opportunity to view the development of an artist's style through a comprehensive collection are assets afforded by artist museums.

Norman Rockwell Museum seeks to engage a worldwide audience to inspire art appreciation

through Norman Rockwell's artwork and is commited to presenting the best illustration art and educational programs. Pressed by space needs for its growing collections, audience, and programs, the Museum moved in 1993 to its present home, designed by architect Robert A.M. Stern. The Museum presents Rockwell's collection in classic, naturally lit galleries and provides room for changing illustration exhibitions and an active educational program. The Museum is situated in rural Stockbridge overlooking the Housatonic River on the former Linwood Estate, which features an elegant 1859 Berkshire "cottage" built by New York attorney Charles Butler, now home of the Museum's administrative offices. Norman Rockwell's studio was moved to the grounds in 1984. A restored Victorian carriage barn, stone potting shed, and icehouse complete the complex of buildings. An arboretum featuring ornamental specimen trees was planted on the property during the late 1800s.

NORMAN ROCKWELL ART COLLECTION TRUST

In 1973, Norman Rockwell established the Norman Rockwell Art Collection Trust, which forms the nucleus of the Museum's collections. The seventy-nine-year-old Rockwell created the Trust as a safeguard to insure that his treasured personal collection remained intact. Designated for art education and art appreciation, the Norman Rockwell Art Collection Trust comprises approximately one hundred twenty works that Rockwell placed in the perpetual care and custody of the young Stockbridge museum. Many of Norman Rockwell's most enduring images are in the Trust collection, including the *Four Freedoms* (1942), *Going and Coming* (1947), *Girl at Mirror* (1954), *Marriage License* (1955), *The Runaway* (1958), *Triple Self-Portrait* (1960), and *Home for Christmas* (1967).

The first cover that Norman Rockwell created for *The Saturday Evening Post, Boy With Baby Carriage,* which was published in 1916, launched one of the most successful artist/publishing relationships in history. He painted three hundred twenty-one covers for the *Post,* and during the course of his career with the magazine his subject matter changed from the humorous, carefree scenes of his early years to coverage of invention, history, social change, and the poignant nuances of life's

transitions. His final *Post* cover, *Portrait of John F. Kennedy,* was published a second time upon President Kennedy's death in 1963.

Adhering to the centuries-old tradition of self-portraiture, Rockwell painted his *Triple Self-Portrait* in 1960. This well-known image, in which he paints a portrait of himself painting his self-portrait, is at once self-deprecating, as he depicts himself as a younger man in the self-portrait, and self-conscious, as it reveals the artist in the process of painting himself. It also demonstrates his familiarity with art history. Tacked on the easel are portraits of artists Rockwell admired, including Dürer, Rembrandt, Picasso, and Van Gogh.

Girl at Mirror (1954) is an image of a young girl at the dawn of adolescence who studies herself in the mirror, another traditional subject in art history. Not quite ready to cast aside her doll, she contemplates experimenting with brush and makeup as she compares herself with the movie star in the magazine in her lap. As so often occurs in Rockwell's paintings, we are given a voyeuristic glimpse into a private moment that is also symbolic of universal passage, in this case from girlhood to womanhood.

The *Four Freedoms* are among Rockwell's best-known images. President Franklin Delano Roosevelt, in his 1941 State of the Union address, identified four basic human rights that should be guaranteed "everywhere in the world—freedom of speech, freedom of worship, freedom from want, and freedom from fear." Painted by Rockwell during World War II as his contribution to the war effort, these powerful works conveyed Roosevelt's ideals in terms that were understood and appreciated by a broad audience. An immediate success from their first appearance in *The Saturday Evening Post* in 1943, the *Four Freedoms* continue today to be iconic images of American democracy and freedom.

In the *Golden Rule*, painted for the cover of *The Saturday Evening Post* in 1961, Rockwell portrays a sea of faces, multicolored ethnic costumes and religious symbols, illustrating his personal belief in tolerance and the universal oneness of mankind. Painted when he was sixty-seven-years-old, the cover was one of his last for the *Post*. In it, the artist acknowledged his dissatisfaction with a world still beset by religious and racial differences and strife decades after World War II. It was during this period in his

life that he left the *Post* and began painting subjects of contemporary relevance for *Look* magazine, moving away from the humor and pathos that were the hallmarks of his prior work.

The Norman Rockwell Art Collection Trust holds a significant collection of drawings, striking examples of Rockwell's skill as a draftsman. He sketched every detail of his paintings to the scale of the final image. Working in charcoal, he often cut out blank paper to patch over an area or detail he wanted to rework. A scene from Karachi, Pakistan (1956), done on commission for Pan Am, the sponsor of his trip around the world, is a fine example of his drafting talent. Rockwell's skill in creating the strong "architecture" needed for his finished paintings is apparent in his drawings.

The Trust collection is also filled with experimental works created during Rockwell's late-in-life travels and from sketch classes he attended to refresh his inspiration. These efforts to rejuvenate his painting coincided with grieving the death of his wife Mary in 1959. His 1961 marriage to his third wife, Molly Punderson, symbolized a new beginning and a period of world travel that gave rise to increasingly political themes in his work. Numerous illustrations for *Look* magazine during the 1960s were the result of Rockwell's travels to the former Soviet Union, Africa, the Middle East, South America, and throughout the United States. A loose, colorful group of sketches painted in his later years reveals another side of the artist that emerged during the rare moments he was not working for hire. *Houghton Mill* (1964, in England) and *Dunottar Castle* (1969, in Scotland) are examples of his fresh, quick sketching style, similar to his Russian portraits (*Portrait of a Russian Girl,* 1964) and other artworks completed during the 1960s.

NORMAN ROCKWELL MUSEUM COLLECTION

Almost from the inception of the Art Collection Trust, the Norman Rockwell Museum began collecting additional Rockwell works. The collection of artworks owned outright by the Museum has been developed through purchase, gift, and bequest, and includes notable magazine covers and story illustrations as well as forty of the drawings in the *American Family Life* series produced for the

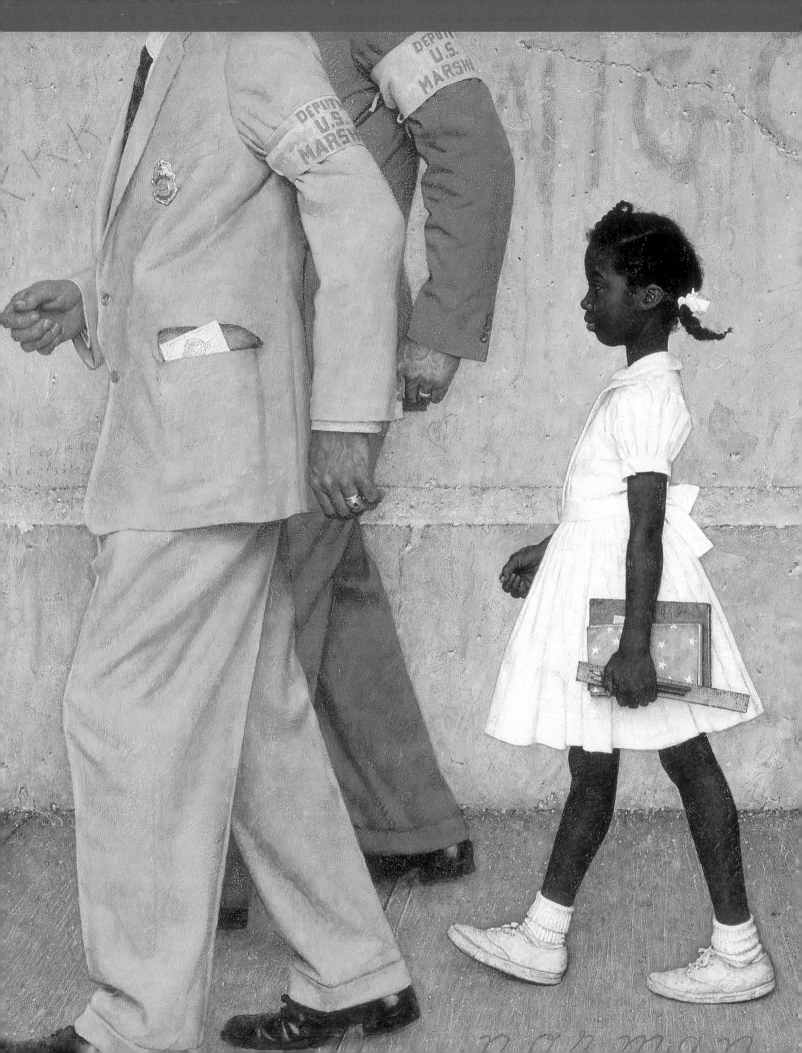

Massachusetts Mutual Life Insurance Company during the 1950s and 1960s. In order to shape the most encyclopedic collection of Rockwell's work, the Museum's collecting philosophy has been to acquire fine representative works of every period and type. Early, middle, and late periods of the artist's work can be studied, as well as his artistic progression throughout his career. Numerous studies, color sketches, and working drawings illustrate the artist's process.

The Problem We All Live With, a powerful visual narrative focusing on school desegregation in the 1960s, was the first purchase made for the Norman Rockwell Museum collection in 1975. Painted in 1963 for the occasion of the tenth anniversary of the Brown v. Board of Education Supreme Court ruling, the picture shows an African American girl being escorted to her newly-integrated school by U.S. marshals. The viewer's eye is drawn to the courageous young girl walking proudly to her new school while epithets and objects are hurled at her. Able to address the Civil Rights movement as a respected commentator who had earned the trust of the nation during his sixty years of painting, he expressed his own, sometimes controversial, views on tolerance, equality, and human dignity. Norman Rockwell pleaded for brotherhood in *Murder in Mississippi* (1965) and viewed race relations through the innocent eyes of children in *New Kids in the Neighborhood* (1967). Some of his most powerful work was created during this period.

Art Critic (1955), a painting that considers the communicative power of art, was acquired by the Museum to complement an extensive series of preparatory studies for it in the Trust collection. The work depicts a young art student studying a Rubenesque portrait, portrayed with the innuendo and sexual humor characteristic of the 1950s. This painting and its accompanying studies offer one of the best examinations of the artist's working process, as it is the final painting of more than eleven sketches for this subject in the Museum's collection. The thumbnail sketch for this painting is typical of the miniature idea vignettes Rockwell would sketch when pitching an illustration idea to an art editor.

The Museum acquired a fine story illustration with *Aunt Ella Takes a Trip* (1942). Created for *Ladies' Home Journal*, the painterly illustration demonstrates Rockwell's skillful hand with light and

Detail of *The Problem We All Live With*, 1963.

expression. A woman resolutely drives her country wagon as a girl rides joyfully at her side in the early morning sunlight that flits like the butterflies on the prairie. Paintings with women were infrequent subjects during Rockwell's early years. One notable 1920s work the Museum added to its collection is an advertisement, done for Raybestos brakes, depicting a mother at the wheel of her motor car with her young daughter at her side.

Of the fifty paintings done for the annual *Boys' Life* cover/calendar series, forty-four are owned by the National Scouting Museum in Irving, Texas. Norman Rockwell Museum was fortunate to add *A Scout is Helpful* (1939), a painting of an Eagle Scout rescuing a child during a storm, possibly inspired by the Great New England Hurricane of 1938, and *Good Friends* (1925), an early image featuring a Cub Scout with puppies. A 1914 image of *Scouting with Daniel Boone* is a fine representation of Rockwell's work as youthful editor of *Boys' Life* magazine.

A gift to the Museum in 2006 added thirty-three sketches from Rockwell's 1955 Pan Am trip around the world, created while on assignment for the airline. These sketches complement the *Karachi, Pakistan*, drawing mentioned earlier and a rare 1920s sketchbook compiled during a trip to Europe.

NORMAN ROCKWELL'S STUDIO

Norman Rockwell's Stockbridge studio, moved from the artist's home near Main Street, is now situated on the Museum grounds, preserved with its historic furnishings, artist materials, daily work diaries, art reference library of books and museum prints, costumes, and travel memorabilia. Open from May through October, the studio offers visitors the opportunity to become immersed in the artist's working environment. Rockwell designed the studio to his exact specifications, incorporating the best features enjoyed from his numerous previous studios. The Stockbridge studio, which he called his "best studio yet," is a converted New England carriage barn that was renovated for him by Shaker craftsman Ejner Handberg. This compact work space was tailored according to his preferences and years of experience, and provided for all the necessities of his workday.

Rockwell's studio, which was also a social place for his guests, contains a spacious north-lit work space, an area for staging and posing models, a dark room and projecting room for tracing drawings, an office area for correspondence, a balcony for the storage of costumes and working studies, back storage rooms for files and supplies, and even a sofa for his afternoon nap. Here he met with his secretary to go over bills to be paid, art supplies to be purchased, and correspondence and fan mail to be reviewed. Everything he needed was present in the studio, to which he brought his storytelling ideas and models, and where he meticulously crafted his paintings. His photographers worked closely with him in this space, capturing the poses of models now immortalized in his art. Family members and friends visited with him during his workday to see his latest painting and to share their reactions.

The studio is filled with memorabilia Rockwell gathered on travels and props used in his paintings. Visitors to the studio experience a sampler of world culture through the unusual artifacts that Rockwell collected. A Turkish samovar, an early whaling ship model, an Ethiopian musical instrument called a *masenqo*, a Dutch pipe, a Navaho blanket, African spears, a Southwestern kachina doll, and masks and armor are highlights of the studio collection of decorative objects. Various religious icons include a mosaic shalom, a crucifix, and a God's eye. The artist's tools and equipment consist of an infrequently-used etching press, a variety of easels, a milk glass palette table, t-squares, canvas stretcher bars, paints, and meticulously-cleaned paintbrushes. A collection of hats, sleigh bells, walking cane, powder horn, and antique muskets are among the props Rockwell used for paintings of early American scenes. Sadly, his collection of authentic period clothing was destroyed in the 1943 Vermont studio fire.

In his later years, Rockwell was sought after as a portrait artist. Famous celebrities such as John Wayne, Frank Sinatra and Arnold Palmer posed in his Stockbridge studio. Working from photographs, he painted Presidents Dwight D. Eisenhower, John F. Kennedy, Lyndon B. Johnson, and Richard M. Nixon, as well as presidential candidates Adlai Stevenson, Nelson D. Rockefeller, Hubert Humphrey, and Ronald Reagan—paintings that now form the nucleus of the Museum's portrait collection.

The Norman Rockwell Museum Reference Center houses the most complete archive of the artist's papers. It contains all the published sources of Rockwell's illustrations, including approximately 4,000 original publications and several complete sets of his *Saturday Evening Post* covers. Other original published source material includes full sets of Rockwell's illustrations, as well as covers and advertisements from *Boys' Life*, *St. Nicholas*, *Youth's Companion*, *Life*, *Literary Digest*, *American Magazine*, and *Look*, among others. All of his published work in early books, magazines, movie posters, and related ephemera is represented in the reference collection.

Rockwell's business correspondence with *Post* art editors and other communications offer a fascinating glimpse into Rockwell's working world. The Museum's media collection includes videotaped interviews with Rockwell's models, contemporary illustrators and historians, and audio and filmed recordings of Rockwell himself. Letters from presidents and boxes of fan mail and birthday cards attest to the enormous popularity that Rockwell enjoyed with the American public during his career. Business ledgers, cancelled checks, and personal correspondence show the many routine demands made of an illustrator of celebrity status. Study sketches, numerous photography collections, and costumes provide an in-depth view of the artist's working process. Among the more notable items in the Museum's costume collection are the suede jacket used in *Freedom of Speech* and the prom dress for *After the Prom*.

The Museum published the *catalogue raisonné* on Norman Rockwell in 1986. The most complete published compilation of the artist's work to date, it contains nearly four thousand entries of every finished painting and sketch known at that time. An addendum to the catalogue is maintained in digital format in the Museum Reference Center. It documents current discoveries of the artist's work, in addition to complete reference photo files on Rockwell's images. The Museum's library holdings specialize in volumes on American and illustration art.

Norman Rockwell Museum's comprehensive photographic collections document Norman

Rockwell's working process. Photographs by Gene Pelham, Louie Lamone, and Bill Scovill captured the artist and his models at work. Portraits of Rockwell by Yousef Karsch and other famous photographers are also represented. Slides of Rockwell's travels during his later years, taken by his wife Molly, form another important collection. A series of photographs by Los Angeles photographer Sam Calder reveal Rockwell's early use of photography in his working process. The archive has grown enormously through gifts by numerous donors and is the world's most significant biographic and artistic reference source for Norman Rockwell.

NORMAN ROCKWELL FAMILY ART COLLECTIONS

Norman Rockwell descended from and fathered an artistic family. Works by Rockwell's maternal grandfather, artist Howard Hill, hung in Rockwell's studio. Rockwell's three sons became artists, and the Museum holds a small but distinguished collection of works by family members. Jarvis, the eldest son, is a modernist and collector of contemporary toys and action figures, and the Museum owns several of his drawings and assemblages. A significant collection of outdoor sculptures by Peter, the artist's youngest son, is well represented on the Museum's bucolic thirty-six-acre-campus. Peter's site-specific installations of life-size bronze acrobats and a carved monster plinth are designed for children to climb; a bronze fountain of acrobatic figures, and other carvings of limestone and marble accent the grounds. A series of bronze maquettes and terracottas are also available for study. Norman Rockwell's middle son, Thomas, worked with his father on the compilation of *My Adventures as an Illustrator,* Rockwell's classic autobiography, and has authored noted books for young readers, including *How to Eat Fried Worms,* which was recently made into a feature film. His books are available in the Museum library.

NORMAN ROCKWELL MUSEUM ILLUSTRATION COLLECTION

Norman Rockwell consistently found inspiration in the work of other artists within the field of illustration and the world of fine art. Norman Rockwell Museum places Rockwell's art firmly within the

context of American art and European narrative tradition by preserving and collecting illustration works representative of the visual and cultural narrative of nineteenth and twentieth-century America. By building a broader collection of original works by a spectrum of illustration masters, the Museum honors Norman Rockwell's commitment to his beloved profession by maintaining and presenting important works that might otherwise be lost.

Norman Rockwell Museum is in the vanguard of preserving and interpreting illustration art and highlighting its significance in American visual culture. Norman Rockwell was a great admirer of illustrators, and over the years he acquired an important collection of illustration art, some of which has come to the Museum through the Rockwell family. Included among these historic works are drawings by Henry Matthew Brock, Edmund Dulac, Thomas Fogarty, A.B. Frost, Rico Lebrun, Maxfield Parrish, Edward Penfield, and Hugh Thompson.

The Museum intends to broaden its collection of illustration art by adding works of important visual communicators—those who were Rockwell's peers and influences and also contemporary illustrators. Anchored by drawings by Howard Pyle and Thomas Fogarty, who each guided Rockwell's development at the Art Students League, and illustrators he admired such as N.C. Wyeth, additional works the Museum may collect include the Old Masters, whose work Rockwell revered, and other artistic inspirations, including, J.C. Leyendecker, Edwin Austin Abbey, Mead Schaeffer, Dean Cornwell, and Alfred Charles Parker.

AMERICA'S VISUAL CULTURE

Norman Rockwell Museum presents exhibitions that inspire awareness, appreciation, and understanding of the art of Norman Rockwell and its significance in the field of art and illustration. Museum exhibitions explore the impact of Rockwell's work and examine the history and evolution of illustration and our visual culture, placing him within the context of his colleagues. Exhibition themes speak to the meaning and presence of illustration in the world and honor the accomplishments of important

visual communicators. Both historical and contemporary, the exhibitions distinguish the Museum as an important center for study and scholarship within and beyond the field of illustration. Loans of artwork to museums around the world, an active educational program, and a popular Web site expand the Museum walls beyond Stockbridge.

Contemporary artists Barbara Nessim, Wendell Minor, Marshall Arisman, Jerry Pinkney, David Macaulay, and C.F. Payne, as well as classic painters and illustrators such as Winslow Homer, Howard Pyle, J.C. Leyendecker, Maxfield Parrish, Rockwell Kent, Violet Oakley, Elizabeth Shippen Green and Jessie Willcox Smith are among the many artists whose work has been featured in Museum exhibitions. Norman Rockwell Museum is dedicated to art, education, and new scholarship that illuminate Rockwell's unique contributions to art, society, and popular culture.

During Norman Rockwell's seven-decade career, burgeoning activity in publishing and the proliferation of adult and children's books, and family, youth, and humor magazines, provided a forum for an illustrious group of artists to interpret and comment on our world to mass audiences. Works spanning Rockwell's lifetime and professional career record evolutionary shifts in style, content, and technology, and demonstrate the vast reach of published imagery to shape culture and society. Exhibitions examining the power of realism, influential trends in fine and applied art, and publishing, provide understanding of twentieth-century popular art and culture. Norman Rockwell Museum celebrates the work of Norman Rockwell and other outstanding visual communicators who have chosen to interpret, comment on, illuminate, and chronicle our world. We see and know ourselves better through their eyes.

Laurie Norton Moffatt
DIRECTOR/CEO
NORMAN ROCKWELL MUSEUM
STOCKBRIDGE

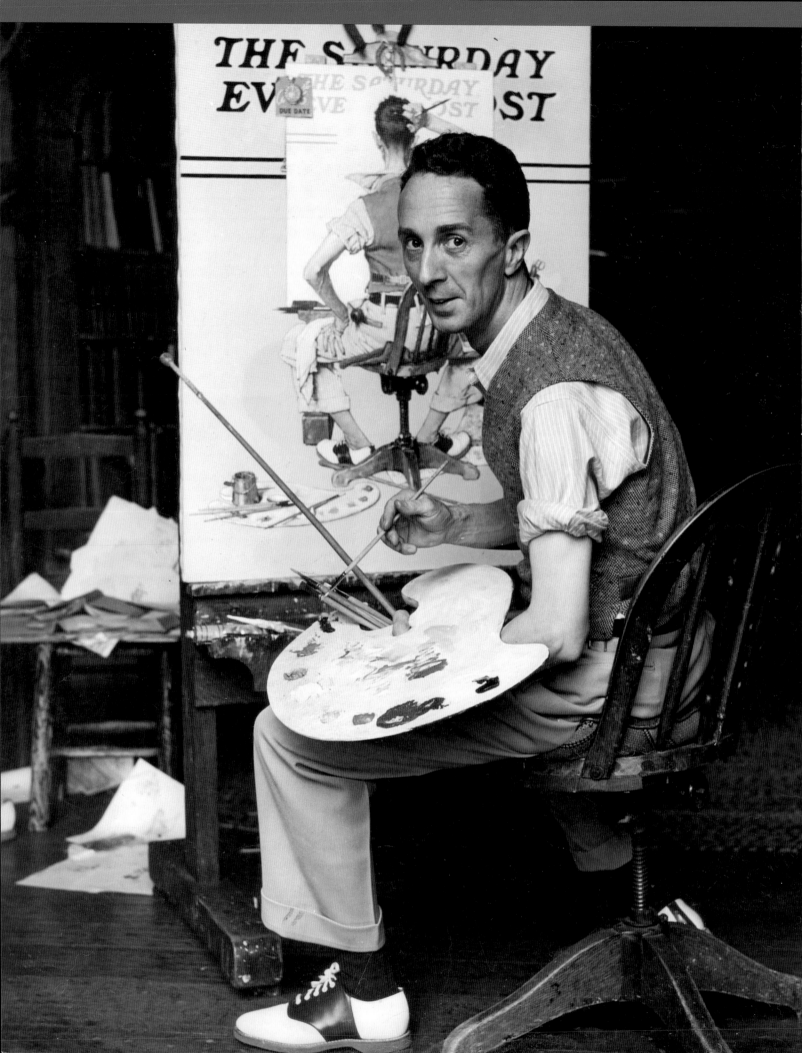

MANHATTAN, MAMARONECK,

AND NEW ROCHELLE

NEW YORK

Norman Rockwell's choice to pursue art as a career had influences from both sides of his family. His father, Jarvis Waring Rockwell, worked in the office of a textile firm, but in his spare time at home, he made copies of famous artists' drawings. Rockwell's mother's father, Howard Hill, earned his living painting meticulously detailed portraits of hunting dogs, family pets, peoples homes, and wild game in lush landscapes. When commissions were absent, he subordinated his skill to the manual labor of housepainting. "Norman Percevel, you have a valiant heritage. Never allow anyone to intimidate you or make you feel the least bit inferior. There has never been a common tradesman in your family. You are descended from artists and gentlemen," were words young Norman heard from his mother, Anne Mary Hill Rockwell, as he was growing up on Manhattan's Upper West Side. Indeed, Rockwell, unlike his older brother, who excelled in athletics and eventually in business, would grow up to be an artist, following not his maternal grandfather's sporadically successful profession but the exciting and financially rewarding path of illustration.

Rockwell was born in New York City on February 3, 1894. The earliest evidence of his interest in art appears in his remembrance of his father copying illustrations from magazines in the evening after dinner. Rockwell said he joined him, sketching "dogs, houses and vegetables and from my imagination, pirates, whales, Indians." Later, for his older brother Jarvis and Jarvis's friend, he would draw a fleet of Spanish battleships, inspired by the 1898 Spanish-American War. After cutting them out and arranging them in battle order, the boys would use scissors to cut up each other's ships

Norman Rockwell with *Artist Facing Blank Canvas*, his October 8, 1938 *Saturday Evening Post* cover painting. Photo by Richard Wyrley Birch, 1938.

to destroy them. "I remember it only used to take them about one second to cut down the whole fleet and it took me a whole day to draw the things."

Even more firmly etched in Rockwell's memory were images evoked by Charles Dickens. Fascinated by Dickens' stories, read to him and Jarvis each evening, Rockwell was inspired to draw their characters even as he listened. "I'd draw Mr. Micawber's head, smudge it, erase and start over, my tongue licking over my upper lip as I concentrated." Rockwell read Dickens throughout his life and adopted Dickens' literary view, observing the world around him and everyday life for its narratives. The powerful characterizations and rich narratives later inspired Rockwell's emotionally complex portraits. At the turn of the century, the steady influx of immigrants into New York City challenged the city's infrastructure as well as its social structure and identity. Seeing this sometimes chaotic world around him and viewing people as Dickens might have, Rockwell grew to be unusually perceptive of personalities, human nature, and the interactions that form the fabric of human relationships. He would become particularly interested in shared human experience.

City life, for Rockwell, was upstaged by summer vacations the family enjoyed at upstate New York boardinghouse-farms. The annual summer idylls ingrained a store of memories and emotions in Rockwell from which he would later draw for his work. They also influenced his permanent move to the country in 1939. As Dickens' stories had confirmed to him, the city was overcrowded, polluted, and intrinsically less humanitarian. "In the city you are constantly confronted by unpleasantness. I find it sordid and unsettling."

In 1907, when Norman was thirteen years old, the Rockwell family (which now included Norman's grandfather, who had been living with them since the death of his wife in 1903), moved into Norman's deceased uncle's house in Mamaroneck, a

suburban village ten miles north of the city. By this point, with the realization that his drawings impressed people, Rockwell determined that he would go to art school. He was already earning tuition money by delivering mail, by bicycle, to the outlying area of Orienta Point. One of his customers, Mrs. James Constable (of the department store Constables) commissioned him to design several Christmas cards; another hired Rockwell to tutor his two sons. This led to an offer of an inflated position of summer school instructor (though not of art) at the local Pennington Academy for Boys.

After his sophomore year at Mamaroneck High School, Rockwell began full-time studies at the National Academy School in New York City. After "tedious and dull" drawing from plaster casts eight hours a day for several months, he transferred to the Art Students League, where relationships between students and teachers were vital and effective, he said—unlike the *ennui* he had experienced with his Academy instructors. At the League, he studied anatomy with George Bridgman and illustration with Thomas Fogarty, learning lessons that lasted throughout his career. Tackling his assignments with a dedication that earned him the nickname "The Deacon," Rockwell became one of the most promising students. With Fogarty's recommendation, Rockwell gained entry to the New York publisher McBride, Nast & Company, which hired him to do eight illustrations for an edition of C.H. Claudy's *Tell-Me-Why Stories* and four illustrations for Gabrielle E. Jackson's *The Maid of Middies' Haven*.

With the fee from his "first really professional job," as Rockwell put it, and by sharing with two other aspiring artists, he rented a studio in Manhattan's Upper West Side. Three months later, his father visited and asked the naïve studio mates if they realized their studio was in a house of prostitution. The next day the three moved to

a studio in Brooklyn, next to the Brooklyn Bridge. The refuge of a studio was crucial for Rockwell during this time period when he still lived with his parents. The family had recently left Mamaroneck for rented rooms in a midtown Manhattan boardinghouse, a culture of displaced persons Rockwell described as "immured in unhappiness." For an eighteen-year-old struggling for a career in a demanding and competitive field, the oppressive boardinghouse made Rockwell feel he couldn't breathe. He decided to spend the summer in Provincetown, Massachusetts, studying with the celebrated New England realist painter Charles W. Hawthorne. Inspired by Titian and Frans Hals, Hawthorne may have been a significant influence during this early stage of Rockwell's development. For example, Rockwell followed Titian in his choice of underpainting in Mars violet, a deep rose that added warmth to skin tones. His primary focus that summer was to emphasize color and depart from all the grays and muddy blacks he'd been using for children's magazines, which were reproduced in black-and-white and therefore often painted in tones of gray. Rockwell called the summer "an idyllic interlude during which I sluffed [sic] all my responsibilities, my city cares, even my ambitions, and lived the life of the most bohemian artist...." He returned refreshed and ready for new challenges.

That fall, Edward Cave, editor of the Boy Scouts' monthly magazine *Boys' Life*, asked Rockwell to illustrate a Boy Scout handbook he had just written. He also retained him for the permanent staff of *Boys' Life*, which was expanding to national circulation. Years later, Cave wrote to Rockwell: "Now I am flattered to find myself second only to the late great Condé Nast [of McBride, Nast & Company] in early recognition of your potential originality, liking for right things and regular people,

and artistic skill." Rockwell's first *Boys' Life* assignment was to illustrate a story of a young Scout and his Cree companion, set in the Ontario wilderness in January. The characters were all heavily clothed, providing Rockwell little opportunity to show off his Art Students League training in anatomical drawing, but Bridgman's emphasis on proportion and balance is apparent. Even in these early works, Rockwell's insistence on making each character a unique individual is clear. He did not yet have the knack of capturing nuances of expression but his choice to individualize his characters rather than to create "types," as many illustrators would do, was one of the elements of his work that would set him apart from many of his peers. In a 1972 interview, Rockwell's son Peter recalled his father saying, "Do you know why Brueghel was able to paint such beautiful trees? Because Brueghel painted each tree as an individual." The opportunity for Rockwell to work on his fine sculptural drawing of the human form, through the sheer volume of work he would have, would come very soon. Following its expansion to national circulation, *Boys' Life* promoted Rockwell to art editor just six months later. Rockwell's responsibilities included illustrating the cover and one set of story illustrations per issue, interviewing illustrators, assigning stories, and approving finished artwork. "The extraordinary part of it," he later said, "was that I had to okay my own work."

In 1913, Rockwell relocated to the artist-rich community of New Rochelle, New York. From 1913 to 1916, his commissions came from children's magazines, *Boys' Life*, *Everyland*, *St. Nicholas*, and *Youth's Companion*, and two book publishers, Harper & Brothers and D. Appleton & Company, for which he illustrated nine books. Almost all were illustrations that described authors' texts. But soon Rockwell would

take on the challenge of developing his own narratives and moving beyond the realm of children's interests. In 1916, at the suggestion of his studio mate, artist/cartoonist Victor Clyde Forsythe, Rockwell submitted his work to the premier showcase for America's top illustrators, *The Saturday Evening Post*. Though years of diligence at *Boys' Life* had honed Rockwell's skills, he wasn't an instant success. His second *Post* cover, of a boy pitching a baseball to an elderly gentleman, had to be repainted five times before it was accepted for publication. Gradually his covers began to include adults, first with children, and later with adult activities and pursuits. Children, however, never completely left his repertoire.

Bolstered by his expectation of financial stability, now that he was added to the roster of *Post* cover artists, Rockwell asked a young lady living in the same boarding-house as his family, Irene O'Connor, to marry him. She accepted and the two moved to their own apartment in New Rochelle. From all accounts, the two lived somewhat separate lives. Though trained as a teacher at Potsdam's Normal College, Irene seemed interested only in pursuing an active and increasingly affluent social life. For a while, when not at his easel, Rockwell joined her in doing some activities together—hosting and attending parties, or visiting Irene's family in Potsdam. But Rockwell's recollections of this period paint a picture of emotional distance and incompatibility. Meanwhile, Rockwell was becoming prominent in a community known for its super-star illustrators. By 1924, New Rochelle was the state's most affluent city, and had more artists per capita than almost any other city in the country. It was home to such illustration titans as Edward Penfield, art editor of *Harper's* magazine; J.C. Leyendecker, the *Post's* top cover artist and illustrator of Arrow collar ads; Coles Phillips, famous for the fade-away girl; and Mead Schaeffer, illustrator of fictional classics for Dodd Mead & Co. Many of the artists met socially, shared models, and critiqued each other's work.

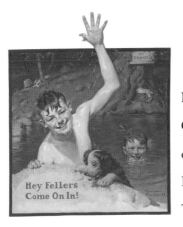

Hey Fellers
Come On In!

In addition to The New Rochelle Art Association, New York's Society of Illustrators and Salmagundi Club offered the illustrators additional networking opportunities, and in 1920, the Art Directors Club of New York was formed to promote advertising art. The Club's first exhibition, held at the National Arts Club in Gramercy Park in 1921, included works by N.C. Wyeth, F.R. Gruger, Maxfield Parrish, J.C. Leyendecker, Edward Penfield, Dean Cornwell, and Norman Rockwell. In this pre-television era when people eagerly awaited the weekly arrival of *The Saturday Evening Post* for its humor, stories, and current events, illustrators became celebrities. As celebrities, they were chosen to judge Atlantic City's annual Miss America Beauty Contest. Rockwell was a judge at the second, third, and fifth contests, in 1922, 1923, and 1925, sharing the dais in 1922 with Coles Phillips, Willy Pogany, and Howard Chandler Christy, and in 1923 with Dean Cornwell.

Taking notice of his *Post* covers, art directors of *Life*, *Judge*, and *Leslie's* offered Rockwell work. In 1924, at age thirty, he typically spent twelve to fourteen hours a day in his studio. As Rockwell's popularity soared, Curtis Publishing pulled in its reins and became the sole publisher of Rockwell illustrations in its three magazines, the *Post*, *Ladies' Home Journal*, and *Country Gentleman*. In 1934, assignments began to appear in *American Magazine*—but no other serial publication. Though it was understood that Rockwell could do work for her sister publications, the *Post* still expected him to give them priority. In 1939, Rockwell received a letter from art editor Pete Martin expressing his distress upon hearing his next assignment would be late because he was redoing a picture for *Ladies' Home Journal*. "The fact that the other magazine is another Curtis publication has no possible bearing on the case," admonished

Martin. The embargo on non-*Post* work was still intimated in 1950 when Rockwell received a letter from editor Ben Hibbs expressing shock at seeing one of Rockwell's Boy Scout calendar images reproduced in rival publication *Look*. "To find a picture of yours in another magazine—and especially in *Look*—was … quite a shock. I just hope this doesn't mean that your work is to be used by others of our competitors." So proprietary was *Post* management about Rockwell's work that later that year, when publicists wanted to run an article in *Country Gentleman* about Rockwell's Hallmark Christmas cards, Hibbs said he was against it even though the *Post* had "no legal right to prevent [it]." Fortunately, other types of illustration such as advertising and book illustration were excluded from this "understanding," enabling Rockwell to take lucrative assignments from major American corporations—possibly one reason for his prodigious output of advertising illustration (he produced illustrations for more than 160 companies).

After a separation from Irene O'Connor in 1929, Rockwell, now living alone in the Hôtel des Artistes, was invited for a California vacation by his former studio mate Clyde Forsythe, who had returned to his native southern California to pursue his career as a painter of western subjects. Forsythe introduced him to twenty-two-year-old Mary Barstow, recently graduated from Stanford University, who was teaching primary school mathematics. Instantly they hit it off, and in three months they were married. They returned to Rockwell's apartment at the hotel, where they lived for several months until the relocation of the tenants of Rockwell's New Rochelle house. Irene had asked for nothing in the divorce settlement. On August 6, 1931, Rockwell's father died of stomach cancer at the age of 63. His father, he later recalled, was the

"gentlest and kindest man that ever lived," attributes any son would have cherished in a role model. (Indeed, in a 1988 interview, Norman Rockwell's doctor's summation of him was that "he was a gentle, kind man.")

One month after the death of Rockwell's father, Rockwell and Mary's first son, Jarvis, was born. (Their second son, Thomas, was born in 1933, and third son, Peter, arrived in 1936.) Despite his family bliss of the early 1930s, Rockwell encountered a major impasse in his work. A break from his surroundings, he felt, would do him good and the stimulation of the arts scene in Paris might give him inspiration and unblock his creative flow. In February 1932, with six-month-old Jarvis and pet German shepherd Raleigh in tow, the family boarded the *Mauretania* for Paris. Rockwell had vacationed in Europe a number of times before, but this trip was intended to kick-start a new direction, or at least to inspire new work. From Mary's letters to her family in California, it appears that Rockwell wanted to shorten the time it took to paint covers and ship them back to the *Post* in order to spend most of his time on non-illustration painting. The success of the plan hinged on whether or not editor George Horace Lorimer would accept Rockwell's new work, which had undergone some modernization. When no word came from the *Post*, there was nothing to do but return. In October, after almost deciding to relocate permanently to Paris, the family returned to New Rochelle.

The next major influence on Rockwell's work came not from an artistic movement or style or a new way of handling light or color, but from using photography. One of the time-saving methods he had used in Paris was to photograph models' poses. "The wear and tear and strain that working with living models placed on me was awful. I would sit for eight hours yelling, 'Lift eyebrows!', 'Raise that arm a little!', and 'Make that smile bigger!' I would carry out all these gestures and facial

expressions myself, and by the end of the day I was so tired and nervous that I was ready to drop." Rockwell said he never got over the feeling it was cheating, and in a letter to Mary's sister wrote that when J.C. Leyendecker visited his studio, which had photos "plastered" over the floor, "neither one of us appeared to notice them but it was just as though a fresh corpse I had just murdered lay there." Four years passed before Rockwell publicly admitted using photographs—for his 1936 *Tom Sawyer* book illustrations.

In 1937, Lorimer retired as editor of the *Post* and Wesley Winans Stout succeeded him. Aside from his aloof tone with Rockwell, Stout's letters were signed with the noncommittal and ambiguous single word "Truly." Truly what? Rockwell may have wondered, for he remembered this period as one of increased insecurity. Stout was always asking for changes. His "constant nagging," Rockwell said, "sapped my inspiration." Ironically, as Rockwell was feeling the sting of Stout's edits, he was garnering the praise of the wider publishing community. In 1938, less than midway in his career, *Judge* magazine honored Rockwell with its High Hat Award. Their list of Rockwell's accomplishments prophesied the success he would achieve in the next thirty-eight years of his career.

[For] having become, while still a young man, a tradition in art; for having kept alive the affectionate interest of America by his re-creation of figures of the late eighteenth and early nineteenth centuries; for having faithfully portrayed persons and scenes familiar to the common man; for having painted one of the finest murals in the Nassau Tavern at Princeton; for having developed his camera eye for fine detail, which has

proven that careless modernization is not part of good craftsmanship; for having
been the inspiration for a school of drawing; for his faithful and grateful attach-
ment to The Saturday Evening Post *and its traditions; for his encouragement*
given to aspiring young artists; for his story-telling ability; for his youthful enthu-
siasm for, and curiosity about, all things; for his tireless energy; for his splendid
sense of humor; and for his fine private life.

That year, during a vacation in London, where Rockwell visited prominent illus-
trators Arthur Rackham, Edmund Dulac, and George Belcher, the Rockwell family
took a side trip to Oxford where they bicycled around the countryside. The sights and
smells awakened in Rockwell a yearning for the country life he had experienced in his
childhood. His decision to find a country getaway when they returned from England
would precipitate a major change for the Rockwell family.

Daniel Boone, Pioneer Scout and The Road Led Through the Passes of the Hills 1914
Norman Rockwell (1894–1978)
Oil on canvas

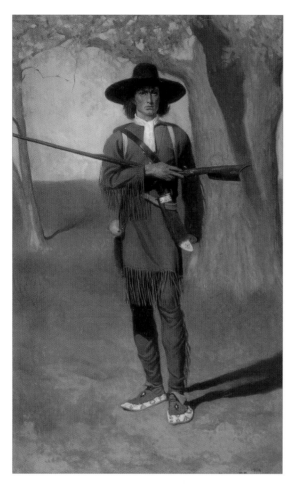

In 1912, after illustrating the new *Boy Scout Hike Book* for the Boy Scouts of America, Rockwell was offered a permanent job on their new monthly, *Boys' Life*. After just six months, he was promoted to art director at a salary of $50 per month, and was responsible for producing cover

art, illustrating one story per issue, and hiring and editing all additional artwork for the magazine.

In 1914, Rockwell produced nineteen paintings and drawings to illustrate Everett T. Tomlinson's *Scouting With Daniel Boone* in eight installments of the magazine. In Tomlinson's story, set in 1773, Boone is hired by Virginia's Governor Dunmore to lead five families from Yadkin, North Carolina, through the wilderness hunting grounds of the Shawnee Indians to a settlement in Clinch, Virginia.

Daniel Boone, Pioneer Scout and *The Road Led Through the Passes of the Hills* illustrated the story's second and fourth installments. In the first, *Daniel Boone, Pioneer Scout*, Rockwell shows Boone as he is described by the text—"a tall man, quiet in his bearing, lean almost to thinness, in the prime of middle life and with every indication of self-control as well as of strength stamped upon his face and form." Later in the story, Boone escorts a band of twenty-seven men, hired to clear a road from the settlement in Clinch to a region in Kentucky. *The Road Led Through the Passes of the*

Painting for *Boys' Life* story illustration, July 1914
20 x 12.5 inches
Norman Rockwell Museum Collection, NRM.1989.1

Daniel Boone, Pioneer Scout and The Road Led Through the Passes of the Hills 1914
Norman Rockwell (1894–1978)
Oil on canvas

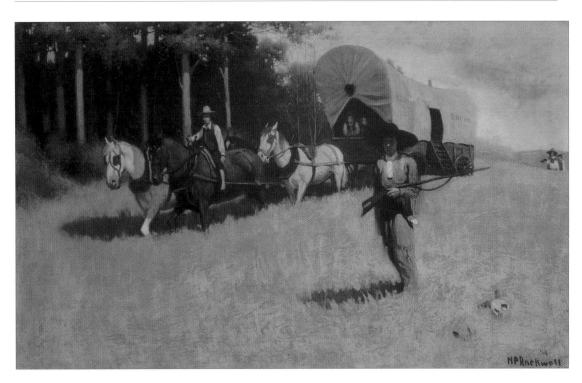

Hills depicts Boone as sentry during their journey.

Both illustrations are painted *en grisaille*, French for "in gray." When illustrators knew their work would be printed in black and white, they often painted in tones of a single color, usually gray, brown, or blue, enabling them to better judge how the illustration would look in print. Rockwell used either brown (sometimes called sepia) or gray for his *en grisaille* paintings.

ODDS & ENDS:

To encourage faithful readership of the eight monthly issues containing the Daniel Boone series, *Boys' Life* offered $300 in prizes in an essay contest. The writer of the best essay on "the qualities of Daniel Boone, which made him a good Scout and a valuable citizen, and why those qualities are important in life today," won a prize of $50. Fifty-six runners-up won prizes from $1 to $25.

Painting for *Boys' Life* story illustration, September 1914
17.125 x 28 inches
Norman Rockwell Museum Collection
Gift of the Estate of Samuel and Lillian Whinston, NRM.1995.9

The Magic Foot-ball (I thought you were wrong) 1914
Norman Rockwell (1894–1978)
Oil on canvas *en grisaille*

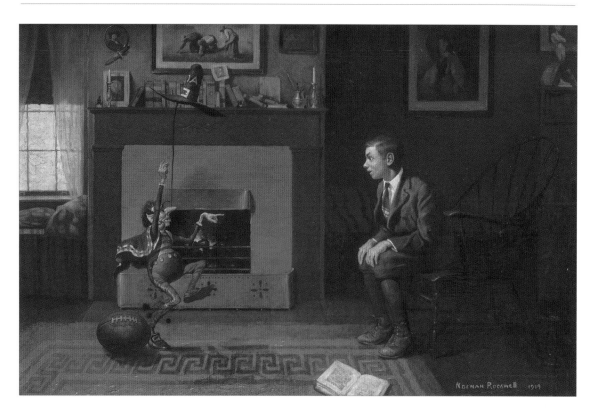

The Magic Foot-ball was the first of eighteen stories illustrated by Norman Rockwell for the children's magazine *St. Nicholas*. In this story, referred to by its author Ralph Henry Barbour as "a fairy tale of today," thirteen-year-old Billy wants to win the big game for his neighborhood football team. He is granted his wish by a strange little fairy who gives him a magic football. Rockwell depicts the fairy visiting the boy's home, and then the boy passing his friend's house on his way to the playing field. In the first illustration, the fairy, late for another appointment of wish-fulfilling, has just twirled his hat, which will show the time by spinning the number of hours it is. In the second illustration, Billy tells the incredulous Tommy, who is home with mumps, that he is going to win the game for their team.

Painting for *St. Nicholas* story illustration, December 1914
19.75 x 29.5 inches
Norman Rockwell Art Collection Trust, NRACT.1973.76

The Magic Foot-ball (Tommy appeared at an upstairs window) 1914
Norman Rockwell (1894–1978)
Oil on canvas *en grisaille*

In the living room scene, Rockwell includes images of *The Gleaners* by Jean François Millet, a self-portrait by Rembrandt Harmensz van Rijn, and a portrait by Thomas Gainsborough. Illuminating the scene with a single light source serves to highlight important features of the boy and the fairy, and keeping much of the room dark adds the appropriate atmosphere of mystery. Rockwell fashions the fairy after a pen-and-ink illustration of Rumpelstiltskin by another frequent contributor to *St. Nicholas*, noted British illustrator Arthur Rackham.

For the second illustration, of Billy walking by Tommy's house, Rockwell borrows a scene from F.R. Gruger's illustration for *The Smart Aleck*, an Irvin S. Cobb story published in the July 18, 1914, *Saturday Evening Post*. In 1940, a *Post* reader discovered Gruger had used part of a work by French artist M. Aime Marot for one of his story illustrations. Gruger told *Post* editor Pete Martin the reader was correct and reminded him he had inscribed the reverse of the drawing with an apology to Marot that noted he had "swiped" a section from Marot's 1889 painting.

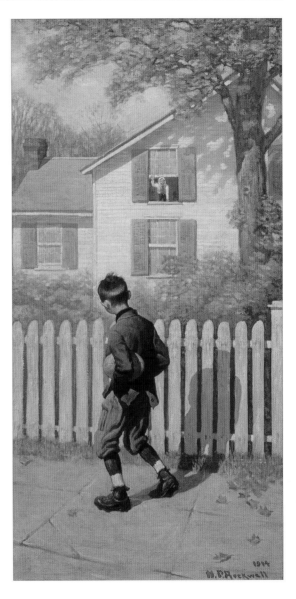

Painting for *St. Nicholas* story illustration, December 1914
29.5 x 14.75 inches
Norman Rockwell Art Collection Trust, NRACT.1973.92

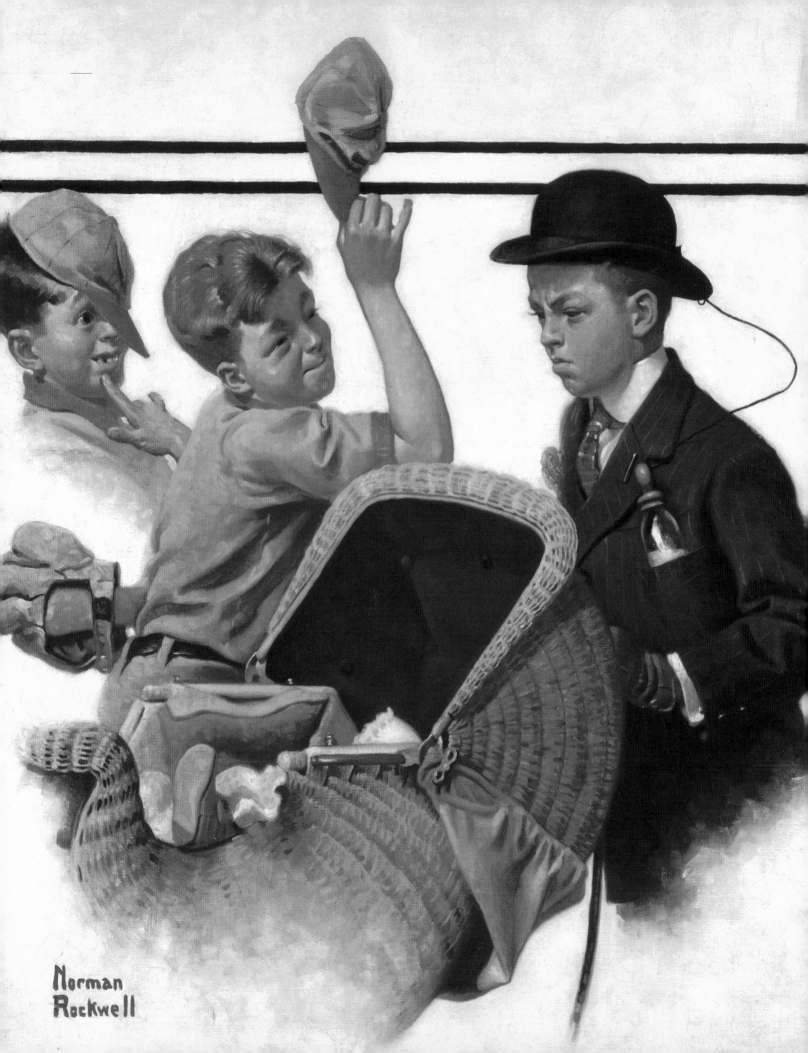

Norman
Rockwell

Boy with Baby Carriage 1916
Norman Rockwell (1894–1978)
Oil on canvas

In 1916, while Rockwell was making $75 a month as art director for *Boys' Life* magazine, he decided he wanted to see his work on the cover of *The Saturday Evening Post*, then viewed as a premier showcase for an illustrator's cover art. Mustering his courage, Rockwell took the train to Philadelphia carrying a newly-crafted wooden case containing *Boy with Baby Carriage*, one other finished painting, and a sketch to submit as a cover idea. The *Post* accepted the two paintings for $75 and told him to go ahead with his sketch idea. Rockwell spent most of the $75 "in telegrams telling people what I had done. I sent one to Mrs. Rockwell—only we weren't married then—and one to Billy Paine, the boy who had posed for me. Gee, how I did jump down the street."

Boy with Baby Carriage was painted in Frederic Remington's former New Rochelle studio rented by Rockwell and cartoonist Clyde Forsythe. A huge cast iron barn, it was hot in summer and cold in the winter "but," said Rockwell, "a good place for kids." "They could ruin the walls and got great satisfaction out of throwing rocks and hearing the clang." A check didn't mean anything to his boy models, so Rockwell paid them cash—25 cents an hour. "At intervals I'd push forward an earned nickel, which kept them interested and also saved much wear and tear on the studio."

Billy Paine, who posed for all three characters in *Boy with Baby Carriage,* was one of Rockwell's favorite models. In a 1920 interview, Rockwell said, "I used him on my first cover and he is absolutely a wonder. He has posed five years and is a dandy little actor; he understands moods and expressions no matter how complicated." Six months later, Rockwell told how Paine, "playing good-natured tricks on another boy . . . had climbed out of one window at his home and started to climb into another when he fell three stories to his death."

ODDS & ENDS

Although being published on the cover of the *Post* signified entry into the ranks of America's foremost illustrators, Rockwell's success did not come instantly or easily. For instance, he had to paint five completely new versions of *Gramps at the Plate*, his third *Post* cover, before it was accepted for publication.

Cover for *The Saturday Evening Post*, May 20, 1916
20.75 x 18.625 inches
Norman Rockwell Art Collection Trust, NRACT.1973.1

Slim Finnegan (We did everything we could to get ready not to be stabbed) 1916
Norman Rockwell (1894–1978)
Oil on canvas *en grisaille*

Slim Finnegan was Norman Rockwell's first story illustration for *The Saturday Evening Post*. It was published July 8, 1916, just three months after Rockwell's first *Post* cover. Rockwell depicted the three children and their rural surroundings on the Mississippi River using elements of his own middle-class New Rochelle town; the distant house resembles those in his suburban neighborhood. Aside from their clothing, the children look like those Rockwell was accustomed to—clean, healthy, and well-cared-for youngsters from middle-class homes. Rockwell avoided many of the details vividly described by author Ellis Parker Butler: "He had a mean-looking face, sort of foxy and sort of sneery, and now it had a sort of grin on it, and it was ugly. It was the kind of grin he had when he twisted a little kid's arm and made him scream. He was just like he always was, sort of muddy-haired and yellow-faced and slouchy in the shoulders, and tobacco juice in the corners of his mouth. He looked just the way he always looked when he was going to have some fun hurting somebody." Despite the menacing character and events that make up this disturbing story about a child bully and his terrorized friends, the painting reads as another charming portrayal of children and a dog.

The turn of the century brought to America waves of immigrants, most of whom settled in the cities. Butler's characterization of Slim Finnegan may have been informed by attitudes about this new class of immigrant and, indeed, immigrant children, who worked in factories or on city streets selling penny papers. Rockwell incorporates the nineteenth-century view of children as small adults doing adult-like things, as reflected in Butler's text, into his interpretation and then imbues it with his own sentiment and middle-class childhood experience. Children sharpening knives on a grindstone and using guns for hunting might have been close to the real existence of children in rural America, but Butler's children also smoke, carry knives, use coarse language, and talk about being for or against Prohibition, making this story seem more like a metaphor for adult society. Rockwell does not integrate all elements of Butler's characterizations, perhaps a task no illustrator could have accomplished given the strangeness of the story.

Painting for *The Saturday Evening Post* story illustration, July 8, 1916
24 x 22 inches
Norman Rockwell Museum Collection, NRM.1987.2

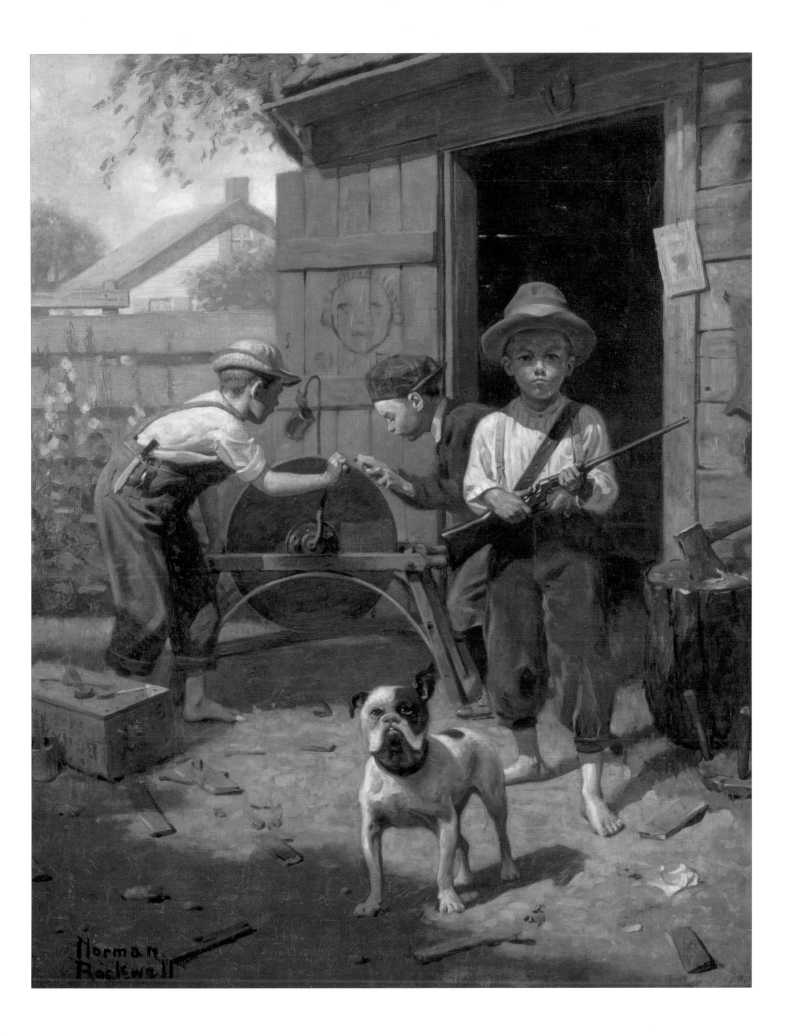

The Ungrateful Man (The whole court was filled with confusion, though the animals,
with no attempt to injure anybody, simply made their way close to the side of the peasant) 1916
Norman Rockwell (1894–1978)
Charcoal and gouache on board

Norman Rockwell drew these images for the children's magazine *St. Nicholas* in 1916, the same year his work began appearing on *Saturday Evening Post* covers. The seven illustrations accompanied *The Ungrateful Man,* a brief story of a peasant who saves a nobleman who has fallen into a pit of wild animals only to have the nobleman go back on his promise to reward him with his palace. Rockwell had not yet traveled abroad—his first trip to Europe was six years away—and he had to rely on references from books and museums for the Venetian scenes and seventeenth-century costumes. Unlike his story illustrations of American life and the American West for *Boys' Life* from 1912 to this period, Rockwell's drawing technique had a sophistication inspired by seventeenth-century Italian Renaissance painting. His drawing of the palace recalls spires of buildings in Caravaggio's cityscapes. Rockwell uses only the initial "R" to sign these illustrations and does so in the same romantic style of the drawings.

Drawing for *St. Nicholas* story illustration, January 1917
12.5 x 18 inches
Norman Rockwell Museum Collection, NRM.1981.03, Gift of
Mr. and Mrs. Carl Hahne in memory of Martha and Alfons Dietrich

The Ungrateful Man (Illustration for the Palace) 1916
Norman Rockwell (1894–1978)
Charcoal and gouache on paper

Drawing for unpublished story illustration for *St. Nicholas*, January 1917
15.125 x 17.25 inches
Norman Rockwell Museum Collection, NRM.2001.1

Cousin Reginald Spells Peloponnesus 1918
Norman Rockwell (1894–1978)
Oil on canvas

Between 1917 and 1922, while Norman Rockwell was illustrating covers for Curtis Publishing Company's *The Saturday Evening Post*, he also produced thirty-nine cover paintings for Curtis's *Country Gentleman*. Since Curtis did not use four-color printing for its covers until 1926, the artwork, regardless of how the original was painted, was printed with just two ink colors—red and black. Blending different percentages of red and black on the covers yielded variations that could appear brown and green.

With few exceptions, Rockwell's focus for *Country Gentleman* was the life and activities of adolescent boys. One theme he explored was the differing social cultures of country boys and city boys. "About the only subject which an illustrator for young people's magazines was permitted to treat humorously was rich, sissyish kids," said Rockwell. "The readers all identified with the regular fellows . . . and laughed with them at the conceited, pompous sissy." Rockwell's country boys initiated Cousin Reginald into rural life through a series of adventures. The country boy was expert at catching fish, driving a horse-pulled buggy, and standing on his head, while the rich sissy succeeded only at spelling bees and other academics. As a boy who was not athletic and who wore glasses (he was nicknamed "Mooney" because of their round shape) and whose mother insisted he use his middle name, Percevel, which, to Rockwell, sounded sissyish, Rockwell's own childhood experiences provided much of the emotion behind the images. But unlike Reginald, Rockwell was never good at spelling and never a stellar student. In fact, he left high school in his sophomore year to study art full-time, and at the end of 1915, as soon as he was no longer living with his parents, Rockwell dropped the middle initial "P" from his signature.

Painting for the *Country Gentleman* cover, February 9, 1918
30 x 30 inches
Norman Rockwell Museum Collection, NRM.1978.11

Hey Fellers, Come On In! 1920
Norman Rockwell (1894–1978)
Oil on canvas

Although the lion's share—321 paintings—of Norman Rockwell's cover art was published by *The Saturday Evening Post*, his work also appeared on the covers of thirty-one other publications. In some cases a magazine commissioned just a few Rockwell covers, but in others his contribution was substantial. For *Country Gentleman*, he created thirty-nine cover illustrations from 1917 to 1922, including *Hey Fellers, Come On In!*

Painting what he knew best from his former position as illustrator and art director of *Boys' Life*, Rockwell's subject for the majority of his covers was the pastimes and antics of adolescent boys. In *Hey Fellers, Come On In!* Rockwell expresses his love and idealization of country life. The theme of swimming where "No Swimming" is posted recurs throughout Rockwell's career, perhaps an expression of his tolerant attitude toward minor rule-breaking and enjoyment of pranks and practical jokes. Boys who posed in Rockwell's studio enjoyed an atmosphere of lenience and camaraderie with the painter.

The device of painting part of the image outside the lines delineating the picture area is often used in Rockwell's cover art to produce the effect of pushing the action off the page as if it were coming alive, making it more dynamic to the viewer. In *Hey Fellers, Come On In!* not only does the boy's hand reach out of the frame, but drops of water appear to fly out of and then back into the picture.

Odds & Ends:

Curtis Publishing Company, publisher of *The Saturday Evening Post*, also published *Country Gentleman* and *Ladies' Home Journal*. Despite their common publisher, the magazines were independently staffed and vied with each other for Rockwell's work.

Painting for *Country Gentleman* cover, June 19, 1920
20 x 19.75 inches
Norman Rockwell Museum Collection, NRM.1985.4

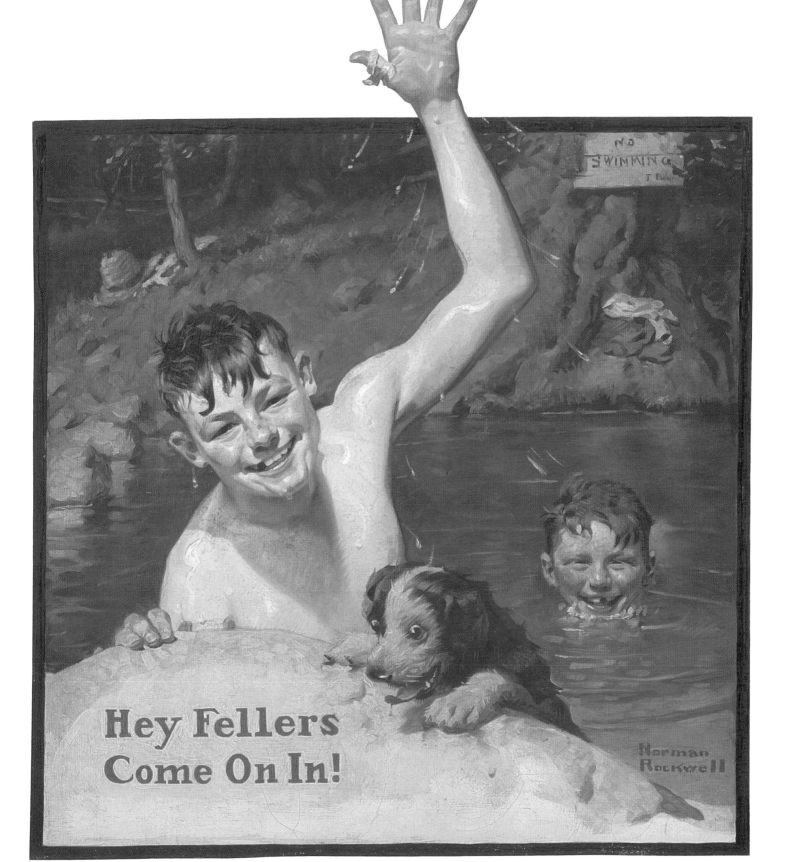

No Swimming 1921
Norman Rockwell (1894–1978)
Oil on canvas

Norman Rockwell might have been thinking of his boyhood summer vacations in upstate New York as he captured a simple joy of country life in *No Swimming*. Rockwell was branded as an illustrator of children during his early career, which was dominated by his association with *Boys' Life* magazine and another children's magazine, *St. Nicholas*. He perfected the art of painting from the point of view of boys and girls in genre scenes such as this one, capturing slices of life as a camera might have. But such images, just a click away for photographers, were a challenge for artists.

Before Rockwell began using photography to aid his painting process, his models had to hold their poses for lengthy stretches, sometimes with limbs propped up by stacks of books or held with ropes and pulleys. Rockwell kept a pile of nickels on a table next to his easel. "Every twenty-five minutes," he recorded, "I'd transfer five of the nickels to the other side of the table, saying, 'Now that's your pile.'"

Painting for *The Saturday Evening Post* cover, June 4, 1921
25.25 x 22.25 inches
Norman Rockwell Art Collection Trust, 1973.15

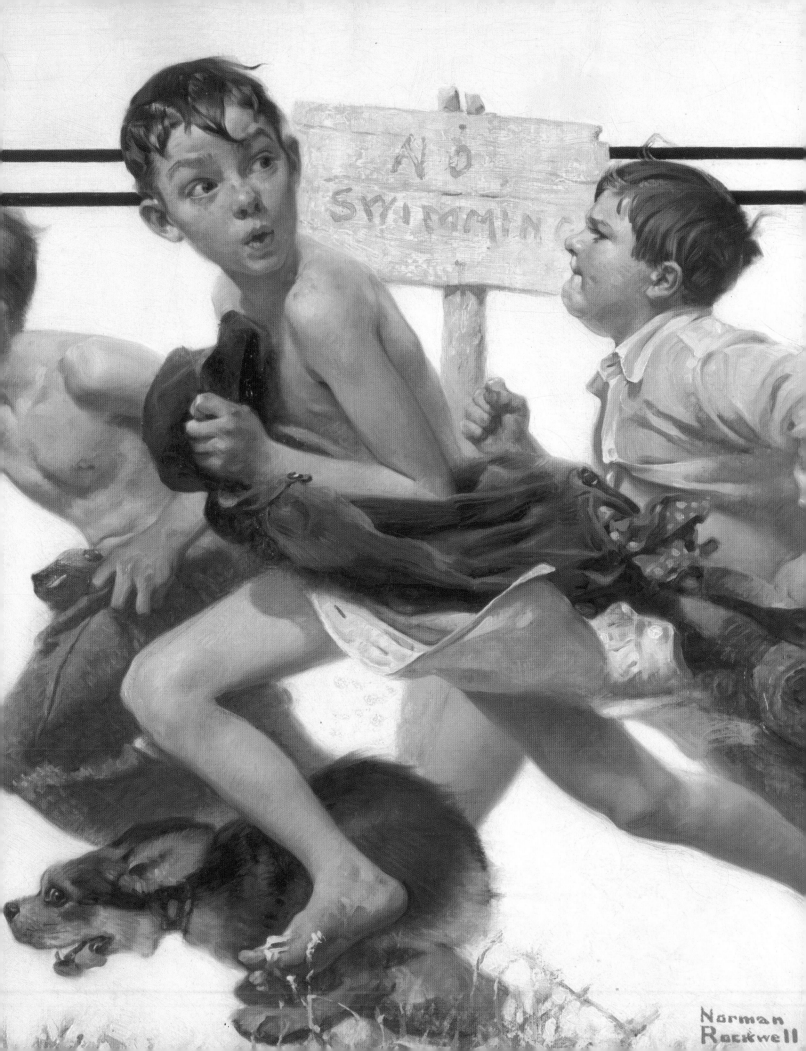

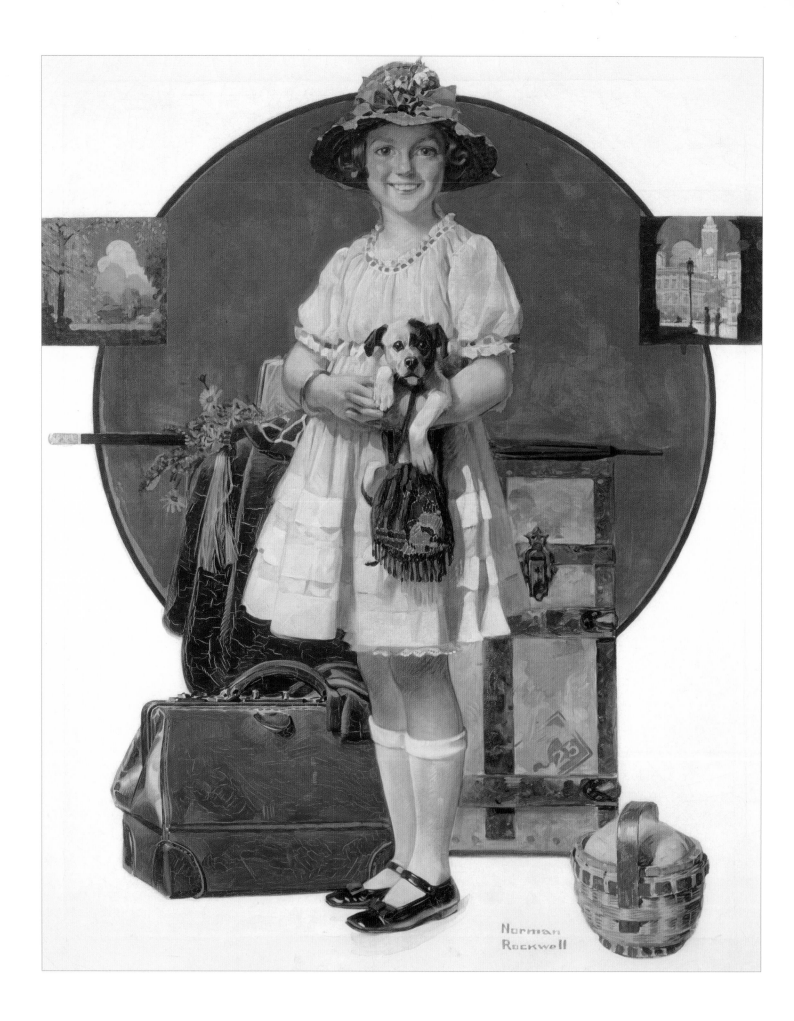

Vacation's Over 1921
Norman Rockwell (1894–1978)
Oil on canvas

From 1918 to 1923, Norman Rockwell produced forty-seven covers for *Literary Digest* magazine. His topical images for the current events weekly portrayed a rich cross-section of American society. Covers pictured city and country dwellers and people of all ages and economic classes at work, in school, enjoying leisure activities, or simply daydreaming.

Vacation's Over pictures a well-to-do little girl returning from vacation. Carrying a puppy, perhaps acquired during her vacation, she is surrounded by her steamer trunk adorned with travel stickers, a satchel, and a Chinese lunch basket. Miniature paintings on each side of the canvas, one of a country scene and the other of a city scene, may record places she has traveled.

The lure and joy of travel is keenly felt in this painting, published just as Rockwell was to have his first taste of travel abroad. In November 1921, while at work on an ad campaign for General Electric's Edison Mazda division, the art director and his staff were given an all-expenses-paid trip to South America as a reward for the campaign's success. Rockwell was taken along as the director's assistant. The trip had its ups and downs but left Rockwell feeling "shaken up," which he liked. "In short, I'd developed chronic wanderlust. A bad case—I haven't got over it yet."

The compositional device of a circle or an oval in a background was used by many early cover artists to help frame or anchor the subject on the cover's expanse of white background. When the circle was filled in with color, as it is here, it provided contrast in color or tone to the subject—in this case separating the pale pink dress from the white background. Cover artists sometimes painted the circle as an object, such as a moon, an umbrella, or even a tire, or it might be used to hold a portion of sky or landscape or to contain an imagined scene in a kind of thought bubble.

Painting for *Literary Digest* cover, August 27, 1921
30.125 x 25 inches
Norman Rockwell Museum Collection, NRM.1991.3

Artists Costume Ball 1921
Norman Rockwell (1894–1978)
Oil on canvas

After World War I, the New Rochelle (New York) Art Association held three annual costume balls to raise funds for a war memorial. Rockwell, then living in New Rochelle, painted this poster design in 1921 to advertise one of the balls. Since he was a member of the Association, we can guess that he volunteered his time and talents for this poster.

In her brief history of the Association, Ann Maloney Lyons said, "These galas were immensely popular and successful. Dancing lasted from 8 pm till 4 am." Artists' posters, such as this one, were auctioned off at the end of the evening, adding to the fun and raising additional funds.

From its thinly applied but broad brushstrokes, it appears that Rockwell painted this quickly, perhaps completing it within an hour and at one sitting. Though painted seven years before *Checkers*, the basic interpretation of the clown is the same. Note the white cap that hugs the clown's head, the arrow-shaped eyebrows, and the lines through the eyes and at the cleft of the chin. Each clown wears a ruffled collar, and the same circular shapes, painted in primary colors, accent the hat and the cap.

The "reverse" painting of the signature—leaving space for each letter—was probably done with the aid of pencil lines.

Painting for costume ball poster
29 x 21.5 inches
Norman Rockwell Museum Collection, Gift of Evelyn F. Hitchcock in memory of Ethan Wolcott Hitchcock, NRM.2004.1

ARTISTS COSTUME BALL

APRIL 8

Norman Rockwell

I'm Thinking About My Kiddie 1922

Norman Rockwell (1894–1978)

Oil on canvas *en grisaille*

Raybestos, a brake parts company, took a democratic approach in its 1922 advertising campaign, targeting its ads, which emphasized the importance of safety, to a wide demographic of the American public. For his seven illustrations for Raybestos print ads, Norman Rockwell portrayed a traffic policeman, a mechanic, a couple in a touring car, a bus driver, an elderly male driver, a farmer, and this image of a young urban woman and her daughter. Simple in its monochromatic rendering, the haunting gaze and Mona Lisa smile of the subject leave us wanting to know more about her and her possible relationship with Rockwell.

Ironically, as these ads stressed the improved driving safety of their products, Raybestos workers were falling ill with asbestosis, a chronic inflammatory lung disease caused by inhalation of asbestos fibers. As the company's name suggests, Raybestos brakes contained asbestos, a mineral whose microscopic strands were released into the air when woven into brake lining fabric. The American public, however, would not learn the extent of the devastating effects of asbestos for forty more years.

Painting for Raybestos brake parts advertisement, detail
12 x 18 inches
Norman Rockwell Museum Collection,
NRM.1985.6

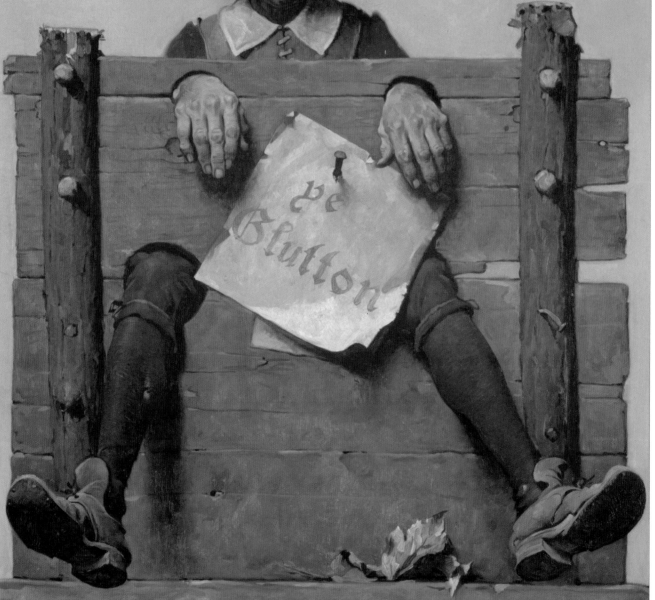

Founded in 1883 by a group of young Harvard men as a rival publication to *Judge* magazine, *Life* targeted a sophisticated audience with its emphasis on satire and criticism. In the 1920s, *Life's* pages featured cartoons and humorous illustrations, a format that continued until 1932 under the direction of *Life's* longtime illustrator and new owner, Charles Dana Gibson. Presented in good fun, *Life's* irreverent commentary on any and every subject of daily life, including prohibition, the emerging independence of women, politics, and big business, entertained weekly readers and provided a forum for the talents of the humorist-illustrators of the day.

In portraying the deadly sin of gluttony, Norman Rockwell's choice of a thin man diverged from the stereotype and presented the novel idea that anyone could be a glutton and fair game for criticism. Rockwell enjoyed the costumes and romantic settings of historical illustrations and the challenge of recording authentic details over creating imaginary ones. He often employed a professional research service in New York City, which sent him documents and tear sheets, and also received help from local librarians who searched out material for him. In addition to these resources, Rockwell acquired a collection of books and prints for handy research in his studio, and rented or purchased costumes from theatrical supply firms in New York and Boston. His wife Mary searched for props in neighborhood antique shops.

Rockwell continued to do historical illustrations into the 1930s, until losing his reference collections in the 1943 fire that destroyed his Vermont studio. After that, he turned to more topical subjects.

Painting for *Life* cover, November 22, 1923
31 x 22 inches
Norman Rockwell Museum Collection, NRM.1986.3

Christmas Trio 1923

Norman Rockwell (1894–1978)

Oil on canvas

Norman Rockwell was fond of painting lively and richly decorated images set in Victorian or Elizabethan England, probably due to his childhood immersion in Dickens stories and his mother's proud tales of his English ancestry. Holiday celebrations from Dickens' "Merrie Olde England" appealed to readers' nostalgia for home, bygone times, and universal good cheer and benevolence, and provided relief from the commercial bustle of the modern holiday. Many of Rockwell's early Christmas covers for *The* *Saturday Evening Post* pictured such scenes, and for these, Rockwell could draw on his extensive collection of period costumes. Before 1926, *Post* covers were printed in just two colors—black and red—and to make the actual painting more interesting, Rockwell sometimes added others. In this case, he painted the violinist's coat a rusty green.

Painting for *The Saturday Evening Post* cover, December 8, 1923
28.25 x 21.5 inches
Norman Rockwell Art Collection Trust, NRACT.1973.2

If Your Wisdom Teeth Could Talk They'd Say, "Use Colgate's" 1924

Norman Rockwell (1894–1978)

Oil on canvas

A perfect example of Norman Rockwell's early twentieth-century style of advertising illustration, this painting for Colgate toothpaste mentions but does not picture the product. Since the ads of such products in the 1920s were marketed to adults, Rockwell's subtlety would not have been missed. An assignment such as this made it easy for Rockwell to paint the kind of storytelling pictures he preferred. In keeping with his penchant for picturing children with benevolent grandfathers, Rockwell composes his scene with an elderly man and a young boy. From the body language and the props, it appears the man is telling the boy about an adventure of his own youth. The map and the Civil War memorabilia suggest that his story relates to an actual historical event. To hear first-hand of Civil War service would have been a profound learning experience for an imaginative youth. Since this image was used as a magazine print ad reduced to one-half or one-third page size, readers may have overlooked the incongruity of cavalry, infantry, officer, and drummer boy memorabilia. Later in his career, Rockwell would become extremely careful in researching information for his paintings as readers invariably wrote to him if they found errors.

In 1903, when Rockwell was nine, his paternal grandmother, Phebe Rockwell, died. So that Rockwell's grandfather would not be alone, the family moved from their New York City apartment at 103rd Street to John Rockwell's apartment at St. Nicholas Avenue and 152nd Street. They remained living together—even after moving to Mamaroneck in 1907—until 1911, when Rockwell's mother, complaining of the hardship of caring for her father-in-law, persuaded her husband to move the (nuclear) family to a boarding house in New Rochelle. During the eight years of proximity with his grandfather, it is likely Rockwell would have heard stories of his grandfather's brother, George Sigourney Rockwell, a sergeant in the Union Army, who was mortally wounded in the final days of battle at Stones River, Tennessee. Rockwell never mentioned his grandfather, nor does it appear that he used him as a model in any of his pictures of elderly men. But just as Rockwell seems to compensate for the lack of affection and warmth in his family by painting it into his pictures, the tender grandfather-grandchild relationship is abundant in his work.

Painting for Colgate dental cream advertisement, 1924
26.5 x 32 inches
Collection of the Norman Rockwell Museum, NRM.1979.1

Good Friends 1925
Norman Rockwell (1894–1978)
Oil on canvas

In this simple image of a Boy Scout feeding a litter of puppies, Norman Rockwell captures the eagerness of one set and the reticence of the other. Rockwell's brush strokes make the silky feel of their new coats almost palpable. Because calendar publication required about two years of production time, *Good Friends* was painted in 1925 for the 1927 season. It was Rockwell's third in a series of fifty-one paintings used by the Boy Scouts of America as calendar illustrations and *Boys' Life* magazine covers.

The country setting of this scene is far from Rockwell's own urban youth and alludes to his idea of the goodness of country life. His message of friendship is expressed through the relationship of the boy and his pets as well as between the bonds that will form between the puppies.

Painting for Boys Scouts of America calendar, February 1927
27 x 25 inches
Norman Rockwell Museum Collection,
Partial gift of Robert P. McNeill and Thomas B. McNeill
in memory of Don McNeill, NRM.2003.1

Book of Romance 1927
Norman Rockwell (1894–1978)
Oil on canvas

Norman Rockwell began illustrating magazine stories in 1912, producing over two hundred illustrations for *Boys' Life* alone by 1919. During this early part of his career, he also illustrated stories for *St. Nicholas, Everyland, American Boy,* and *Youth's Companion,* and in the late teens and 1920s, he produced story illustrations for *Ladies' Home Journal, American Magazine,* and *The Saturday Evening Post.*

In addition to illustrating short stories, Rockwell produced a number of what he called subject pictures. These were narrative scenes unaccompanied by text, much like cover art. They appeared inside the magazine and were published with a brief title to give the reader a hint of their theme. Unlike his *Post* cover art of this period, which had little background, Rockwell's subject pictures told their story in a more richly detailed visual context—a quality he would be identified with in years to come.

One good example of the narrative style of Rockwell's subject pictures is *Book of Romance.* It was inspired by the painting *Der Bücherwurm* (*The Bookworm*) by popular nineteenth-century German painter Carl Spitzweg, who, as part of his training, made many copies of seventeenth-century Dutch paintings. (One can see the influence of Vermeer and Rembrandt here.) One device used often in Spitzweg's and, not accidentally, in many of Rockwell's paintings, is the dichotomy between setting and theme. In this case, an old library filled with dusty old volumes in which an elderly gentleman experiences life vicariously is contrasted with a young couple enjoying a romantic interlude.

Subject picture for *Ladies' Home Journal,* July 1927
32 x 42 inches
Norman Rockwell Museum Collection, NRM.1985.3

The Law Student 1927
Norman Rockwell (1894–1978)
Oil on canvas

To celebrate the February 12 birthday of President Abraham Lincoln, Norman Rockwell painted this picture of a store clerk reading law books. While it alludes to Lincoln's own study of law, the chronology is slightly mistaken. Though Lincoln had been a store clerk and then part-owner of a store, it wasn't until two years later, after he had started a political career as a representative in the Illinois General Assembly, that he began to study law. The point is well taken, however, and provides a picturesque cover. Far from resembling Lincoln, the handsome Rockwell model adds to the cover's charm. Later in his career, Rockwell would paint authentic representations of Lincoln for Boy Scout calendars and historical illustrations.

Business invoices tacked to the wall identify this setting as the back room of a store. These papers, the leather-bound books, the tear sheets of Lincoln images, and the wooden barrel give Rockwell an opportunity to represent a variety of textures. Now that *The Saturday Evening Post* was printing covers in full color (note the capitals of the signature), Rockwell could use color to enhance his composition. He added touches of vermillion strategically around the student, eventually leading the reader's eye to the rosy glow of the student's light-bathed face, framing the scene and lending it warmth.

The Law Student earns a place as one of Rockwell's symbolic portrayals of the American dream, presenting the notion that with diligence, a person of meager means can aspire to greatness. Rockwell's own diligence was leading him to financial success and illustration fame, thus securing his American dream. In 1927, he was a member of the local yacht and country clubs, drove a canary-yellow Apperson Jack Rabbit, and spent $23,000 (the equivalent of $253,000 in 2006 dollars) building a studio next to his newly-purchased $38,000 New Rochelle house. Later that summer he embarked on a four-month tour of Europe with two friends.

Painting for *The Saturday Evening Post* cover, February 19, 1927
36 x 27.5 inches
Norman Rockwell Museum Collection, NRM.1979.4

The Stay at Homes (Outward Bound) 1927
Norman Rockwell (1894–1978)
Oil on canvas

Over a forty-nine-year period beginning in 1924, Norman Rockwell contributed thirty-seven illustrations to *Ladies' Home Journal*. Some accompanied fictional stories, and some, like this one, told their own story, published with title only. The motif of children and the elderly was common throughout Rockwell's career. Rockwell enjoyed working with children and older adults. Because they were less self-conscious and less concerned about their dignity, he said, they were freer to act out the feelings he wanted them to express and less worried about how they might be portrayed.

When an artist depicts a person facing away from us, we are invited to place ourselves in that person's role, becoming the surrogate of the character. By presenting two choices, Rockwell increases the pool of viewers who might empathize with his characters, and he offers two different—in this case opposite—perspectives. This illustration would have worked just as well in a children's publication or one for seniors, but its overall sentimentality appealed to women. Other subjects Rockwell painted for the *Journal* included a young woman dreaming of romance, a Christmas visit to a sick friend, a young actor yearning for Hollywood stardom, and a woman posing for her portrait.

The foreground of this painting indicates a New England setting. In the summer of 1912, Rockwell spent three months studying painting with Charles Hawthorne in Provincetown, Massachusetts, which was then a Portuguese fishing village. Hawthorne had studied *plein air* painting (painting outdoors) with William Merritt Chase. In Rockwell's painterly treatment of the roofs, waves, trees, grass, and man's trousers, we see the influence of Chase's impressionistic style.

Similar to his magazine covers, Rockwell's subject pictures often provide clues for viewers to create a story continuum. In this case, the shingle-roofed cottage in the foreground may be the home the child and grandfather have left to climb the hill for a better look at the departing ship. When the ship is out of sight, or when night approaches—the westerly setting sun has already begun to cast them in shadow—they might return to light a fire to take the chill off a damp evening or to boil water for tea and reminisce about the grandfather's sailing adventures.

Painting for *Ladies' Home Journal* illustration, October 1927
39.25 x 32.5 inches
Norman Rockwell Art Collection Trust, NRACT.1973.82

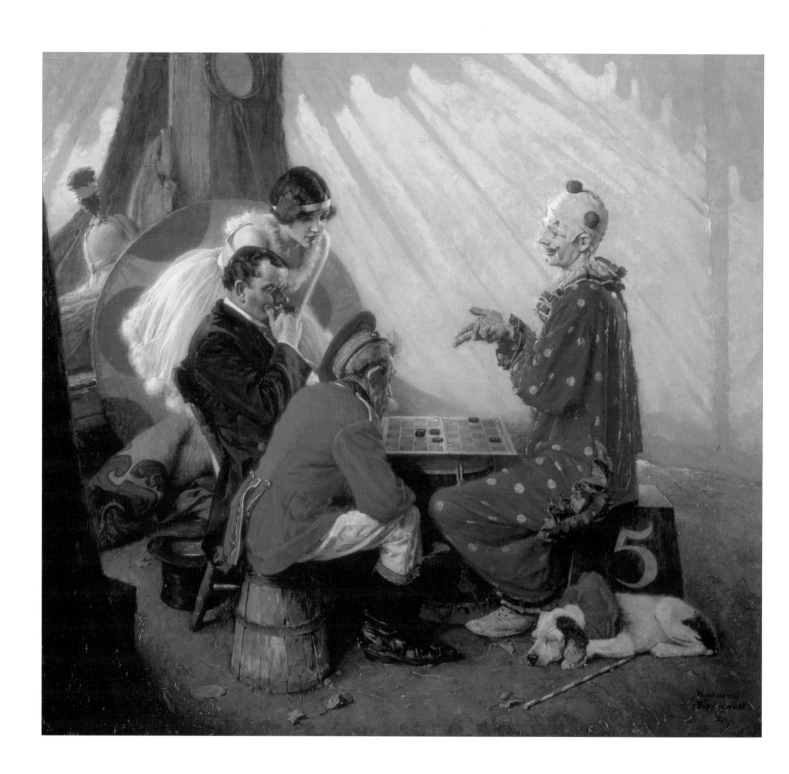

Checkers 1928
Norman Rockwell (1894–1978)
Oil on canvas

Checkers, published in 1929 for *Ladies' Home Journal*, illustrates a story by Courtney Ryley Cooper about a circus clown named Pokey Joe who no longer feels that he is funny. His circus pals decide to lift his spirits and renew his confidence by letting him win a high-stakes game of checkers—the only thing he really cares about.

The subject of circus characters is fertile ground for Rockwell to create dimensional characters in exotic costumes. The drama and flair of the circus world are expressed through the richness of his colors and in a painterly style found most often in Rockwell's earlier work of the 1920s and 1930s. It is a true illustration in the sense that it describes the text of a story and adds to our enjoyment and appreciation of the tale through its visual richness.

Circus life and performers are favored themes in Rockwell's repertoire. His childhood experience of going to the circus, and of being around performers as an extra at the Metropolitan Opera during his art student days, are fondly recalled through these images.

Painting for *Ladies' Home Journal* story illustration, July 1929
35 x 39 inches
Norman Rockwell Museum Collection, NRM.1976.1

Welcome to Elmville 1929
Norman Rockwell (1894–1978)
Oil on canvas

"There was one kind of idea which I didn't have to struggle over—the timely idea. I'd just keep my ear to the wind and, when I heard of a craze or fad or anything which everyone was talking about, I'd do a cover of it." *Welcome to Elmville* was one such idea. Norman Rockwell said that at the time, rather than imposing new taxes on their citizens, towns were hiring police to set up speed traps and "fine their victims heavily."

The model for this pose was not one of the many professional models engaged by Rockwell when he lived in New Rochelle. Instead, he chose Dave Campion, the owner of a local news store, for this and for other images that required a character who was tall and lean. Positioning him in a crouching position gives his body angles that create movement. The arbitrary shadow behind him adds to this effect. The small streaks of white paint in the foreground tell us a car has just careened by.

Painting for *The Saturday Evening Post* cover, April 20, 1929
33 x 27 inches
Norman Rockwell Museum Collection, NRM.1979.3

Merrie Christmas 1929
Norman Rockwell (1894–1978)
Oil on canvas

Merrie Christmas is an embodiment of Norman Rockwell's imaginative journey with Victorian literature. The painting awakens the sentiments of the Christmas season for all who have read Charles Dickens' works. The portrayal of the coachman is based on Dickens' character of Tony Weller, father of Pickwick's manservant in *Pickwick Papers*. Weller is portly and robust and described as "uncommon fat." He wears top boots, a broad-brimmed hat and a tile-green shawl. "On the stage box he is king," writes Dickens. "Elsewhere he is a mere greenhorn."

In books read to him by his father, Rockwell grew up seeing the illustrations of H.K. Browne, known by his moniker, "Phiz." But Rockwell's full-color renderings bear little resemblance to Browne's linear style intended for engravings. Unlike many of Rockwell's *Saturday Evening Post* covers in which people are slightly caricatured, the flesh and blood realism of *Merrie Christmas* is so convincing that one feels Rockwell views Dickens' world as fact rather than fiction. Knowing Rockwell's empathy and predilection for the characters and imbedded messages in Dickens' works, we feel he must have yearned for a commission to illustrate his novels, but he never received one. Paintings such as this are the only tribute to the author to whom Rockwell credits his way of looking at life.

"This way of looking at things has stuck with me from those nights when my father would read Dickens to us in his even, colorless voice, the book laid flat before him to catch the full light of the lamp, the muffled noises of the city—the rumble of a cart, a shout—becoming the sounds of the London streets. . . . The variety, sadness, humor, happiness, treachery, the twists and turns of life; the sharp impressions of dirt, food, inns, horses, streets; and people—Micawber, Pickwick, Dombey (and son), Joe Gargery—in Dickens shocked and delighted me. 'So that,' I thought, 'is what the world is really like.' I began to look around me; I became insatiably curious."

Painting for *The Saturday Evening Post* cover, December 7, 1929
44.125 x 33.125 inches
Norman Rockwell Museum Collection,
Gift of the family of John W. Hanes, NRM.2000.3

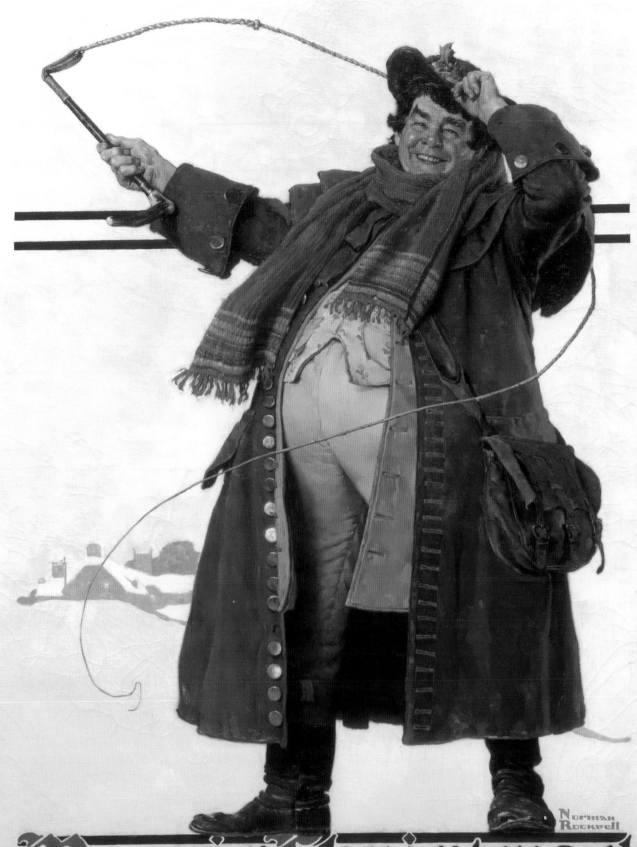

Merrie Christmas

Brass Merchant 1934

Norman Rockwell (1894–1978)

Oil on canvas

While other *Saturday Evening Post* artists were portraying beautiful women gazing out from the cover, Norman Rockwell was painting women engaged in activities giving them dimension and identity beyond beauty or social status. In *Brass Merchant*, Rockwell's shopper, though elegantly dressed, is driving a hard bargain for a coffee pot. Surrounding the merchant's feet are objects typical of Rockwell's studio inventory—antiques collected to decorate his studio according to the fashion of the day or for use as needed in a painting. As he sat at his drawing table sketching ideas, perhaps Rockwell's eye fell upon his own samovar, suggesting the idea for this cover.

The painting's composition leaves us to guess what the outcome of the bargaining session will be. The two bodies are angled equally, giving neither an advantage, and the pot is squarely in the middle. In addition to the beauty of the symmetry, the painting is so delicately painted—almost as if the medium were watercolor and not oil—that it has a translucence yielding vibrancy and freshness. We feel the characters could walk off the page.

Painting for *The Saturday Evening Post* cover, May 19, 1934
34 x 28 inches
Norman Rockwell Museum Collection, NRM.1978.2

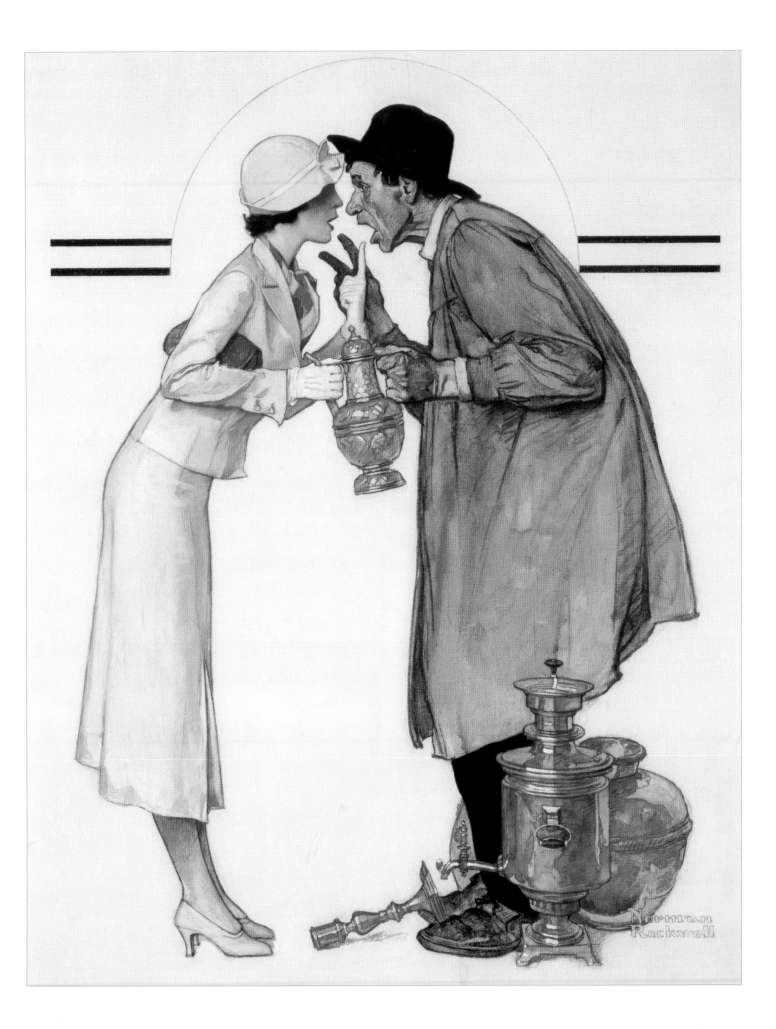

Early in September 1937, a four-by-eleven-and-a-half-foot oil-on-canvas painting by Norman Rockwell was delivered to the taproom of the Nassau Tavern in Princeton, New Jersey. Rockwell's painting of a colonial tavern sign painter in the February 1936 issue of *The Saturday Evening Post* had caught the eye of

Princeton architect Thomas Stapleton, who decided to commission Rockwell to paint the large oil for the reconstructed 1756 Nassau Tavern at its new Princeton site. Rockwell enjoyed doing colonial subjects, and as Princeton was the site of a major Revolutionary War battle, a painting of Yankee Doodle was appropriate. The Tavern, relocated near its original site in a new town square known as Palmer Square, was part of a redevelopment project by Princeton University graduate Edgar Palmer, who began its planning in 1925 and bankrolled the project in 1936. Rockwell's painting was placed behind the bar to be enjoyed by all the male guests, as the taproom was still "reserved for guests who may enjoy their wine in peace and speak freely of Politicks and such subjects of peculiar interest to the Male." Women were excluded until 1972.

Rockwell researched and had new costumes made for his Hessian and British soldier models. He engaged his friend Fred Hildebrandt, a

professional model and illustrator, who had posed as the colonial sign painter, to pose as Yankee Doodle. Work continued during the ensuing months. Rockwell completed a large Wolff pencil preliminary, seen here, in preparation for the oil. He hired New Rochelle cover artist Walter Beach Humphrey to letter in the lyrics. ("I have never learned to letter well, for lettering is an art in itself, so whenever I have needed lettering, as in this case, I have called on an expert to draw it. Then I have painted it, believing that I could thus get character of my own into it.") Pressured by competing deadlines for *Post* covers and story illustrations for *American Magazine* and the *Post*, Rockwell's attentions were divided. When he wasn't at work on it, he felt the painting hung suspended over his head "like the sword of Damocles."

The tune of Yankee Doodle is said to derive from an English nursery rhyme. The nonsense lyrics were written in 1755 by British army physician Richard Shackburg to mock the disheveled colonials with whom the British served during the French and Indian War. During the Revolution it was appropriated by the colonists and became a favorite tune of colonial soldiers who sang it "in battle, in defeat, and victory." The lyrics of a later chorus, used in Rockwell's depiction, are credited to Edward Bangs. In this preliminary, Rockwell used the word "went," but he changed it to "came" in the final oil painting. The term Yankee was used by the British as a derogatory term for a Puritan, a "doodle" was a simpleton, and "macaroni" was either the knot on which the feather was fastened or a dandyish young man, the latter being the common interpretation.

Detail of *Yankee Doodle*

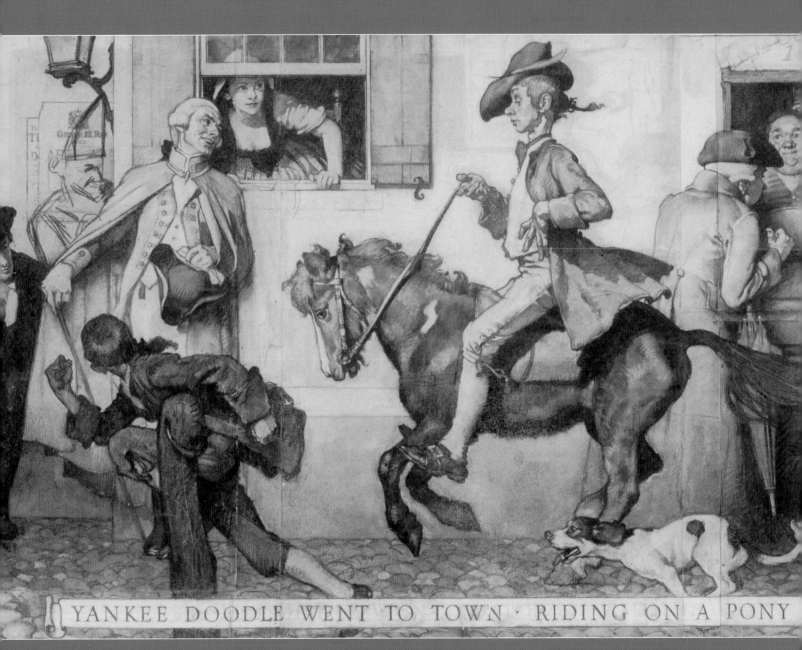

YANKEE DOODLE WENT TO TOWN · RIDING ON A PONY

CK A FEATHER IN HIS HAT · AND CALLED IT MACARONI

Drawing for the Nassau Tavern Inn
24.5 x 72 inches
Norman Rockwell Museum Collection, NRM.1981.1

Turn of the Tide 1937
Norman Rockwell (1894–1978)
Oil on canvas

A legendary eighty-pound salmon waits for the turn of the tide to be pulled out of the bay by the current of Rainy River. In the clean river sand she will lay her eggs and meet the end of her six-year life cycle. During an early morning fishing trip to Cultus Bay to attempt to land the salmon, a dam builder and the elderly owner of a logging company are about to confirm a deal to dam the Rainy River, which will cut the owner's cost of running logs down to the sea. After making his long-wished-for catch, with the help of his fishing guide's special lure, the salmon's sacrifice for her progeny suddenly resonates with the old man, inspiring him to release her back into the bay. In his last act, seconds before his own death from the enormous exertion of catching the salmon, he gives $2,000 to his young guide, who reminds him of his own deceased and childless son, knowing it will be enough for him to marry and begin his own family.

The ruthlessness of the old man who has no reservations about destroying the spawning route of the local salmon is not apparent in the facial expression Norman Rockwell paints for his readers. Not until the reader learns of the old man's reflection on his son's death and his own imminent end does it become clear that Rockwell has painted these more thoughtful and desolate expressions of the last moments of life. Characters with this much angst are not found in Rockwell storytelling covers or subject pictures, but when illustrating an author's text he was compelled to paint character types he might not invent for his own storytelling.

Painting for *American Magazine* story illustration, October 1937
20 x 32 inches
Norman Rockwell Museum Collection, NRM.1997.18

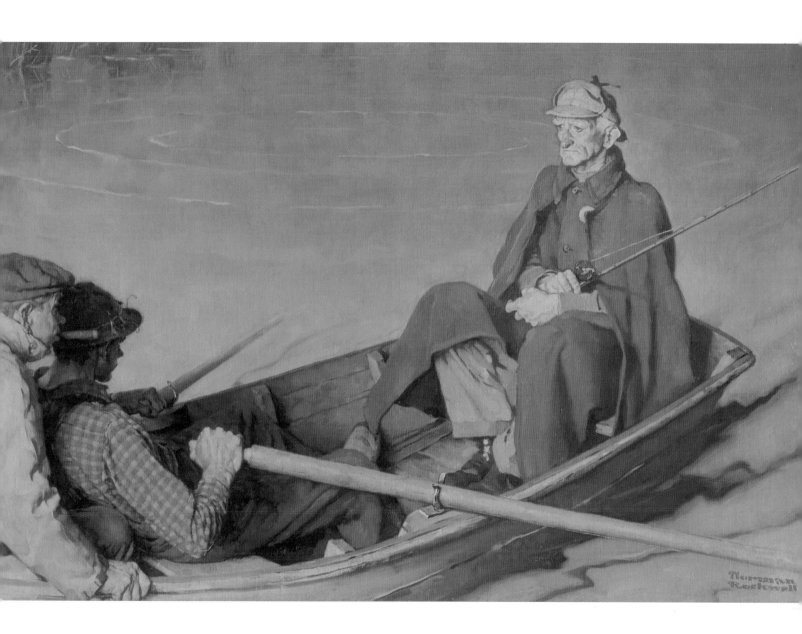

Ichabod Crane c. 1937

Norman Rockwell (1894–1978)

Oil on canvas

In 1936, book publisher George Macy commissioned Norman Rockwell to illustrate new editions of *Tom Sawyer* and *Huckleberry Finn*. Eager to repeat Rockwell's success with additional titles, Macy encouraged him to explore other subjects for illustrated books. Rockwell began work on a series of pictures of celebrated characters in American fiction, which would be paired with excerpts from the stories. As one of the first in the series, he chose Ichabod Crane, the schoolmaster from the 1819 Washington Irving story *The Legend of Sleepy Hollow*. Rockwell painted this first version of Ichabod and then a second, more developed version, which is now in the collection of Utah's Draper Elementary School.

It is likely that Rockwell's good friend and New Rochelle model Fred Hildebrandt, who had just posed as the schoolmaster in *Tom Sawyer*, also appears in Ichabod Crane. Irving described his character as "tall, but exceedingly lank, with narrow shoulders, long arms and legs, hands that dangled a mile out of his sleeves, feet that might have served for shovels, and his whole frame most loosely hung together. His head was small, and flat at top, with huge ears, large green glassy eyes, and a long snipe nose, so that it looked like a weathercock perched upon his spindle neck to tell which way the wind blew."

Rockwell's artistic interpretation departs from a version created ten years earlier by Arthur Rackham, one of his favorite illustrators. Rackham's spidery pen-and-ink rendering suits the skinny, gawky Crane, whereas Rockwell's figure is more substantial, making us feel slightly unsettled by the penetrating demeanor of his sideways glance, and fortunate that we are confronted by a painting and not the actual man.

Unpublished illustration
49.5 x 24.5 inches
Norman Rockwell Art Collection Trust, NRACT.1973.107

Heart's Dearest, Why Do You Cry? 1938
Norman Rockwell (1894–1978)
Oil on canvas

In 1937, Norman Rockwell traveled to the home of Louisa May Alcott in Concord, Massachusetts, to research Alcott's life for his illustrations of Katharine Anthony's biographical essay "The Most Beloved American Writer." There he studied the Alcott homestead, chatted with Alcott descendants, and ordered costumes for his models. That fall, on a moose-hunting trip to Canada, he took along Alcott's *Little Women*. "Every evening I would sit reading *Little Women* while my three companions—great husky, broad-shouldered guys—were talking about killing moose." A Boston newspaper got wind of his trip and in December reported this humorous juxtaposition of events, adding that Rockwell kept telling his jeering companions that it was "a darn good story."

The serialized biographical essay, with Rockwell's fourteen illustrations, appeared in four consecutive issues of *Woman's Home Companion*, from December 1937 to March 1938. Rockwell's images traced Alcott's life from her birth through her early tutoring by her father, to her relationship with a young Polish musician, her European travels, and a meeting with her publisher. Rockwell chose to depict several scenes from Alcott's *Little Women*, though they weren't mentioned in Anthony's essay, perhaps because these scenes lingered in his memory after reading the book. Each pictures the character Jo, who represents the author. *Heart's Dearest, Why Do You Cry?* depicts Jo trying to hide her tears from Professor Bhaer, with whom she has fallen in love.

Rockwell later wrote: "One of the real handicaps to American Illustration is the fact that every girl, in every illustration in every magazine, must be made beautiful—no matter what the story." He said editors believed "American women would not stand for anything but glamorous females." Rockwell tried to paint Alcott as she appeared in photographs. "Though she had character, they showed her as anything but beautiful." But the editor made him "pretty her up," which he felt weakened the picture. His sentiment wasn't shared by his peers, however. Cover artist Coles Phillips, then editor at *The Elks Magazine*, wrote saying that he and the director at *Elks* were "immensely interested" in his Alcott illustrations. "You are making the rest of the boys [illustrators] look sick, Norman," Phillips said.

Painting for *Woman's Home Companion* story illustration, March 1938
32 x 18 inches
Norman Rockwell Museum Collection, NRM.1994.3

Artist Facing Blank Canvas (The Deadline) 1938
Norman Rockwell (1894–1978)
Oil on canvas

As an illustrator, Norman Rockwell struggled with deadlines his entire life. He said of this painting, "Meeting deadlines and thinking up ideas are the scourges of an illustrator's life. This is not a caricature of myself; I really look like this." Commissions for advertising, story, and book illustrations came with suggestions or even imperatives for the subject of a painting, but cover art for a publication such as *The Saturday Evening Post* required Rockwell to develop his own original and, preferably, new ideas. He had never used the theme of an artist facing a deadline before, but in 1938, after returning from an extended family vacation in England, it became useful.

Though he often posed for characters in his own paintings when "extras" were needed for a scene with a lot of people, Rockwell did few formal self-portraits or paintings in which he was the sole character. *Artist Facing Blank Canvas* is one. In it Rockwell is surrounded by his references. Museum reproductions, art history books, artists' monographs, illustrators' annuals, and books and tear sheets on such subjects as birds, animals, and trees comprised his library. Photos taken for one painting were saved in files and binders, and sometimes were used a second or third time. Sketches strewn about represent rejected ideas for

this *Post* cover. These elements accurately portray Rockwell. Others don't ring true. Rockwell did have a horseshoe, but it hung on his studio wall—not from his easel, where it would have been in the way of his work. Orienting it opposite the usual upside-down placement believed to bring good luck may symbolize the bad luck he has encountered; his August due date had long passed. Rockwell rarely began a painting at the oil-on-canvas stage. By the time a canvas was primed and on his easel, he had completed a fully detailed drawing, the same size as the canvas, ready to have its basic composition traced to the final support. His palette table, which was always to the left of his easel, has been replaced by a hand-held palette on the floor to his left, perhaps as a compositional counterbalance to the sketches on the floor to his right. Rockwell's pipe, included in all his self-portraits because he thought of himself as "an inveterate pipe smoker," is in his pants pocket because he thought it would be more prominent. And, finally, Rockwell's costume is fictional, created with the idea of brightening things up.

Painting for *The Saturday Evening Post* cover, October 8, 1938
38.5 x 30.5 inches
Inscribed "To my good friends Jorj and Ben Harris"
Norman Rockwell Art Collection Trust, 1973.4

Football Hero 1938

Norman Rockwell (1894–1978)

Oil on canvas

After exposing the difficulty of finding good ideas for new covers in *Artist Facing Blank Canvas*, his previous *Saturday Evening Post* cover, Norman Rockwell turned to an easy and obvious choice for autumn—football. From the initials on the horn, we learn the football player and cheerleader are high school students. Rockwell may have used the initial "M" to represent Mamaroneck, his own New York high school.

Readers have the opportunity to bring their own interpretations to this scene. The halo above the football player's head may indicate he has only platonic feelings for the cheerleader, or it could suggest he is struggling against the temptation her closeness brings. But it could also mean that he sees his patience, in waiting for his jersey to be sewn, as angelic. In fact, the kneeling position of the player, the larger halo connecting both characters, and the overall triangular composition of this work (typically seen in Renaissance paintings of the Holy Family) give it a religious feeling. With the exception of a brief period in the late 1920s when he played golf to be in fashion, or in 1929 when he rode horses in Central Park to fill his lonely morning hours (he was then separated from his first wife, Irene), Rockwell was unathletic and uninterested in sports. Spare time was devoted to travel, including trips to the city to see Broadway plays and to visit museums. His previous devotion to church, however, first as a choir boy at New York City's St. Luke's Church and Cathedral of St. John the Divine, and then at St. Luke's in Mamaroneck, was considerable.

Painting for *The Saturday Evening Post* cover, November 19, 1938
30 x 24 inches
Norman Rockwell Museum Collection, NRM.1975.2,
Gift of Connie Adams Maples

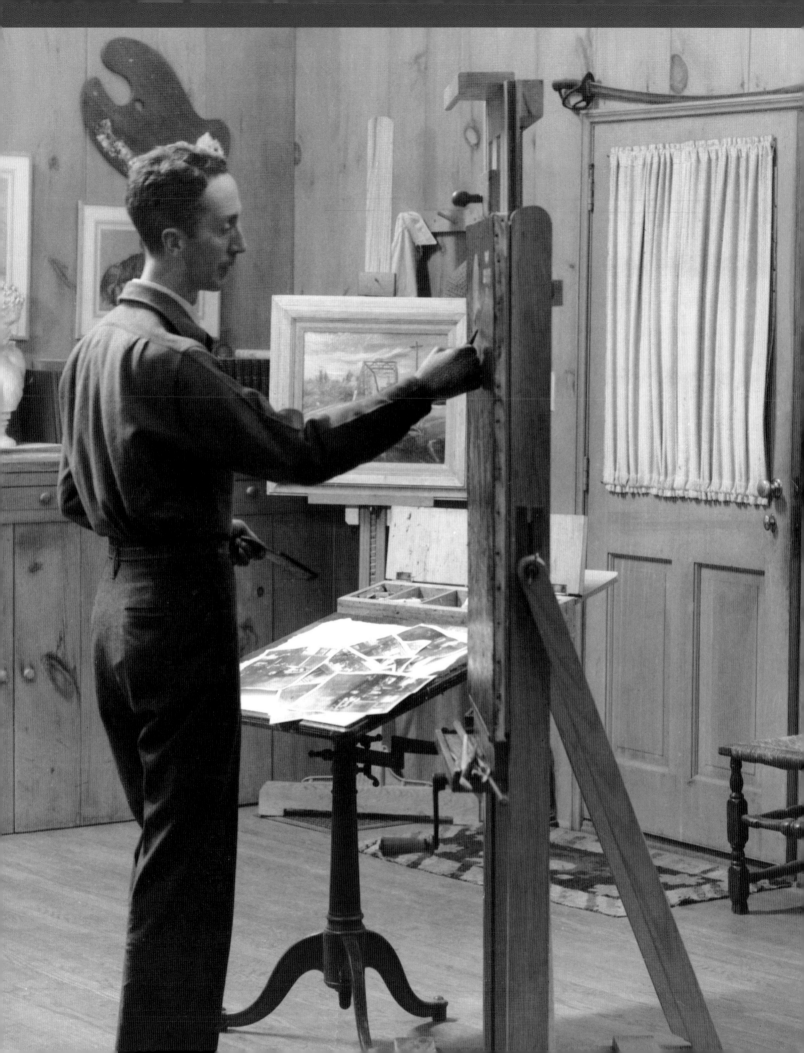

ARLINGTON,

VERMONT

three-week trip to England in 1938 put the Rockwell family, now including three young sons, on a new course. Exploring by bicycle the countryside near Oxford, Rockwell recollected his youthful summer idylls in upstate New York, and on their return home, Norman and Mary began a search for a summer home in the country. In the Arlington, Vermont, valley that lay below Red Mountain, Minister Mountain, and Swearing Mountain, there sat an eighty-year-old farmhouse with two cow barns. Rockwell purchased this sixty-acre property on the Batten Kill River, and arranged for renovations of the house and the smaller barn, which became his new studio. There, the Rockwell family spent an extended summer in 1938, returning the next summer to make the small community of 1,200 their year-round residence. Describing the charms of country life—picking blueberries, taking long walks in the mountains, climbing through old apple orchards, and enjoying the honesty and integrity of his new neighbors—Rockwell said he'd "fallen into utopia." The move to Vermont brought a whole new retinue of models, and after a 1943 fire destroyed his studio complete with costume, reference, and prop collections, he reevaluated his choice of subjects as well. Rockwell had always wanted to be topical and record the current scene, and now his artistic path was fixed.

Soon after Rockwell's move to Vermont, he was joined there by fellow *Saturday Evening Post* cover artist Mead Schaeffer and by artist John Atherton. Avid fishermen, Schaeffer and Atherton divided their time between painting and fly-fishing for trout in the Batten Kill and Green Rivers. In 1946 they were joined in Vermont by illus-

Norman Rockwell works on a portrait of neighbor Colonel Fairfax Ayers in his Arlington, Vermont, studio.
Photo by Robert McAfee, 1946.

trator George Hughes. Living in close proximity, the four artists inspired, cajoled, criticized, and supported one another. And though they all drew on the same pool of models from the town and all contributed to the *Post*, they worked very differently in style and subject. Like a patchwork quilt in one of Rockwell's paintings, pieces of their personal and professional lives began fitting together in a pattern of relationships between the four illustrators. Just as Rockwell had been inspired by the narrative humor of A.B. Frost, Carl Spitzweg, and H.K. Browne, George Hughes, to some extent, incorporated some of Rockwell's anecdotal motifs into his own work. Atherton's vision and style were so unique that his work seemed to remain untouched by what the others had on their easels. Rockwell and Atherton had enormous admiration and respect for each other. Their disparate styles didn't distance or keep them from long discussions about painting. Sharing ideas nourished and sustained these geographically sequestered painters in a way similar to that in which creativity is fostered in an artists' colony, and for Rockwell the fellowship turned Arlington into Camelot.

This balanced blend of peaceful surroundings, family, close friends, good neighbors, and the stimulation of artists and illustrators fostered an artistic period in which Rockwell created paintings that were instantly regarded as his finest work. Although he'd had several public showings at the New Rochelle Art Association in the 1910s, now his participation in gallery and museum exhibitions snowballed. The 1943 sixteen-city tour of his *Four Freedoms* paintings catalyzed his burgeoning celebrity, and in 1945, Rockwell shared billing with American painters Charles Burchfield, Thomas Hart Benton, John Stuart Curry, John Sloan, and Charles Sheeler at San Francisco's Palace of the Legion of Honor. Two years later, the Metropolitan Museum of Art included Rockwell's paintings for the movies *The Song of Bernadette* and *The*

Razor's Edge in an exhibition of Motion Picture Art, and in 1951 his *Post* cover *Soldier's Return* was included in a show of works by Art Students League artists. When the Metropolitan Museum purchased a Rockwell painting for its permanent collection in 1952, the *Saturday Evening Post* announced that Rockwell had "arrived."

From 1946 to 1949, eight illustrators were responsible for all but fifteen *Saturday Evening Post* covers. Since four of these eight all lived in the same remote hamlet, *Post* art editor Ken Stuart often traveled to Vermont for consultations with the artists. The camaraderie of the group lessened the pressure of these visits, and upon Stuart's departure they could gather and talk shop. Stuart, an illustrator before his 1943 hire as art editor, had strong opinions about the magazine's artistic direction. One of his first policies was to have the artists paint what they did best—even if it wasn't traditional *Post* cover fare. Stuart didn't want the artists copying a cliché or a predetermined style just because it had once worked. This gave Jack Atherton the freedom to paint mostly fishing and hunting subjects. For Hughes, it meant that his characters could take on a greater measure of sophistication and urbanity honed during his years as a fashion illustrator. For Rockwell it was an affirmation. Attuned to each new movement in contemporary art, he regularly held his work in comparison and questioned its relevance. Stuart's sanction endorsed his penchant for everyday scenes of neighbors and friends doing typical things, depicting their wisdom and follies, their sufferings and joys. But Stuart also encouraged Rockwell to move from his usual close-up composition to a longer view with a more detailed background. Editorial changes of this kind sent the illustrators into lively discussions during their 5 p.m. cocktails. Rockwell called these playful interludes by the forty-year-olds "the children's hour."

Despite his seclusion in the Vermont hills, Rockwell found

ways to refresh his ideas and spirits, away from the long, cold winters. When cabin fever became too much, the Rockwell family took trips to southern California where friends' studios were always available and Mary's relatives were nearby. Rockwell often traveled to New York to lunch or to give lectures for gatherings of the Society of Illustrators or to see new exhibitions—sometimes of his own work. Distant from the activities of the war raging in Europe, Rockwell was challenged to record his interpretation of the effects of World War II on the servicemen and Americans at home. For Rockwell, an unassuming private whose name, Willie Gillis, was coined by Mary from the 1938 Munro Leaf story *Wee Gillis*, told the story of one man's army in a series of fourteen *Post* covers, on which he was depicted doing everything from peeling potatoes to reading his hometown newspaper to proudly receiving a care package from home. Rockwell's only image of a soldier in battle—designed to stimulate ammunition production at munitions factories—featured a powerful machine gunner for the poster *Let's Give Him Enough and on Time*. Rockwell later wrote that he "didn't like to do pictures that glorified killing, even in a good cause." By 1942, Rockwell had finished seven Willie Gillis covers and was at work on the motivational poster for the U.S. Army, but he wanted to do more for the war effort. He decided to illustrate President Franklin Delano Roosevelt's concept of the four basic human freedoms, a job he later said "should have been tackled by Michelangelo."

On May 21, Rockwell and Mead Schaeffer visited the Ordnance Department in Washington, D.C., with a progress report on Rockwell's machine gunner painting. At home in Vermont, they had discussed how they could make a significant contribution to the war effort. With their official business completed, they pitched their proposals. Rockwell would interpret Roosevelt's *Four Freedoms* ideals and Schaeffer would paint

a series of portraits of U.S. servicemen. According to published accounts, the War Department didn't have the time to publish their posters nor could they pay Rockwell or Schaeffer their customary fees. Rockwell later said he offered his work free of charge. On their way home, Schaeffer and Rockwell stopped at Curtis Publishing in Philadelphia and showed their sketches to Ben Hibbs, who had recently succeeded Wesley Stout as editor. Hibbs eagerly embraced their ideas and made plans to include them in the *Post*. Rockwell was given permission to halt all other *Post* work while concentrating on the *Freedoms*, but when he returned to Vermont, he resumed and finished painting two Willie Gillis covers already in development.

Work on the *Four Freedoms* began in earnest in July when Rockwell posed eight models for *Freedom of Speech*. He revised his picture concept and canvas four times until it evolved into the painting we know. In addition to working on the problems with *Freedom of Speech*, Rockwell spent two months on *Freedom to Worship*, changing the subject from a barbershop scene to the less narrative treatment of a composite of profiles. Numerous requests for illustration work streamed in while Rockwell was at work on the *Four Freedoms*. To protect his time, Rockwell refused most of the requests, using the excuse that only subjects that carried a war message would be considered. By the end of 1942, Rockwell completed all four of his *Freedoms* paintings. They took six months instead of the three he had expected, but they were appreciatively received. In his autobiography, Rockwell quoted Hibbs' generous praise of his

work. "The result astonished us all. Those four pictures quickly became the best known and most appreciated paintings of that era. They appeared right at a time when the war was going against us on the battle fronts, and the American people needed the inspirational message which they conveyed so forcefully and so beautifully."

In the middle of the night on May 15, 1943, Rockwell's son Thomas awoke to see the studio in flames. He banged on his father's bedroom door yelling, "Pop, the studio's on fire." Because the phone was wired through the studio, the line was already dead, and Rockwell couldn't call for help. Sending his hired man to the nearest neighbor to summon the fire department, Rockwell dashed to the studio to see what he could save. Suddenly, rifle cartridges and shotgun shells, kept in a drawer in the studio, began exploding. Rockwell and his family could only stand and watch while flames consumed the studio and most of the adjacent barn. Lost were a dozen of Rockwell's favorite paintings, a collection of costumes, props, artist materials, reference files, prints, books, antique guns, and his favorite pipes. Rather than rebuild, Rockwell bought a house closer to town and hired a carpenter to build a new studio. That summer, while his new studio was under construction, Rockwell shared Mead Schaeffer's studio. Schaeffer later said Rockwell so convincingly rationalized how the setback had been beneficial by forcing him to reexamine his work that he was nearly convinced to burn down his own studio.

The paintings of his Vermont years, more than any others, comprised the indelible images that forged Rockwell's identity as an American artist; *The Four Freedoms, Rosie the Riveter, Shuffleton's Barbershop, Saying Grace,* and *Breaking Home Ties* created the Rockwell brand. Though Rockwell's *Post* readers had always enjoyed the antics and exploits of his child models, they now were asked to look at Rockwell's work in

a new way. Childhood in America and Rockwell's reflection of it were changing. On the edge of a changing world, his post-war children were about to meet new challenges. Changes after World War II—including the population swell of the baby boom, the new role and self-image of women forged by their recently acquired skills and opportunities, and, most important, the proliferation of nuclear weapons—forced us to see our world, and ourselves, in a different light. Despite an overt sense of prosperity, there was a new unease; we had exchanged our parents' struggles during the Great Depression and in a real war, with the pervasive fear and threat of nuclear war. As a perennial idealist, Rockwell didn't include the worries of the new generation in his work, but he did look more seriously at the subject of youth, depicting adolescents as more complex, dimensional people. Children were seen less at play and more at learning how to grow up, ultimately to face the problems of a modern world and deal with issues that were previously, in Rockwell's words, "swept under the rug."

Rockwell's association with the *Post* lasted forty-seven years, and though painting covers was what he most liked to do, working for the *Post* had its downside. Ironically, his success was usually the cause of friction with the *Post*, as they often put pressure on him for additional work. In January 1939, the *Post* told Rockwell they were increasing his per-cover price in exchange for being able to make more demands on

his time. Wanting it to appear they had his interest at heart more than theirs, they told Rockwell the arrangement was intended to give him more time for his *Post* cover work (implying he wouldn't need work from others). But the greatest source of anguish to Rockwell was the altering of his paintings by the editorial staff. He accepted the occasional addition of a staff-artist signature, made because his was too close to the bottom of his canvas where it might impinge on the cover's text. But in 1937, a colored background was painted into one of his covers. And in the summer of 1949 while Rockwell was in California, three consecutive *Post* covers were altered.

In the April 23, 1949, cover *Umpires*, the color of the visiting team's uniforms was changed, a portion of sky and a portion of grass were added, part of a sign was relettered, and scoreboard letters were redefined. In *Roadblock*, his next cover, a replica signature was in-painted to replace Rockwell's when several inches of painting were (photographically) cropped off the bottom. And finally, Rockwell's September 24, 1949, cover, *Before the Date*, was partly repainted at the direction of art editor Kenneth Stuart, who said readers would not be able to tell that the man and woman were getting ready for their date in separate rooms. In reply to a letter in which Stuart rationalized his alterations, Rockwell wrote, "Whether or not these things are necessary is not the question with me. It's the feeling I suffered under when Mr. Stout was there—that try as I might it was not good enough. If this is so I had better bow out. I have plenty and more than enough to do. If I could just feel that you people believe in me, and within the necessary limits give me a free hand, I could paint some real pictures. But the worry and doubt and the thought of what will happen to my picture before it is reproduced kills my drive."

Early in 1951, Rockwell's wife Mary began treatment for depression at the

Austen Riggs Center in Stockbridge, Massachusetts. As a regular patient, Mary made the tiring commute from Vermont frequently. A car accident on Halloween night, 1952, in Pownal, Vermont, must have shaken her confidence about the long drive; her car was badly damaged and a child in the car she hit was cut and bruised. In early 1953, Mary began living at the Homestead boardinghouse on Sergeant Street around the corner from the Riggs Center. In the summer of 1953, Rockwell's mother, who was cared for in a convalescent home in Warwick, Rhode Island, died at the age of 87. A few months later, after almost a year of living apart, Rockwell joined Mary at the boardinghouse in Stockbridge and rented studio space in town. Rockwell had intended to stay in Vermont—he had purchased burial spaces in the Arlington cemetery—but Mary's illness necessitated a permanent move to Stockbridge, where she could continue to receive treatment. Rockwell's closest friends had already left Vermont—Mead Schaeffer moved to New York in 1950 and Jack Atherton died suddenly of a heart attack in 1952.

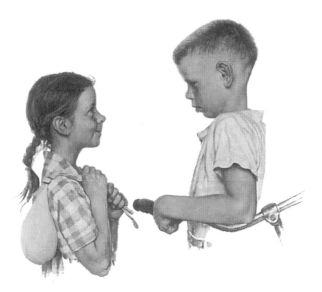

A Scout Is Helpful 1939
Norman Rockwell (1894–1978)
Oil on canvas

After successfully illustrating the new *Boy Scout Hike Book* in the fall of 1912, Rockwell was retained for the permanent staff of *Boys' Life*. The weekly magazine of the Boy Scouts of America had just expanded to national circulation. Six months later, Rockwell was promoted to art editor and he continued to work for *Boys' Life* until 1917. In gratitude for this early break and the valuable experience he gained, Rockwell made a lifelong commitment to the Boy Scouts of America, producing their annual calendar illustrations from 1925 to 1976.

Painted in 1939, Rockwell's 1941 Boy Scout calendar illustration of a Scout rescuing a child in a swollen river was inspired by the Great New England Hurricane of 1938.* Both that storm and the Great Atlantic Hurricane of 1944 affected towns in New England as far north as Rockwell's Arlington, Vermont, home town.

Of all Rockwell's clients, the Boy Scouts of America demanded the most in changes to his work. Rockwell often had to redraw studies or repaint portions of canvases, necessitating shipping the artwork from the publisher to Rockwell, back and forth, until it was perfect. *A Scout Is Helpful* was no exception. Rockwell's first version showed the Scout in long pants, which were wet from the knees down. The Boy Scouts' editor asked Rockwell to put the boy in short pants, as Scouts were always to be shown neat, and wet pants would not appear neat.

ODDS & ENDS:

Neither Rockwell nor any of his three sons were Boy Scouts.

Painting for Boy Scouts of America calendar, 1941
34 x 24 inches
Norman Rockwell Museum Collection, NRM.1988.10

*The National Weather Service did not begin naming hurricanes until 1950.

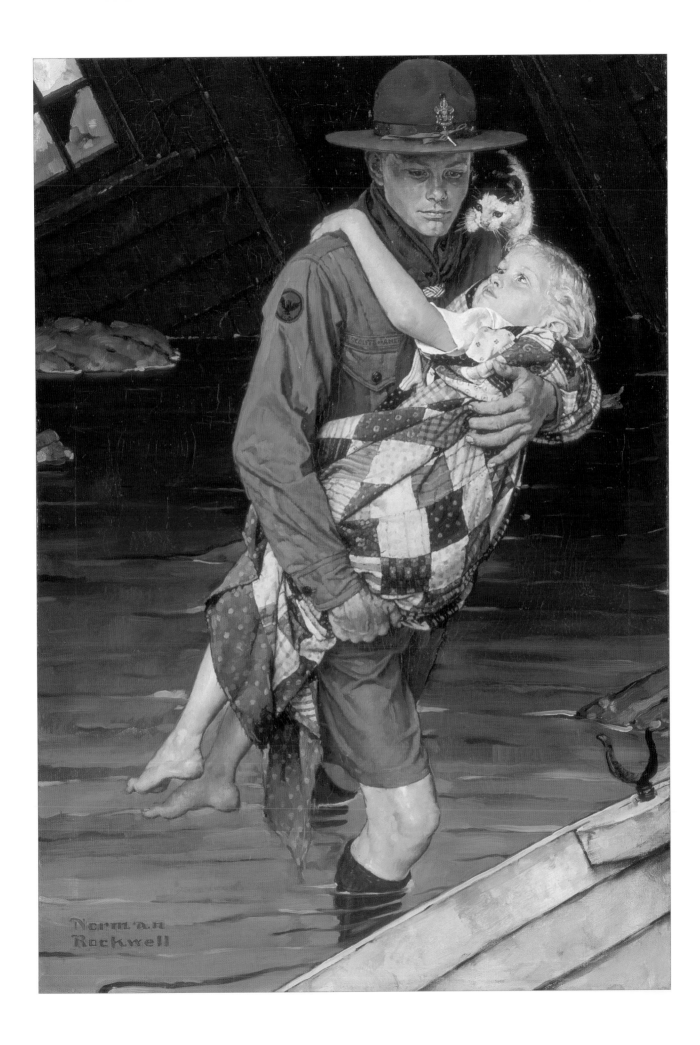

Girl Reading the Post 1941
Norman Rockwell (1894–1978)
Oil on board

Always aiming for the widest possible audience for his *Saturday Evening Post* covers, Rockwell pictures often have several layers of interest. To assure a successful cover, Rockwell grabs the viewer's attention with a trick—he matches the cover girl's face perfectly to the schoolgirl's body. By picturing a reader so engrossed in the *Post*, Rockwell emphasizes the interest and allure of the magazine, thus promoting its sale on newsstands.

Beyond the gimmick, a story of growing up emerges in the simple scene of commuting to school. This young girl may soon leave behind her scuffed saddle shoes for polished heels, and her cozy mittens for kidskin gloves.

Painting for *The Saturday Evening Post* cover, March 1, 1941
35.25 x 27.25 inches
Norman Rockwell Museum Collection,
Gift of the Walt Disney Family, NRM.1999.3

Strictly a Sharpshooter 1941
Norman Rockwell (1894–1978)
Oil on canvas

In this short story by D.D. Beauchamp for the June 1941 issue of *American Magazine*, the gold-digging girlfriend of a young boxer encourages him to fight a match against a seasoned fighter for the promise of big winnings. When he loses the fight, her true colors are revealed as she yells out her rejection of him.

Living in Vermont, a long distance from urban environments that he continued to use in many of his illustrations, Rockwell often traveled to find the right settings. In this case he went to a boxing club at Columbus Circle in New York and studied the smoke-filled atmosphere and the types of people who frequented the club. He relied on friends and neighbors for his models, with the exception of the young boxer on the left who was a professional model. Elizabeth Schaeffer, illustrator Mead Schaeffer's wife, posed for the character of the young boxer's girlfriend.

The departure from his usual vertical format for a magazine cover was an opportunity Rockwell said he enjoyed. He said that the relationship between picture proportion and subject matter was always important in his work. The strong parallel lines of the ropes and floor accentuate the horizontal format of this scene.

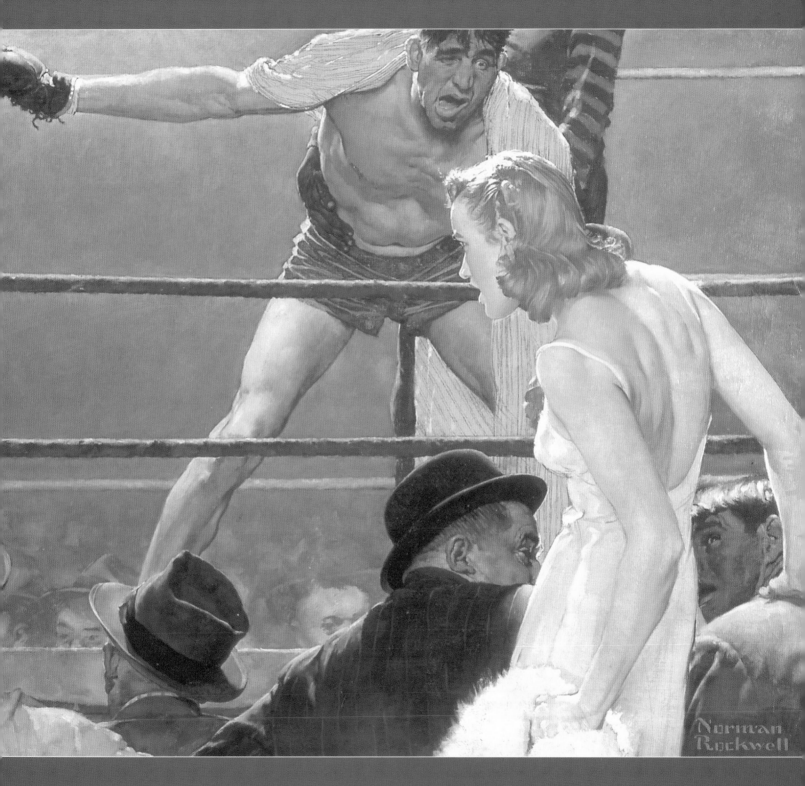

Painting for *American Magazine* story illustration, June 1941
30 x 71 inches
Norman Rockwell Museum Collection, NRM.1979.2

Aunt Ella Takes a Trip 1942

Norman Rockwell (1894–1978)

Oil on canvas

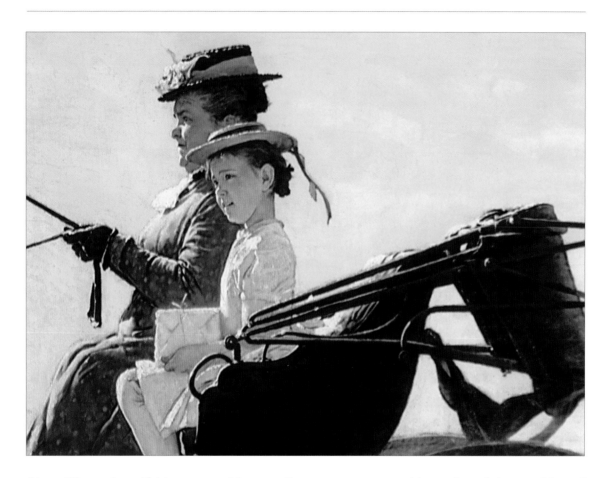

"Aunt Ella was beautiful in my eyes. Not too tall, and a lovely plump front," read the caption with this Norman Rockwell illustration in *Ladies' Home Journal.* Aunt Ella's niece, Liz'beth, continues her story: "You knew, somehow, that she had grown up on sunshine and good times and lots of Irish loving. She had just the right plumpness, with dimples in her elbows and cheeks, a clear,

Detail from *Aunt Ella Takes a Trip*

pink complexion and auburn hair." From this description, Rockwell created Aunt Ella's image for the 1942 story by Marcelene Cox. Childless, Aunt Ella is determined to see that Liz'beth's sister Mary gets for her graduation the beautiful dress her parents cannot afford. Driven to subterfuge by her stingy husband's disapproval of charity, Aunt Ella discretely drives horse and buggy to town to sell some grain to buy fabric for the new dress. Rockwell illustrates their return from town, after which they will hide the horse and buggy tracks and wipe down Nell, the horse, to hide any evidence of their clandestine trip.

He also illustrates the complex emotions Aunt Ella and Liz'beth feel. This is what Rockwell does best: he expresses emotions, and even thoughts, through subtle nuances of facial expression and body language. Aunt Ella's face and bearing are strong and resolute. She has stood on principle and opposed her husband's wishes, but she will spare their relationship the stress and discord that would result from discovery of her actions. The urgency of returning to the farm to conceal her activities and quickly perform a full day's chores can be felt within the calm serenity of the summer day. Liz'beth's demeanor expresses happiness at their accomplishment—and perhaps thoughts of how her sister will look in her new dress.

ODDS & ENDS:

By June 1941, the Rockwell family completed their move from New Rochelle, New York, to Arlington, Vermont. With no professional models nearby, Rockwell relied almost exclusively on local people to sit for him. This painting is a rare exception. For it, Liz' beth was modeled by child film star Joan Carroll, best known for her roles in *Meet Me in St. Louis* and *The Bells of St. Mary's*.

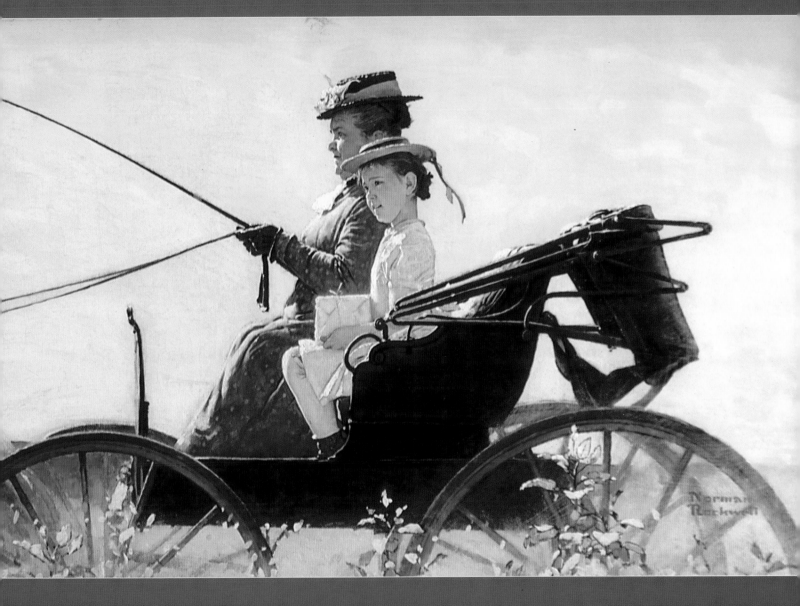

Painting for *Ladies' Home Journal* story illustration, April 1942
60 x 23 inches
Norman Rockwell Museum Collection, NRM.1983.9

Norman Rockwell's Four Freedoms 1942
Norman Rockwell (1894–1978)
Oil on canvas

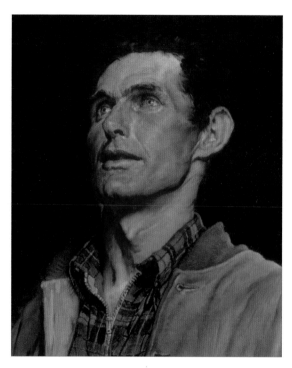

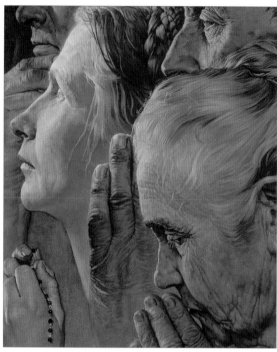

In his January 1941 address to Congress, President Franklin Delano Roosevelt articulated his vision for a postwar world founded on four basic human freedoms: freedom of speech, freedom of religion, freedom from want, and freedom from fear. In the spring of 1942, Norman Rockwell was working on a piece commissioned by the Ordnance Department of the U.S. Army, a painting of a machine gunner in need of ammunition. Posters of the gunner, titled "Let's Give Him Enough and On Time," were distributed to ordnance plants throughout the country to encourage production. But Rockwell wanted to do more for the war effort and decided he would illustrate Roosevelt's four freedoms. Finding new ideas for paintings never came easily, but this was a greater challenge. "It was so darned high-blown," Rockwell said. "Somehow I just couldn't get my mind around it." While mulling it over, Rockwell, by chance, attended a town meeting where one man rose among his neighbors and voiced an unpopular view. That night Rockwell awoke with the realization that he could paint the freedoms best from the perspective of his own hometown experiences using everyday, simple scenes such as his own town meeting. Rockwell made some rough sketches and, accompanied by fellow *Post* cover artist

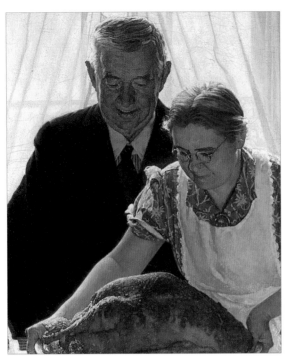 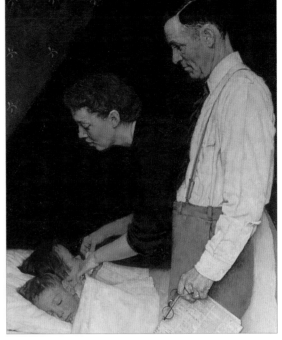

Mead Schaeffer, went to Washington to propose his poster idea.

The timing was wrong. The Ordnance Department didn't have the resources for another commission. On his way back to Vermont, Rockwell stopped at Curtis Publishing Company, publisher of *The Saturday Evening Post,* and showed his sketches to editor Ben Hibbs. Hibbs immediately made plans to use the illustrations in the *Post.* Rockwell was given permission to interrupt his work for the magazine—typically one cover per month—for three months. But Rockwell "got a bad case of stage fright," and it was two and a half months before he even began the project.

The paintings were a phenomenal success. In May 1943, representatives from the *Post* and the U.S. Department of the Treasury announced a joint campaign to sell war bonds and stamps. They would send the Four Freedoms paintings along with 1,000 original cartoons and paintings by other illustrators and original manuscripts from *The Saturday Evening Post* on a national tour. Traveling to sixteen cities, the exhibition was visited by more than a million people who purchased $133 million worth of war bonds and stamps.

Details from *Norman Rockwell's Four Freedoms*

Freedom of Speech 1942

Norman Rockwell (1894–1978)

Oil on canvas

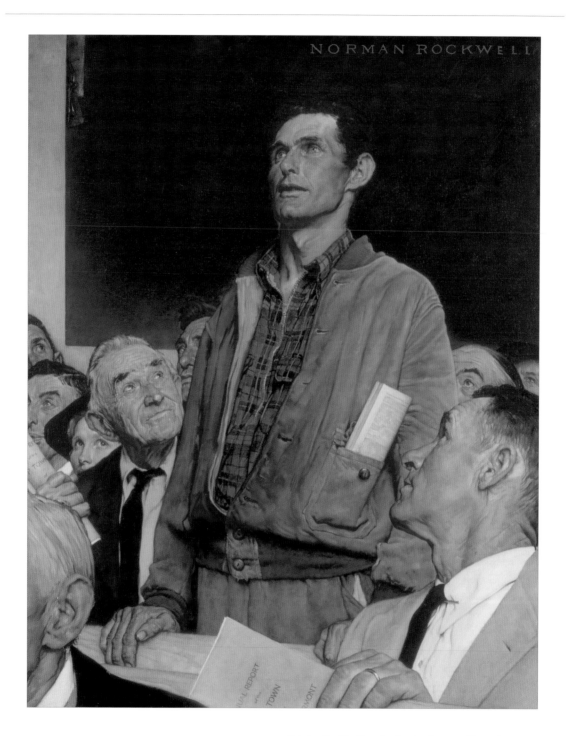

Painting for *The Saturday Evening Post* story illustration
February 20, 1943
45.75 x 35.5 inches
Norman Rockwell Art Collection Trust, NRACT.1973.23

Freedom of Worship 1942

Norman Rockwell (1894–1978)

Oil on canvas

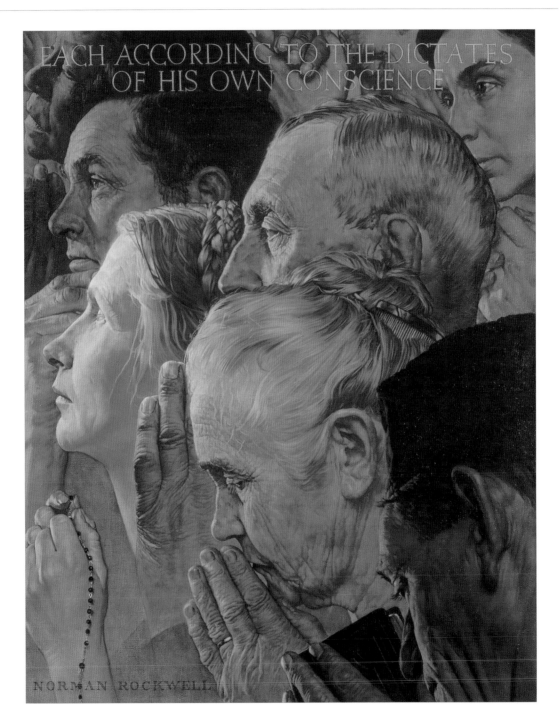

Painting for *The Saturday Evening Post* story illustration
February 27, 1943
46 x 35.5 inches
Norman Rockwell Art Collection Trust, NRACT.1973.23

Freedom from Want 1942

Norman Rockwell (1894–1978)

Oil on canvas

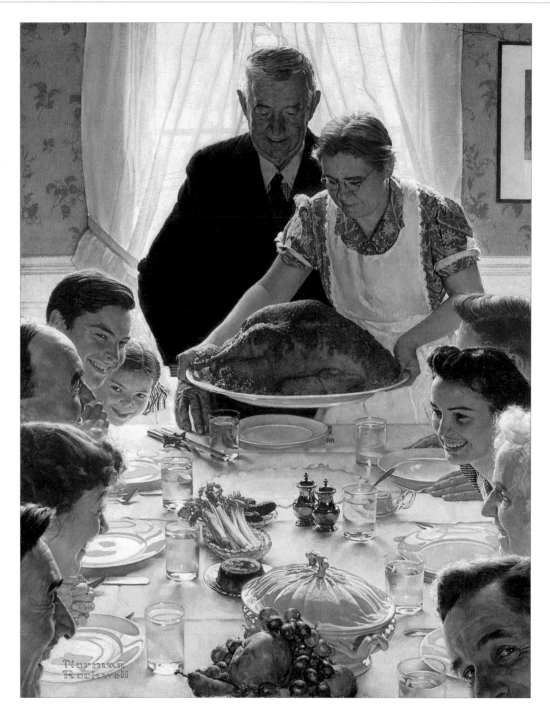

Painting for *The Saturday Evening Post* story illustration
March 6, 1943
45.75 x 35.5 inches
Norman Rockwell Art Collection Trust, NRACT.1973.22

Freedom from Fear 1942

Norman Rockwell (1894–1978)

Oil on canvas

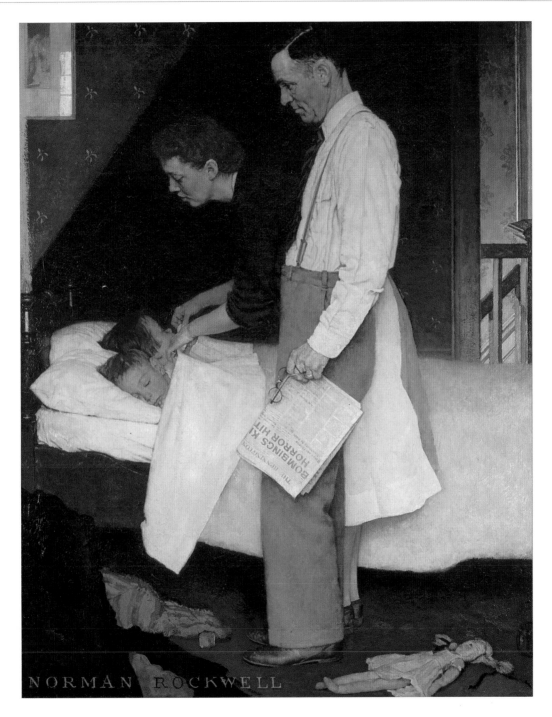

Painting for *The Saturday Evening Post* story illustration
March 13, 1943
45.75 x 35.5 inches
Norman Rockwell Art Collection Trust, NRACT.1973.20

Mine America's Coal 1944
Norman Rockwell (1894–1978)
Oil on canvas

Painted for the War Manpower Commission, this image was published as a poster, which read "Mine America's Coal. We'll make it hot for the enemy! See your United States Employment Service." World War II posters carried many varied messages. In addition to propaganda posters designed specifically to inspire fear of the enemy by showing atrocious acts committed by German or Japanese soldiers, many posters carried gentle and encouraging messages, such as appeals for increased farm production or conservation of resources like gasoline and food. Many posters encouraged workers in their war-related work, urging them not to take days off or leave their jobs. Some gave advice about how to become and stay healthy. *Mine America's Coal* showed that a middle-aged man, who was already sacrificing two children in service of the war, was willing to give even more by mining coal. Patriotism was invoked to recruit new workers for a dangerous trade.

Painting for the U.S. Office of War Information poster, 1944
21 x 14 inches
Norman Rockwell Museum Collection, NRM.1978.12

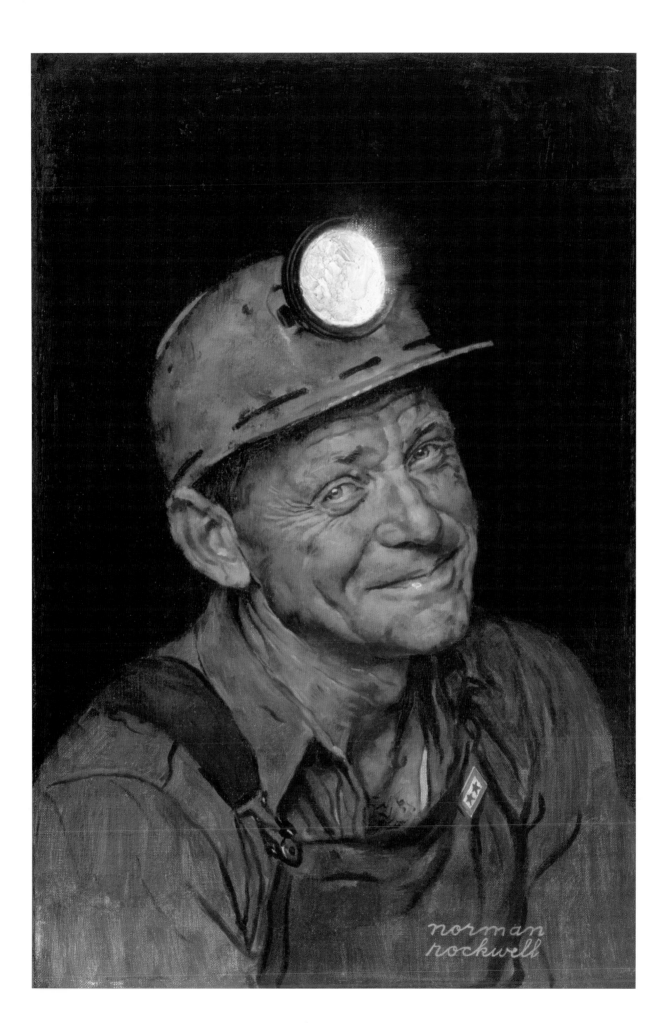

to Mr Comar
of the Quality Resteran
sincerely
Norman
Rockwell

War News 1944
Norman Rockwell (1894–1978)
Oil on canvas

Intended as a cover for *The Saturday Evening Post* but never completed, *War News* pictures a restaurant counterman and his customers, including a Western Union boy, a clerk, and a deliveryman, gathering to listen to a radio report. Painted in January or February of 1944 about the proposed invasion of Normandy, Norman Rockwell intended to later paint in the headline of the January 17, 1944 *Times Record* on the newspaper lying on the counter. It would have read "Invasion Plans At France Possible," part of the full title, "Eisenhower Reports Invasion Plans Advanced; Blow at France Possible." Rockwell decided not to submit *War News* to the *Post*, perhaps because it was hard to convey what the men were hearing or to make the newspaper headline discernible. He instead created a second painting of a man charting war maneuvers.

Unpublished
41.25 x 40.5 inches
Norman Rockwell Museum Collection, NRM.1976.2

The Razor's Edge 1946
Norman Rockwell (1894–1978)
Oil on canvas

Although not known for his movie poster art-work, Norman Rockwell created paintings for six Hollywood movies between 1942 and 1966. In each, Rockwell's signature technique of precise realism and his hallmark portraiture captured the movie's style and the viewer's attention. In the lobbies of theaters, on billboards, and in print ads, Rockwell's poster images prepared the movie-goer with artwork that unmistakably defined the role and communicated the character each actor was portraying.

In 1946, Rockwell was commissioned by 20th Century Fox to create a poster for a movie based on W. Somerset Maugham's novel *The Razor's Edge.* The movie starred Hollywood's then-favorite leading man, Tyrone Power, as a man searching for the meaning of life. Surrounding

Rockwell's dramatic figure of Power are portraits of supporting actors John Payne, Gene Tierney, Clifton Webb, Herbert Marshall, and Anne Baxter. Rockwell was not the only illustrator recruited in the new trend to engage artists and illustrators to do advertising art for the motion picture industry. Fellow illustrators John Falter, Dean Cornwell, Douglas Crockwell, Constantin Alajalov, Gilbert Bundy, and Russell Patterson also were commissioned to do posters. In January 1947, Rockwell's paintings for *The Razor's Edge* and *The Song of Bernadette* (1943) were featured in the Metropolitan Museum of Art's first exhibi-tion of motion picture advertising art.

Painting for 20th Century Fox advertisement, 1946
54.125 x 26.125 inches
Norman Rockwell Museum Collection, NRM.2001.2

norman rockwell

Boy in a Dining Car 1946
Norman Rockwell (1894–1978)
Oil on canvas

Using a dining car from the New York Central's Lake Shore Limited as his setting, Rockwell captured a moment in his own son's life that he thought would touch a common chord. Inspired by H.K. Browne's illustration of a similar scene in Charles Dickens' *David Copperfield*, Rockwell's painting describes a young boy's first experience of calculating a waiter's tip. At Rockwell's request, the New York Central diverted a dining car bound for Albany to New York City where he and his ten-year-old son Peter met it for a model shoot. Once there, he decided the "20th Century Limited" was too modern, and he requested an older model. The first three dining car waiters he interviewed were unsuitable for the role. The following week, an older car and a twenty-eight-year veteran waiter were provided, all to Rockwell's satisfaction. In appreciation for the efforts of the railroad, Rockwell included a postcard of their 20th Century Limited locomotive on the boy's table and the *Post* credited them in the cover's caption, resulting in $10,000 worth of publicity for the New York Central.

Painting for *The Saturday Evening Post* cover, December 7, 1946
38 x 36 inches
Norman Rockwell Museum Collection, NRM.1988.2

Between 1943 and 1948, the *Post* sent Rockwell on eight visits around the country to record the lives of representative Americans in a pictorial series. For each visual report, the artist produced multiple images in order to document contemporary life in America. He shared with *Post* readers what it was like to spend a night with paratroopers on a troop train; wait with reporters and photographers to see the President at the White House; apply at a ration board in Manchester, Vermont; vote at a polling station in Cedar Rapids, Iowa; visit a newspaper in Monroe County, Missouri; attend a one-room school in rural Georgia; spend a day with a family doctor in Arlington, Vermont; and make the rounds with a county agent in Jay County, Indiana.

In *Norman Rockwell Visits a Family Doctor*, Rockwell interprets a scene of a genuine Vermont family consulting with their doctor in the tradition of Victorian artist Luke Fildes who was admired by Rockwell for his Dickensian interpretation of London's poor. Fildes constructed whole interiors in his studio to be sure his scene was accurate, a preparation Rockwell might have taken had he not had the camera. For *Family Doctor*, Rockwell recorded the life of his own hometown family physician, Dr. George Russell. He painstakingly reproduced Russell's office, hiring an architect to do drawings of the room since his cameraman couldn't shoot the whole width of the office within the small space. So exact were his details that one reader noticed that the photo on Dr. Russell's desk looked just like a nurse who attended him in an Army hospital in England in 1945. A reply to his letter to the *Post* confirmed that Dr. Russell's daughter had been a nurse in England in 1945.

An Arlington family posed with their baby girl as the patient, but the dog, Bozo, was Dr. Russell's. Apparently some people questioned the ethics of permitting a dog in the office but Rockwell said, "Nobody ever seemed the worse for it." Dr. George Russell is now remembered by researchers and historians as the compiler of the most extensive collection of Vermont historical material in the state, collected during his fifty-seven-year career.

Detail from painting for *The Saturday Evening Post* story illustration

Painting for *The Saturday Evening Post* story illustration, April 12, 1947
32 x 60 inches
Norman Rockwell Museum Collection, NRM.1980.1

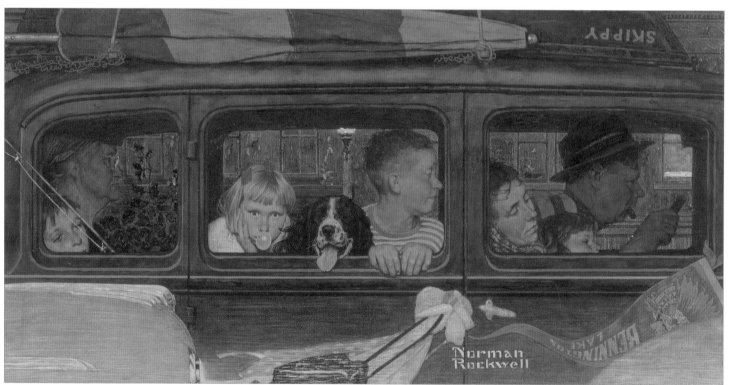

Going and Coming 1947
Norman Rockwell (1894–1978)
Oil on canvas

Rockwell's *Post* covers were often of seasonal or topical subjects. This was especially true after the 1943 studio fire that destroyed his collection of historical costumes. Not only was a magazine cover intended to be a story that was easily "read" and understood, it was often intended to be relevant to the daily life of the reader.

Going and Coming, published in August 1947, is a good example of a story painting that is both seasonal and topical. The added ingredient of humor makes it even more engaging and thus contributes to its success. The use of two images within one picture allows Rockwell to be more detailed and create a continuum of time. We see the before and the after of the imagined event, a family's summer outing by the lake. Clues abound for the reader's enjoyment in unraveling the story line.

The use of a split canvas to portray a juxtaposition of an event, time, age, or place is an effective device that invites comparison of the two scenes. This technique is employed by Rockwell in only two other *Post* covers, but was commonly used by other *Post* cover illustrators. In most cases, it derives from a comic strip's use of a series of "frames" to tell a story. In this case, however, artist Don Spaulding, who studied with Rockwell in 1950 and spent several months living in the schoolhouse on the West Arlington Green in Vermont, cites George Hand Wright's painting of *Going to and Returning from the Seashore* as the inspiration for *Going and Coming*.

Painting for *The Saturday Evening Post* cover, August 30, 1947
upper canvas, 16 x 31.5 inches; lower canvas, 16 x 31.5 inches
Norman Rockwell Art Collection Trust, NRACT.1973.9

Christmas Homecoming 1948
Norman Rockwell (1894–1978)
Oil on canvas

The desire to focus his artistic energy on painting the human condition was so strong that to please his art editor, who urged him to fill his canvases, Rockwell packed his picture with figures until the only remaining background was a foot or so of floor area. With the barest reference to Christmas, Rockwell conveys a festive holiday scene purely through the smiles on all of the faces and a few touches of bright red paint. The entire Rockwell family is in this cast. Son Peter (with eyeglasses) appears in the left corner; son Tom is in the plaid shirt; wife Mary is hugging son Jarvis who has just arrived from school; and Norman is seen on their right. In the upper left corner, good friend and fellow *Post* illustrator Mead Schaeffer looks on, as does painter Grandma Moses. Behind Peter is Mead Schaeffer's daughter Patty and between Jarvis and Norman, his other daughter Lee. Mary Atherton, daughter of illustrator Jack Atherton (another close friend and neighbor of Rockwell), waves from behind Mary Rockwell.

Painting for *The Saturday Evening Post* cover, December 25, 1948
35.5 x 33.5 inches
Norman Rockwell Museum Collection, NRM.1978.10

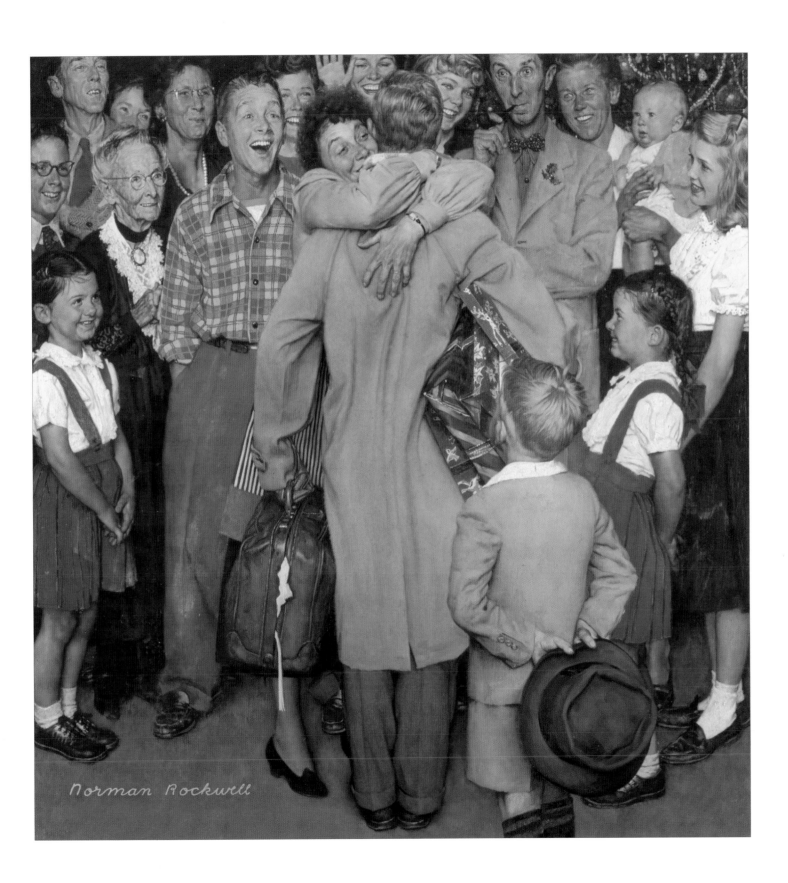

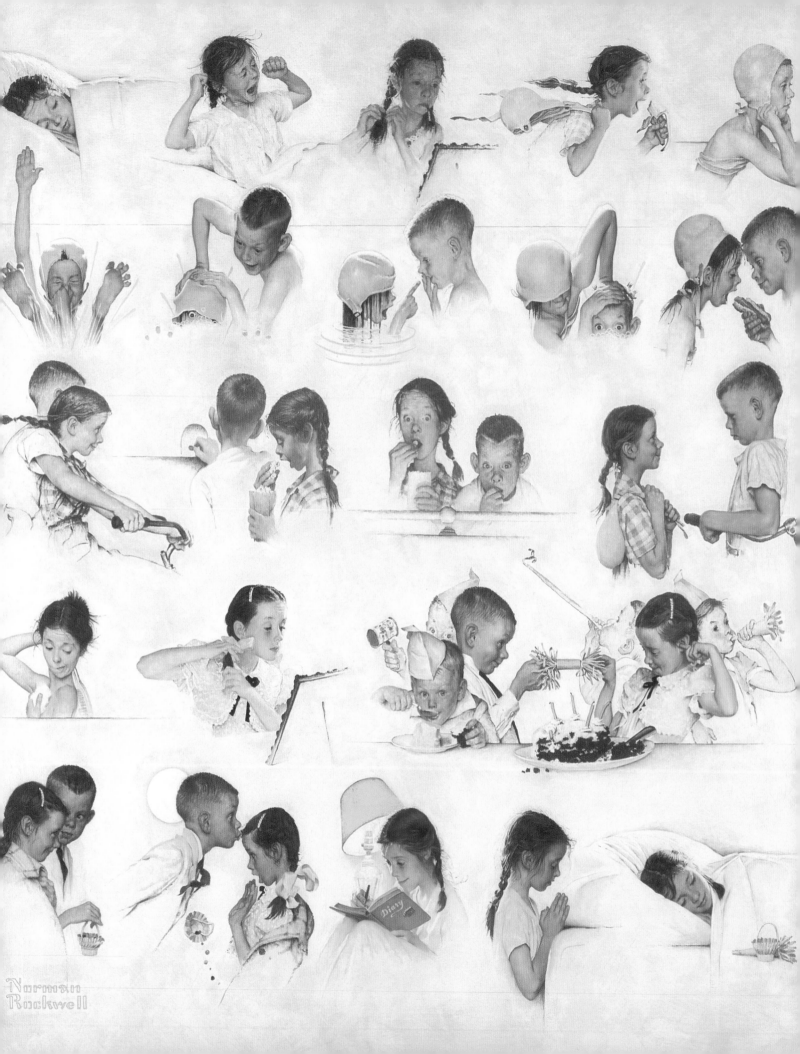

Day in the Life of a Little Girl 1952
Norman Rockwell (1894–1978)
Oil on canvas

This is a companion painting to *Day in the Life of a Little Boy*, Rockwell's prior cover painting for the *Post* published three months earlier. It would seem that painting thirty-two heads is far more work than one or two, but to Rockwell, whose forte was portraiture, telling a complete story using this method was far less challenging than a cover with a detailed background. The events of the girl's day were so typical to the American child that this cover could be appreciated by large numbers of viewers. In other countries, Rockwell's *Post* covers were popular because their images were easily interpreted as the essence of American culture.

Painting for *The Saturday Evening Post* cover, August 30, 1952
45 x 42 inches
Norman Rockwell Museum Collection, NRM.1980.2

Portrait of Dwight D. Eisenhower 1952

Norman Rockwell (1894–1978)

Oil on canvas

The first use of a Norman Rockwell portrait on the cover of *The Saturday Evening Post* came in 1952 when Rockwell painted General Dwight D. Eisenhower as the Republican candidate for the presidency. In addition to the cover portrait, the *Post* published Rockwell's account of his session with Eisenhower, complete with five additional portraits of the General (including the one seen here) and a portrait of his wife, Mamie. The *Post* revealed its Republican bias by running an Eisenhower cover but not one of Adlai Stevenson, the Democratic candidate. The Rockwell-authored essay would also garner support for the Republican Party's candidate.

When Rockwell arrived in Denver for the modeling session, he said Eisenhower's "eyes were far away." In an attempt to get a smiling Eisenhower, Rockwell threw out a few remarks. The one that most changed Eisenhower's expression was "How are those grandchildren, General —pretty nice, eh?" It was the smile after this remark that Rockwell captured for the cover. The conversation turned to the presidential campaign. According to Rockwell, Eisenhower remarked that even though a leader might need advisors, there was no need to give up his freedom of speech, commenting that, "I'd rather be defeated than not say in my campaign exactly what I believe." The *Post* published the portrait seen here with the caption: "The campaign? Instantly, he was deeply serious. No punch-pulling for him! He'd rather lose the election than not tell the people just what he thinks." Later, Rockwell received a letter from *Post* reader John Maass of Philadelphia pointing out that the quotation was virtually the same as one from Stevenson's July 26 nomination acceptance speech: "Better we lose the election than mislead the people, and better we lose than misgovern the people." Maass continued, "You are famous for your warmth and sincere liking for people, but this election is a terribly serious matter and you should not let yourself be taken in by a nice smile. Even as an Eisenhower worshiper (Rockwell had ended his essay by saying "I'm an Eisenhower worshiper"), you ought to know that the General campaigns entirely by reading off ghostwritten speeches." The *Post* published four letters from readers about the Eisenhower cover, but not the one from Maass.

Painting for *The Saturday Evening Post* story illustration
October 11, 1952
Collection of the Norman Rockwell Museum, NRM.1986.2

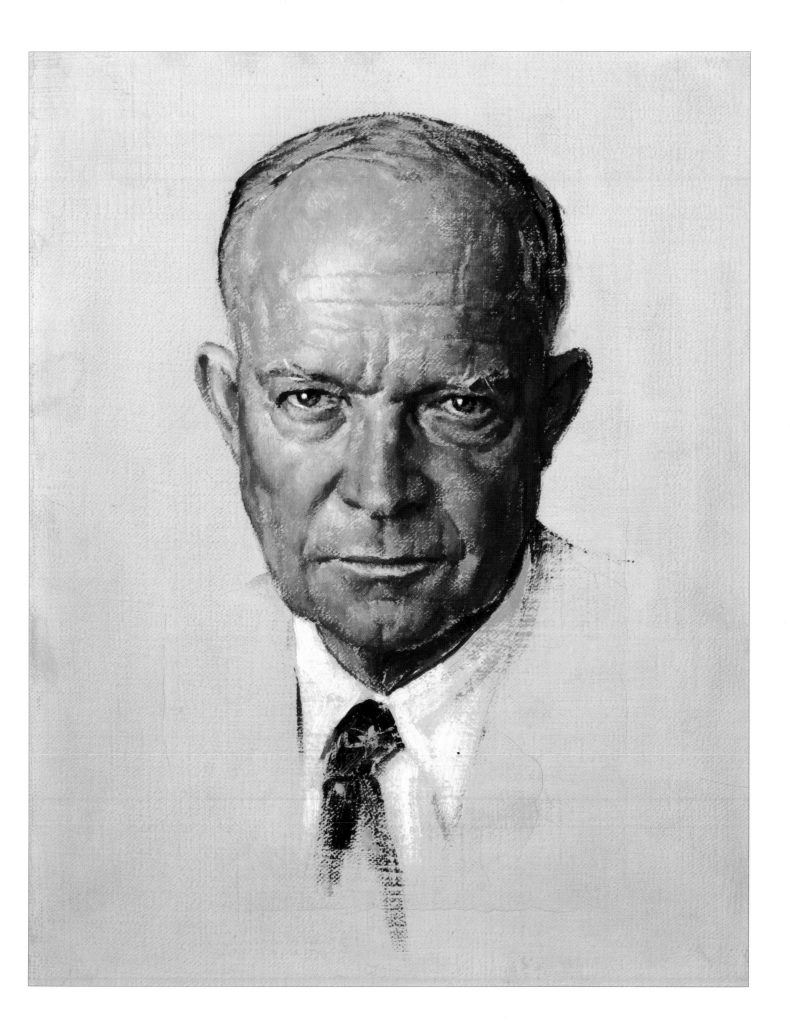

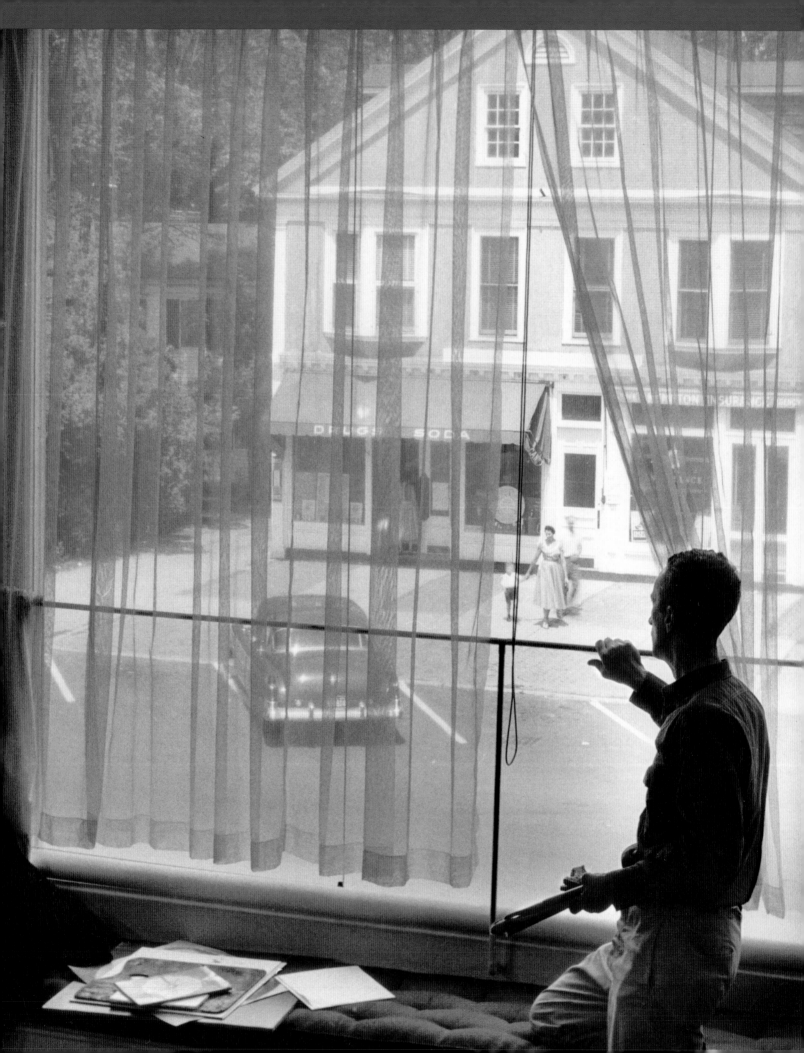

STOCKBRIDGE,

MASSACHUSETTS

In 1953, Norman Rockwell and wife Mary relocated from Arlington, Vermont, to Stockbridge, Massachusetts. The small town of 2,100 people provided new faces and new inspirations for such pictures as *Family Tree*, which traced the lineage of the "all-American boy" from a sixteenth-century pirate and his Spanish princess captured on the Caribbean Sea. In progress were several of his most memorable paintings—*Girl at Mirror*, *Breaking Home Ties*, and *Choir Boy*—and, as always, deadlines loomed. He continued to hire neighbors to pose for everyday scenes, choosing a professional model only when he needed a woman to pose naked for his 1955 *Mermaid* cover.

In January 1954, Rockwell finished painting his *Post* cover of a choirboy. Appropriate for the Easter season, it was also an echo of his many years as a choirboy in New York City and Mamaroneck. Although Rockwell no longer attended church ("If I don't go to church now I still have a pretty good average," he once said), it was still a part of his visual iconography. Rockwell had summoned *Choir Boy* from his past, but his next cover painting was influenced by more timely events. In 1952, all three Rockwell sons were away from home. Jarvis was in the Air Force stationed in Korea, Thomas had started Bard College, and Peter was attending prep school in Putney, Vermont. The loss of their companionship and possibly Mary's, whose depression had worsened, inspired one of Rockwell's most poignant paintings. Continuing an artistic tradition of communicating the rite of passage of a child's leaving home, Rockwell created *Breaking Home Ties*. Annual commitments of artwork for Hallmark, Brown & Bigelow, and Boy Scouts of America were a concern for the

Norman Rockwell in his Main Street, Stockbridge, studio. Photo by Bill Scovill, 1954.

busy artist. Four images for Hallmark, due in the fall of 1953, went undone. Rockwell pleaded for an extension saying he had "gotten into an unbelievable jam." Worried that his relationship with Hallmark might be in jeopardy, he asked his secretary to write a second letter admitting that Rockwell was having "personal problems" and asking for confirmation that Rockwell was still in their good graces. It was March 1954 before Rockwell shipped off his four watercolor paintings for Hallmark's next Christmas series, and they were among his best. Each featured a Santa Claus, always the favorite of card buyers.

Finding the need for more space in his Main Street studio, Rockwell rented the room next to his, and with permission, removed the dividing wall between the two and enlarged its north window. To announce Rockwell's Stockbridge move to their readers, the *Saturday Evening Post* published photos of Rockwell looking out from the window of his new studio. In March, Norman and Mary purchased a house adjacent to a cemetery on West Main Street. In addition to *Breaking Home Ties*, Rockwell spent his spring and summer on a *Rock of Ages* painting, a new series of *Four Seasons* sketches for the Brown & Bigelow calendar company, a painting of a doctor and boy for Upjohn Pharmaceuticals, and a Massachusetts Mutual Life Insurance picture of a family at a circus. Then, according to Rockwell biographer Laura Claridge, Rockwell

was admitted to Pittsfield's St. Luke's Hospital in October for "a rest." Only one more *Post* cover was produced that year in the Main Street studio. Another autobiographical work, *Art Critic*, was inspired by Rockwell's experiences as an art student and the experiences of his son, Jarvis, then enrolled at the School of the Museum of Fine Arts in Boston. Rockwell labored over *Art Critic* to the exclusion of other work, producing more than a dozen preliminaries for the portrait within the painting and three versions of the Dutch scene in the painting's background. Photographer Bill Scovill said Rockwell had more trouble with *Art Critic* than with any other painting. The result was worth the angst; to this day, *Art Critic* delights museum visitors—and art critics.

The following year, Rockwell was asked to travel around the world for a Pan American Airways advertising campaign. Accompanied by a representative from Pan Am's ad agency, J. Walter Thompson, and a Pan Am photographer, Rockwell would travel to seventeen cities in thirteen countries, recording impressions in his sketchbook. These would be the basis for full-color paintings for ads in the *Post*, *Life*, and *Holiday*. But shortly before the September departure date, Rockwell grew concerned about leaving Mary alone. In addition to her Riggs' therapy, she was now receiving treatment at the Institute for Living in Hartford, Connecticut, and Rockwell, with the consultation of Mary's Riggs' doctor, decided it would be best to place her in their care for the duration of his trip. Rockwell accompanied her to Hartford to spend a week with her before leaving for London. When the local press discovered him there, he used the pretense that he was sketching Bushnell Park's historic monuments and sculptures as warm-up for his Pan Am trip.

By all accounts, Rockwell had loved his life in Arlington, but he never looked back. He welcomed the fresh assortment of faces for his pictures and the new social opportunities. He joined in community activities that were different from his former

Grange experience in Vermont. Now he gathered weekly at the Red Lion Inn with friends in the Marching and Chowder Society to discuss current events over lunch. More formal were his monthly meetings of the Monday Evening Club, a group of prominent Berkshire County citizens. On a rotating basis, each member spoke on a stimulating or provocative topical subject, and group discussion followed. In a talk titled "Extraordinary Men?" Rockwell questioned whether personality traits revealed by political leaders during posing sessions could indicate their true character. Now closer to New York, he made frequent trips to the city to meet with editors and ad agents, to give lectures at the Society of Illustrators, and for holidays at his favorite resting place, the Plaza Hotel.

Though the gregarious Rockwell on one hand enjoyed having a studio in the center of town where he could view prospective models from his second floor picture window, he was accustomed to having a much larger space laid out in the familiar manner of his former custom-built studios in New Rochelle and Arlington. Meanwhile, for Mary, the view of the cemetery from their kitchen window was an ominous landscape. In 1957, they bought an eighteenth-century home near the center of town, and that summer, they converted its carriage barn into a studio. Rockwell welcomed new friends and neighbors into his studio. He invited school-children from the nearby Plain School to hear him talk about art, and later, when the Old Corner House museum was established, docents came to gain insight about his process.

In the summer of 1959, Mary, to whom Rockwell had been married for twenty-eight years, died suddenly of cardiac arrest. The following summer, to lift himself out of his depression, Rockwell rejoined a local sketch class. Support also came from

Austen Riggs Center therapist Erik Erikson, whom Rockwell had been seeing for work-related problems. In 1961, Rockwell married Molly Punderson, who had recently retired from her post as English teacher at Milton Academy near Boston, and had returned to her home town of Stockbridge. Rockwell's desire to shed his reputation as a painter of nostalgia for a truer image was awakened by the influence of his new wife who was resolute and vocal in her liberal political opinions.

Just as he had in New Rochelle and Arlington, Rockwell contributed often to local projects. For the anniversary of the town's library, he created a fund drive poster. When the women of St. Paul's Episcopal Church published a fundraising cookbook, he sketched a jaunty looking chef for their cover. And for the dedication ceremony of a new post office, Rockwell sketched mailman Tom Cary for the program cover. The most amazing tribute to his town, because Rockwell was least of all a painter of landscapes, was an eight-foot-long painting of the town's Main Street, published by *McCall's* to celebrate Christmas in small-town America.

In the early 1960s, having lost audience and advertisers to television, the *Post* attempted to capture readers from *Life* and *Look* by using portraits and photographs on their covers, and Rockwell was assigned to paint political figures and celebrities. He was sent to India, Cairo, and Yugoslavia to do portraits of Jawaharlal Nehru, Gamal Abdel-Nasser, and Josip Broz-Tito. Then in June 1963, he wrote to the *Post* stating new conditions for his assignments and expressing concerns for his health that would limit his future work. According to his son Thomas, "This was Pop's way of breaking-without-quite-breaking with the *Post*." There also were problems with some of the *Post's* new staff. The art editor spent a day in Rockwell's studio telling him how to do the brushstrokes in his 1963 Jackie Kennedy portrait, and managing editor Matthew J. Culligan asked him to illustrate the Bible, a project he did not want to do.

Rockwell had been approached by *McCall's* and *Look*, and he grabbed the opportunity. Almost immediately he began work for *Look*. Leaving behind his beloved story-telling scenes, Rockwell threw himself into a new genre—the documentation of social issues. He welcomed the challenge of illustrating not nostalgia, but current social issues. The shackles of *Post* editorial policy had been broken and Rockwell began to voice his opinions. He had always wanted to make a difference, and as a highly marketable illustrator, he now had the opportunity to do so. Humor and pathos—traits that made his *Post* covers successful—were not needed for telling the story of life in 1960s America. The textures and colors once used to weave his light-hearted yarns were replaced by a direct, pared down, reportorial style appropriate for magazine editorials. Rockwell even experimented with his medium, in some cases replacing his usual oils with casein or acrylic or both.

In the years that followed, Rockwell reported on John F. Kennedy's Peace Corps program and the race to space, depicting the moon landing before and after it actually happened. In 1967, he illustrated a status report on the desegregation of the suburbs, and that fall began work on *The Right to Know*, an urgent call for government disclosure and accountability regarding Vietnam. With financial security, an adoring public and the admiration of his peers—in 1959 Rockwell was the first inductee named to the prestigious Society of Illustrators Hall of Fame—he was now free to tip the balance of his work toward the controversial subjects that concerned him: racial discrimination, poverty, and the rights of Americans to know the reasons for the choices of their government's leaders. America was at war in Vietnam and in its cities' streets, and Rockwell had the opportunity to voice his opinion. In 1971, when, after a brief hiatus, the *Post* resumed publishing under new ownership, the new editors asked Rockwell to work for them once again. When he wavered, his wife Molly inter-

ceded, saying, "Norman, you mustn't!" In 1977, President Gerald R. Ford honored Rockwell with the Presidential Medal of Freedom, the nation's highest peacetime award, for having portrayed "the American scene with unrivalled freshness and clarity," and with "insight, optimism and good humor."

During his Stockbridge years, Rockwell produced paintings that will always resonate. *The Problem We All Live With* gently presents an aggressive assertion on moral decency. Art critics, connoisseurs, and historians continue to examine and reflect on *The Connoisseur* as they discuss "high" and "low" art and the meanings of abstract art. *Art Critic* will always intrigue us for its masterly technique and the delight we feel as we are drawn into its secret life. For five decades, Rockwell opened our hearts by lovingly portraying our foibles. When he shifted his attention to the broader picture of social ills, he faced an audience ready to receive his messages, helping us evolve into a more compassionate culture.

Despite declining health, Rockwell accepted a commission to paint the July 1976 cover of *American Artist* magazine, celebrating the country's bicentennial. That summer, in a parade and celebration, the people of Stockbridge claimed Rockwell as their own hometown hero. With the onset of dementia and the effects of emphysema resulting from years of pipe-smoking, Rockwell could no longer do the work that had so completely and passionately driven his life. In 1978, at age 84, Rockwell died at home.

Hallmark Santas 1953
Norman Rockwell (1894–1978)
Pencil on paper

Norman Rockwell's images for Hallmark Cards have become enduring representations of the feelings and fantasies associated with Christmas. From 1946 to 1957, the Kansas City greeting card company Hall Brothers, Inc., published and reproduced year after year a line of Christmas cards that featured more than thirty paintings by Norman Rockwell. Company president Joyce C. Hall impressed on Rockwell that the illustrations should reflect the spirit of Christmas with humor and lots of color. The cards were to epitomize Christmas as embraced by the broadest possible market—America's growing post-war middle class.

For thirty-six years, Rockwell had been studying the preferences and interests of American consumers and magazine readers in order to create popular covers and advertisements. "The old traditional ideas are the most acceptable to most people, so they are your best bet," he said, adding, "A subject for a Christmas card which conveys the cheer and good will of the season is much better than the most brilliant modern wise-

crack." In addition to being sold as individual cards, each year's line was packaged in boxed sets of four different images. The four scenes for the 1954 line pictured Santa preparing his list of good boys and girls, getting his reindeer ready, filling the children's stockings, and resting on Christmas Day. The sketches and drawings seen here show Rockwell's initial idea and final drawing for each of the watercolor and pen-and-ink paintings held in Hallmark's collection. During this period, Rockwell's Stockbridge studio was in the same building as Malumphy's Restaurant, and Rockwell found the owner, John Malumphy, to be the perfect model for his 1954 series. "My friends and neighbors seem to enjoy taking part in my work, even when it entails dressing out in winter clothes for a Christmas card painting in June or July."

Details of *Hallmark Santas*

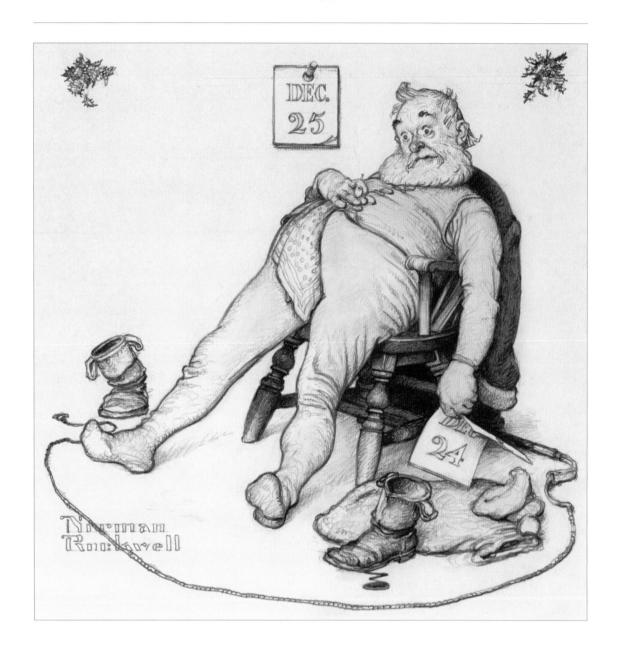

Preliminary drawing for Hallmark Christmas card
11.5 x 11.5 inches
Norman Rockwell Museum Collection, NRM.2006.1

To All a Good Night 1953
Norman Rockwell (1894–1978)
Pencil on paper

Preliminary drawing for Hallmark Christmas card
5 x 5 inches
Norman Rockwell Museum Collection, NRM.2006.2

Checking Up 1953
Norman Rockwell (1894–1978)
Pencil on paper

Preliminary drawing for Hallmark Christmas card
11.5 x 11.5 inches
Norman Rockwell Museum Collection, NRM.2006.3

Checking Up 1953

Norman Rockwell (1894–1978)

Pencil on paper

Preliminary drawing for Hallmark Christmas card
5 x 5 inches
Norman Rockwell Museum Collection, NRM.2006.4

Filling the Stockings 1953

Norman Rockwell (1894–1978)

Pencil on paper

Preliminary drawing for Hallmark Christmas card
11.5 x 11.5 inches
Norman Rockwell Museum Collection, NRM.2006.5

Filling the Stockings 1953
Norman Rockwell (1894–1978)

Pencil on paper

Preliminary drawing for Hallmark Christmas card
5 x 5 inches
Norman Rockwell Museum Collection, NRM.2006.6

Getting Ready 1953

Norman Rockwell (1894–1978)

Pencil on paper

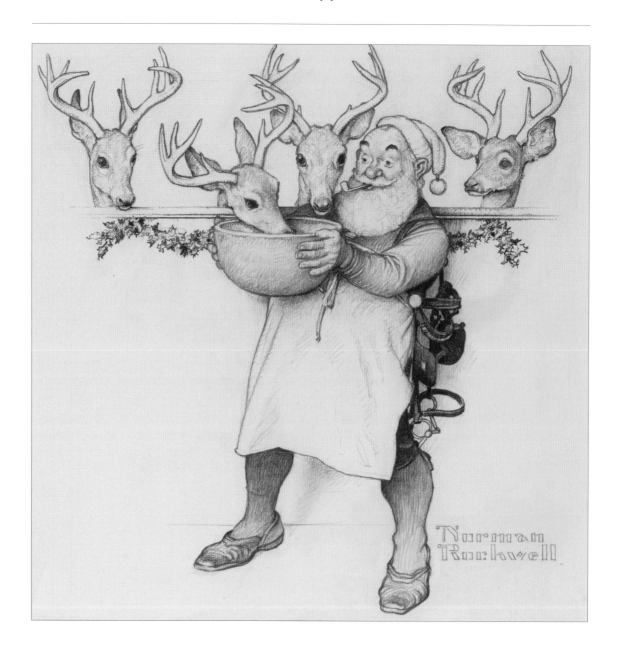

Preliminary drawing for Hallmark Christmas card
11.5 x 11.5 inches
Norman Rockwell Museum Collection, NRM.2006.7

Getting Ready 1953

Norman Rockwell (1894–1978)

Pencil on paper

Preliminary drawing for Hallmark Christmas card
5 x 5 inches
Norman Rockwell Art Collection Trust, NRACT.1976.237

Sis 1954

Norman Rockwell (1894–1978)

Oil on canvas

In the early 1950s, with a stroke of creative acumen, Chicago advertising director Leo Burnett paired popular icons Superman, Howdy Doody, and Norman Rockwell with Battle Creek Michigan's star cereal maker, Kellogg. With an innovative color palette and contemporary design, the ad campaign changed the look of cereal boxes and inspired shoppers to eagerly reach for them on their grocery store shelves. Central to the success of Kellogg's Corn Flakes were Rockwell's signature fresh-faced kids, who beamed out at us from store displays and magazine print ads with enthusiasm, happiness, and most of all, good health.

American companies such as Kellogg found in Rockwell qualities they wanted associated with their products: honesty, artistry, competence, and status. Using words such as "distinguished" and "noted" and phrases such as "American Legacy," "elegant taste and discrimination," "unexcelled craftsmanship," and "accustomed to the finest," advertisements described their products or their customers while alluding to Rockwell.

Paintings for Kellogg Company corn flakes advertisements
14.75 x 14.75 inches
Collection of the Norman Rockwell Museum, NRM.1993.1,
NRM.1993.3, NRM.1993.4, NRM.1993.6,
Gift of Kellogg Company

Beanie 1954

Norman Rockwell (1894–1978)

Oil on canvas

Freckles 1954
Norman Rockwell (1894–1978)
Oil on canvas

Girl with String 1955

Norman Rockwell (1894–1978)

Oil on canvas

Girl at Mirror 1954
Norman Rockwell (1894–1978)
Oil on canvas

Girl at Mirror follows a long tradition of fine artists who have pictured a woman contemplating her reflection. George Hughes, fellow *Post* cover artist, said that a painting by Edouard Manet inspired this painting. Two paintings by other artists stand out as strong candidates, however. Included in Rockwell's reference files are examples of Picasso's *Girl at Mirror* and Elizabeth Vigée-Lebrun's *The Artist's Daughter*, each of which could have directly influenced this work.

Painting for *The Saturday Evening Post* cover, March 6, 1954
31.5 x 29.5
Norman Rockwell Art Collection Trust, NRACT.1973.8

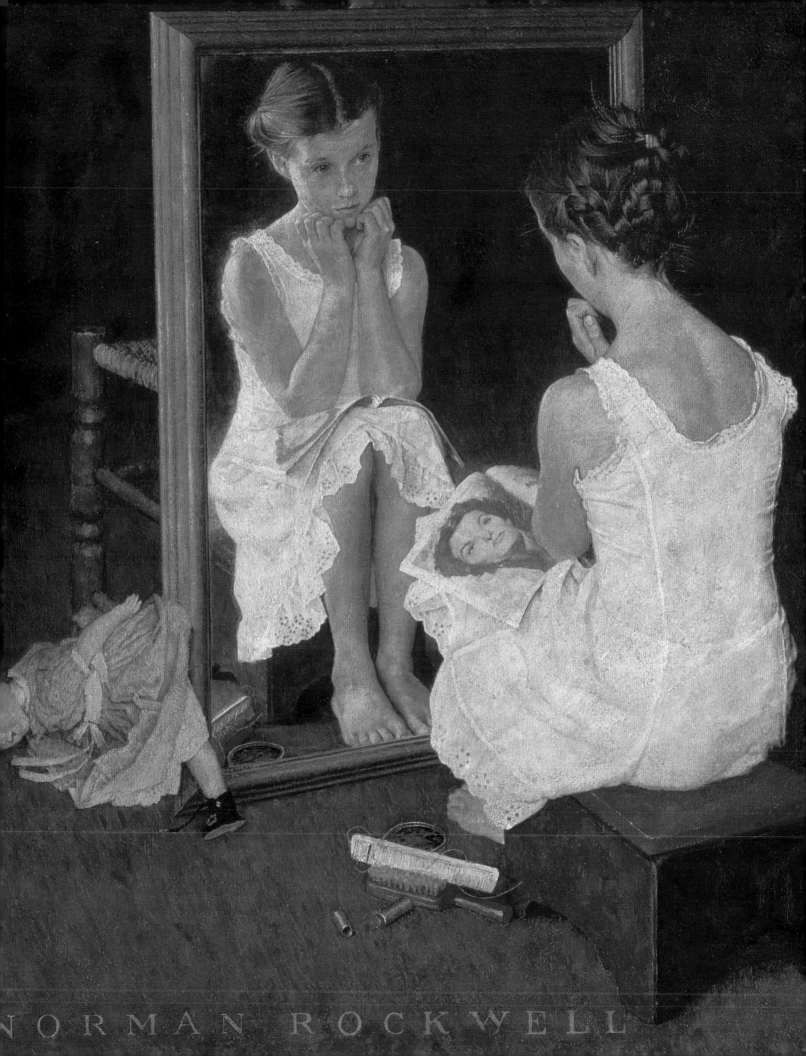

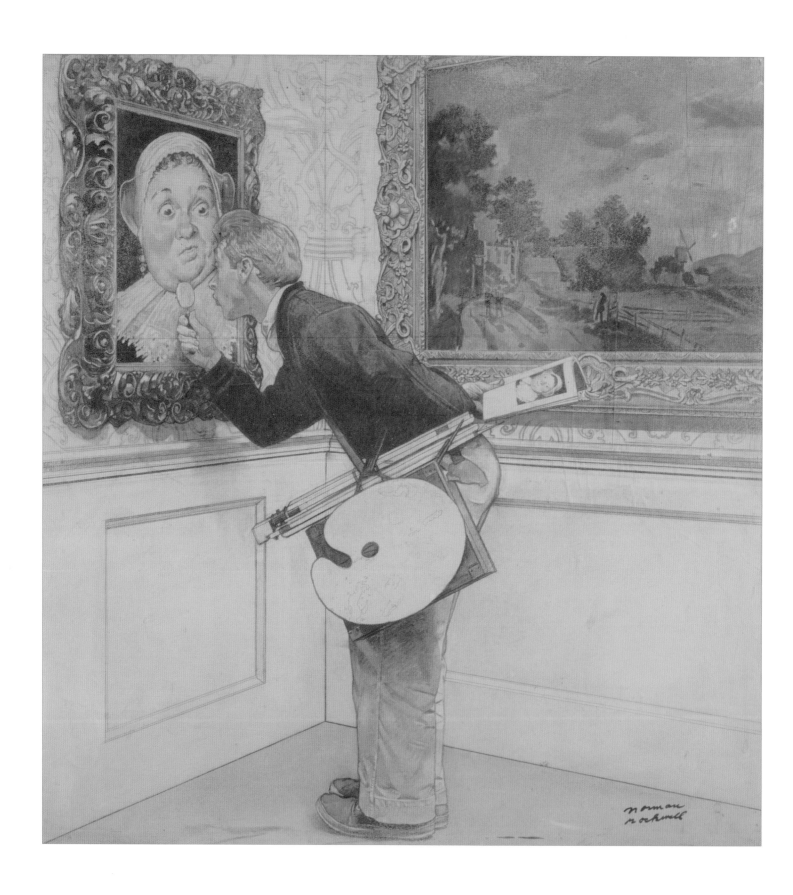

Art Critic 1955

Norman Rockwell (1894–1978)

Charcoal on paper mounted to board

Knowing that the success of his covers depended on the strength of his ideas, Norman Rockwell struggled to develop engaging picture themes. Once a direction was established, usually after making numerous small idea sketches, he began by selecting models, costumes, and props. Then, acting as a director might, he posed his subjects so a photographer could record elements of the scene. Despite urgent deadlines, each Rockwell illustration involved from five to as many as fifteen steps.

Using his photographs as a reference, Rockwell worked with the details of composition and value in richly detailed black-and-white Wolff pencil-and-charcoal drawings. "I take the making of the charcoal layouts very seriously," he said. "Too many novices, I believe, wait until they are on the canvas before trying to solve many of their problems. It is much better to wrestle with them ahead through studies. . . ." Rockwell applied charcoal freely, blending it with his thumb to achieve a range of textures and tones. This was the reason his right-hand thumb was so large, said his son Tom. If an image needed reworking and many erasures thinned the paper, that portion was cut away, fresh paper added, and the area redrawn. Pin holes in the paper appear where photos were attached for reference. The size of the final drawing indicated the size of the final painting, since the drawing's basic outlines were transferred to the canvas before painting began.

Rockwell's drawings reveal careful consideration of small details later added to canvases and brought to life with color, shading, and the texture of paint. Rockwell, however, was far from beginning his final painting when he completed this drawing. He considered this one of his most difficult paintings and spent more time on it than on almost any other *Post* cover. The face of the woman in the portrait changed no fewer than seventeen times. For each change, Rockwell painted a separate oil-on-acetate sketch, which he could then place for consideration within the portrait's frame. At some point, probably as his Frans Hals housewife turned into a Peter Paul Rubens lady, Rockwell replaced the seventeenth-century landscape on the opposite wall with a group portrait of Dutch cavaliers. This adds a new dynamic of critical reaction to the student's close examination of the lady's pendant, and further, compels the viewer's participation in Rockwell's invented reality.

Preliminary drawing for *The Saturday Evening Post* cover
April 16, 1955
38 x 36 inches
Norman Rockwell Art Collection Trust, NRACT.1973.3e

Art Critic 1955

Norman Rockwell (1894–1978)

Oil on canvas

Norman Rockwell once said he envied students who swooned when viewing the *Mona Lisa* because he never felt such passion. Rockwell may have seen himself as a more analytical artist, such as the one examining a seventeenth-century Dutch painting in his 1955 *Art Critic*. His original draft depicts a student examining painter Frans Hals' technique in a portrait of a Dutch housewife. In that study, a Dutch landscape on an adjacent wall places the student in a gallery of Dutch artwork. But a recurring Rockwell theme of fantasy and reality exchanging places seems to have taken over, and the painting changed course.

With typical humor, Rockwell replaced the homely woman with one more alluring—based on a Peter Paul Rubens portrait of his wife. The Dutch landscape became a group of Dutch cavaliers, brought to life with animated facial expressions. They are wary and concerned. Is the student getting too close to the painting? Is he being too personal with their gallery colleague? The scene's movement from reality to fantasy refutes the view that Rockwell's work is only photographic.

Odds & Ends:

On the student's palette, three-dimensional dollops of paint remind us that we too are standing in a gallery looking at a painting.

Painting for The Saturday Evening Post cover, April 16, 1955
39.5 x 36.25 inches
Norman Rockwell Museum Collection, NRM.1998.4

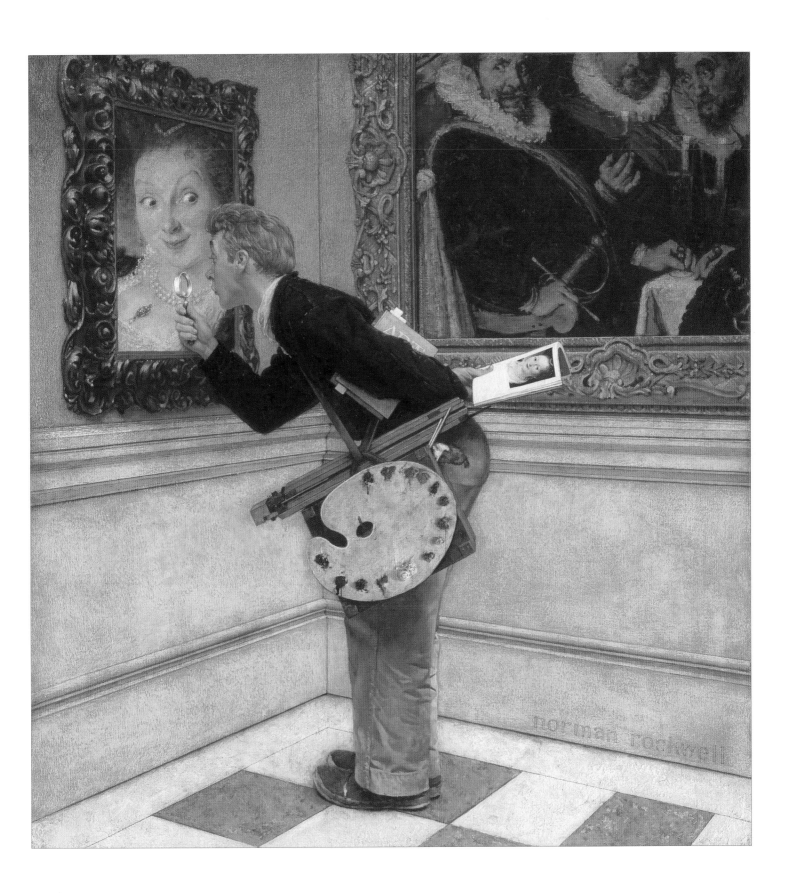

Beefeater

Tower of London
guard

Tower of London Guard, Beefeater 1955

Norman Rockwell (1894–1978)

Wolff pencil on paper

In 1955, Norman Rockwell was asked to do illustrations for a Pan American World Airways ad campaign to encourage round-the-world travel by Americans. The airline, which began service in 1927, was, in 1947, the first to offer commercial, round-the-world service. Pan Am wanted to emphasize the time savings of air travel, the number and variety of their routes—by 1956 they were flying to eighty countries—and the ease of moving from one country to another. A great lover of travel, Rockwell enthusiastically embraced his new assignment. In two months, Rockwell visited seventeen cities in thirteen countries, recording in his sketchbook the people and sights he witnessed. "People from bullfighters and priests to snake charmers, monkey tamers, Arabs, and Geisha girls. Scenes from a fountain in Rome to a camel-elephant-water buffalo-bicycle-and-beggar-

thronged street in Karachi," said Rockwell in his autobiography. By integrating American tourists in some of the scenes, he made travel to foreign countries seem familiar, and shaped people's expectations of how they might experience diverse cultures. In Pan Am's interest, he sent the message that tourists could safely experience exotic locales and new situations. The ads ran throughout 1956 in *Life*, *The Saturday Evening Post*, and *Holiday*. Rockwell's "round-the-world spread" was a "solid hit," according to the J. Walter Thompson ad agency, which handled the Pan Am account. "No travel advertisement ever caused so much talk."

Preliminary drawing for Pan American World Airways advertisement
1955
16.375 x 13.625 inches
Norman Rockwell Museum Collection, NRM.2006.49
Gift of Shirlee N. and Salvatore F. Scoma, 2006

The Discovery 1956
Norman Rockwell (1894–1978)
Oil on canvas

Intending it to be used as a September or October cover, Rockwell sent this painting of a small boy discovering a Santa suit in the bottom drawer of his father's dresser to *The Saturday Evening Post* in July. Instead the *Post* ran the image as the December 29 cover. Though the obvious interpretation of the painting is the boy's discovery that Santa does not exist, the *Post* in its contents section provided an alternate explanation (one that ignored the presence of mothballs): Santa had left his clothes to be sent to the cleaners.

In *The Discovery*, Rockwell makes use of *doorkijkje*, a device favored by seventeenth-century Dutch artists, which literally means a "look through." An open door through which a distant view can be seen creates another picture plane, which adds depth. This is one of very few images set in a room in Rockwell's own home. The bureau and pipe were Rockwell's as well, but the Santa suit was not.

Painting for *The Saturday Evening Post* cover, December 29, 1956
35.25 x 32.5 inches
Norman Rockwell Art Collection Trust, NRACT.1973.5

norman rockwell

Expense Account 1957
Norman Rockwell (1894–1978)
Oil on canvas

Rockwell conceived this picture as a business traveler's desperate late-night attempt to reconcile his expense account. He told art editor Ken Stuart he wanted a "cold almost bluish light" to evoke the feeling of desperation. When Stuart suggested they overlay an expense account around the traveler, Rockwell set the Pullman car scene against boundless white space. He replaced his early model, Louie Lamone, with his neighbor Ernest Hall, whose body language was more harried and more humorous.

To augment his story, Rockwell used lots of ready props. His numerous business trips to New York and his 1955 round-the-world trip for Pan American Airlines provided him with lots of ticket stubs, receipts, and nightclub ephemera. *Post* readers reacted to the cover with the usual assortment of feelings. A man from Norfolk, Virginia, said it was "far from funny . . . a moral tragedy," but a Cleveland reader, called it "superb," and said he did a lot of traveling and well appreciated the character's dilemma. And a woman from Texas said her three-year-old son learned his first curse word, "damn," while his father was preparing his expense account.

Painting for *The Saturday Evening Post* cover, November 30, 1957
31.25 x 29 inches
Norman Rockwell Art Collection Trust, NRACT.1973.6

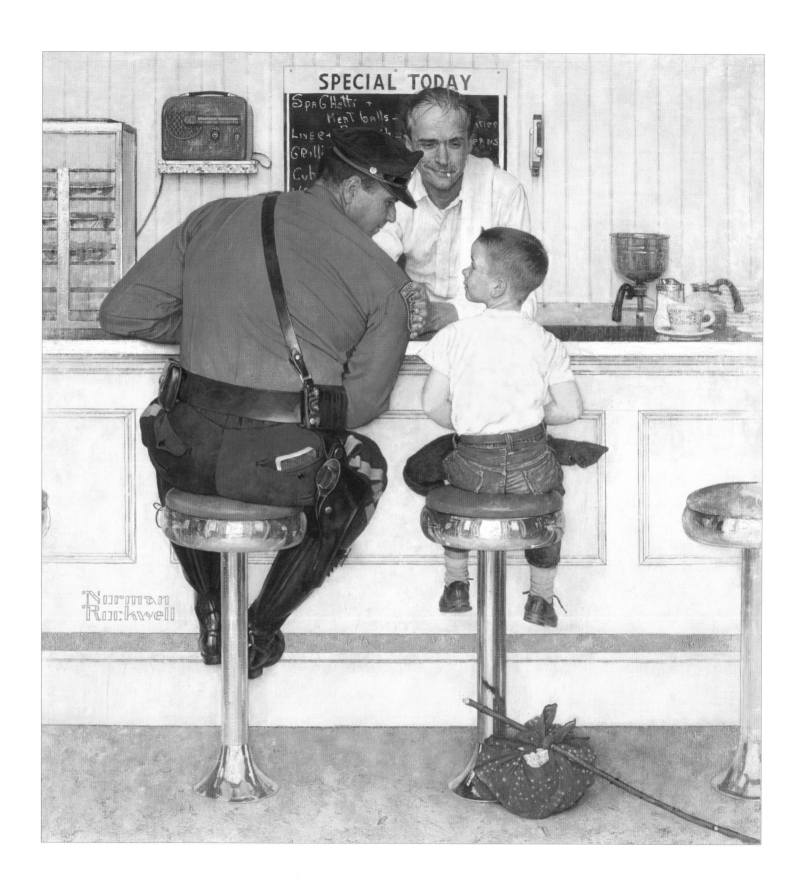

SPECIAL TODAY

SpaGhetti +
MeaT balls -
Liver +
GrILL
Cub

Norman
Rockwell

The Runaway 1958

Norman Rockwell (1894–1978)

Oil on canvas

"I like to paint kids . . . people think of their own youth," Rockwell once said, and he had firsthand experience as reference for this work. "I ran away from home when I was a kid in Mamaroneck and mooned around the shore; kicking stones and watching the whitecaps on Long Island Sound. Pretty soon it began to get dark and a cold wind sprang up and moaned in the trees. So I went home."

Painting for *The Saturday Evening Post* cover, September 20, 1958
35.75 x 33.5 inches
Norman Rockwell Art Collection Trust, NRACT.1973.18

Family Tree 1959

Norman Rockwell (1894–1978)

Oil on canvas

In 1959, Rockwell began telling his life story to his son Tom Rockwell, who was ghostwriting his autobiography, *Norman Rockwell, My Adventures as an Illustrator.* Recording his family history may have inspired Rockwell to trace the lineage of an American family in a painting, as the final chapter is devoted to a day-by-day account of how *Family Tree* was created.

The basic structure for the painting, a tree, is taken from a twelfth-century Dutch family tree, a photo of which was found for Rockwell by the reference librarian at the Berkshire Athenaeum in Pittsfield, Massachusetts. To simulate the appearance of aged parchment, Rockwell stained the background of his painting with brown paint and sketched in *trompe l'oeil* cracks. For even greater authenticity he rubbed dirt, gravel, and twigs into it, shook it off, then rubbed in more. He then sandpapered the surface, which he said gave it a "beautiful texture." The consistency of family features through the generations is assured by Rockwell's use of the same model for either the man or the woman in each couple on the tree.

The lineage begins with a pirate and a Spanish princess taken by the pirate from a sinking Spanish galleon. The galleon is based on a painting by Rockwell's favorite illustrator of historical subjects, Howard Pyle, whose initials are on the treasure chest.

Rockwell loved the idea of having the "all-American" boy descend from a pirate and his stolen Spanish princess, though it troubled his friend and therapist Erik Erikson. "Do you think you ought to start off the family with him, a cutthroat, a barbarian?" Erikson asked. Rockwell experimented with changing the pirate to a Puritan, then a buccaneer, but finally returned to the original. "Everybody," he said, "had a horse thief or two in his family."

ODDS & ENDS:

Initial work for the painting began on April 27, 1959. It was completed four months later on August 18. Seven days later, Rockwell's wife Mary died.

Painting for *The Saturday Evening Post* cover, October 24, 1959
46 x 42 inches
Norman Rockwell Art Collection Trust, NRACT.1973.7

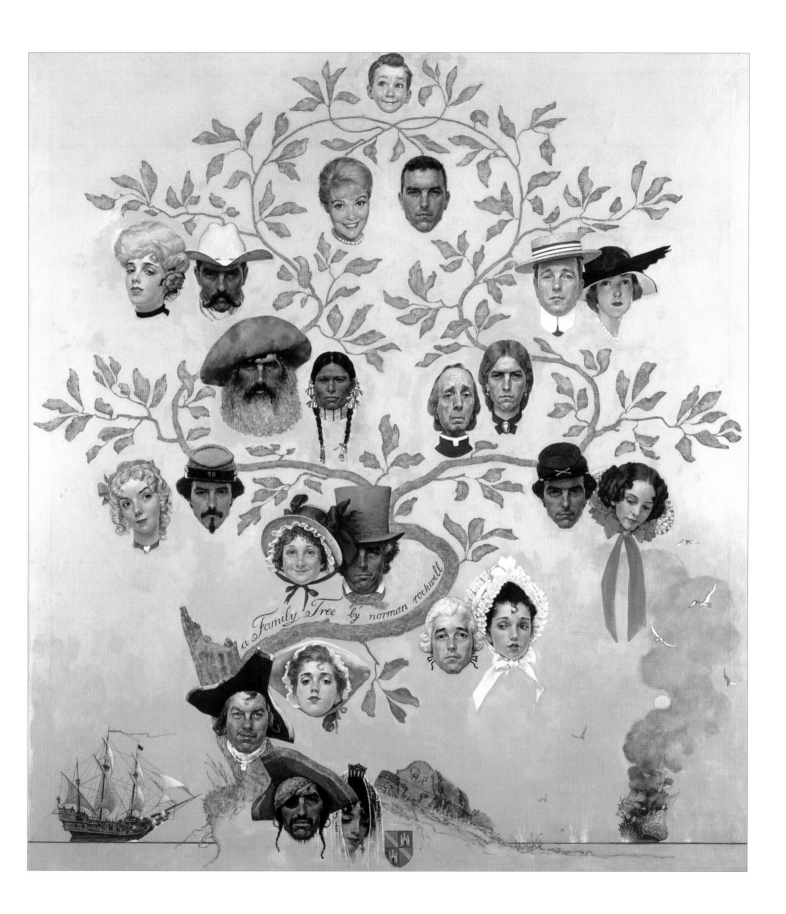

a Family Tree by norman rockwell

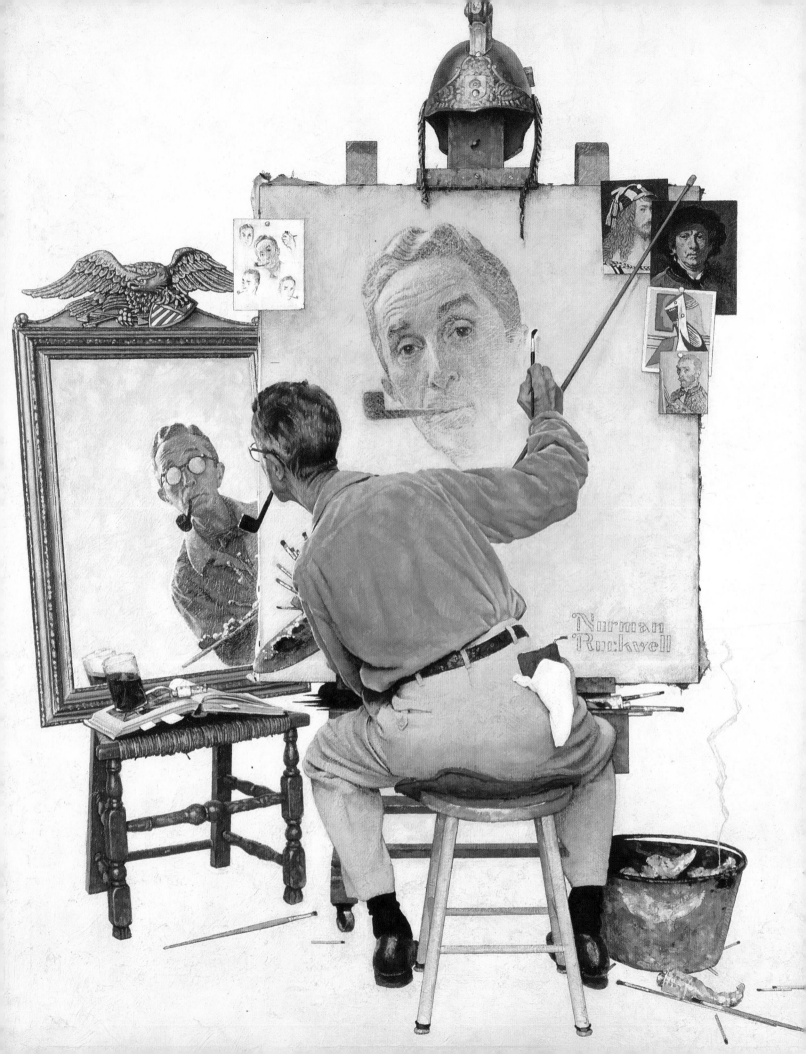

Triple Self-Portrait 1959
Norman Rockwell (1894–1978)
Oil on canvas

Humor and humility were essential aspects of Norman Rockwell's character, so when asked to do a self-portrait that would announce the first of eight excerpts of his autobiography, the result was lighthearted and somewhat self-deprecating. The painting provides the essential elements not of his life as an illustrator, but of the specific commission. Rockwell's life is far too eventful to approach summation in a single work, so he limits the composition to himself, his artists' materials, his references, a canvas on an easel, and a mirror.

Inconsistencies in this painting are cause for wonder. Rockwell was a stickler for neatness, but here he has scattered matchsticks, paint tubes, and brushes over the studio floor. The glass of Coca-Cola, Rockwell's usual afternoon pick-me-up, looks as if it will tip over at any moment. Some discrepancies can be explained away. He has traded his usual Windsor chair for a stool (easier to see more of him?) and his milk glass palette table for a hand-held wooden palette (an economy of picture space?). In real life, Rockwell's mirror was not topped with an eagle; it may have been added to send a message. Most other features are true to life: He did tack or tape studies to his drawings or canvases and he did immerse himself in favorite artwork before beginning a project. That Rockwell's eyes cannot be seen bothers some who try to find a psychological significance. But photos of Rockwell posing show he could not have seen his own eyes; his mirror was directly opposite his studio's massive north window, causing the reflected glare on his lenses.

Paint rags and pipe ashes sometimes conspired to ignite small fires in Rockwell's brass bucket, so the wisp of smoke in the painting rings true. Rockwell's brass helmet, usually placed on an unused easel, crowns this one. Just as the smoke is a reminder that once Rockwell's studio caught fire as a result of his carelessness with pipe ashes, the helmet refers to a favorite Rockwell story. While in Paris in 1923, Rockwell acquired it from an antiques dealer who sold it as a military relic rather than as the contemporary French fireman's helmet Rockwell later found it to be.

The four self-portraits on his canvas—Albrecht Dürer, Rembrandt van Rijn, Pablo Picasso, and Vincent Van Gogh—are his references. They invite us to compare (as he did) how other artists tackled the problem of a self-portrait.

Painting for *The Saturday Evening Post* cover, February 13, 1960
44.5 x 34.75 inches
Norman Rockwell Art Collection Trust, NRACT.1973.19

Portrait of John F. Kennedy 1960

Norman Rockwell (1894–1978)

Oil on canvas

In 1960, Norman Rockwell was commissioned by *The Saturday Evening Post* to paint portraits of Presidential candidates Senator John F. Kennedy and Vice President Richard M. Nixon. Kennedy appeared on the October 29 cover and Nixon on the November 5 cover. To prepare for the painting of Kennedy, Rockwell arranged to pose and photograph Kennedy at his home in Hyannis Port, Massachusetts. When Rockwell arrived, Kennedy, in his pajamas, leaned out of an upstairs window and told Rockwell to go right in, and that he'd be down in a minute. While Kennedy ate his breakfast, Rockwell chose a room for the session. Rockwell suggested it would be best to use a dignified pose that didn't emphasize Kennedy's youth (he was just forty-three); Kennedy agreed. After photos were taken, the two men walked to the breakwater to see Kennedy's sailboat. Now more relaxed, and feeling he had been a little stiff during the photo session, Kennedy suggested they return to the house for a second shoot. Rockwell was pleased with the result: "His expression was just what I wanted—serious with a certain dignity, but relaxed and pleasant, not hard." Rockwell's modeling session with Nixon was even briefer, squeezing the photo shoot into a forty-five-minute Senate recess.

Painting for *The Saturday Evening Post* cover, October 29, 1960
16 x 12 inches
Norman Rockwell Museum Collection, NRM.1978.01

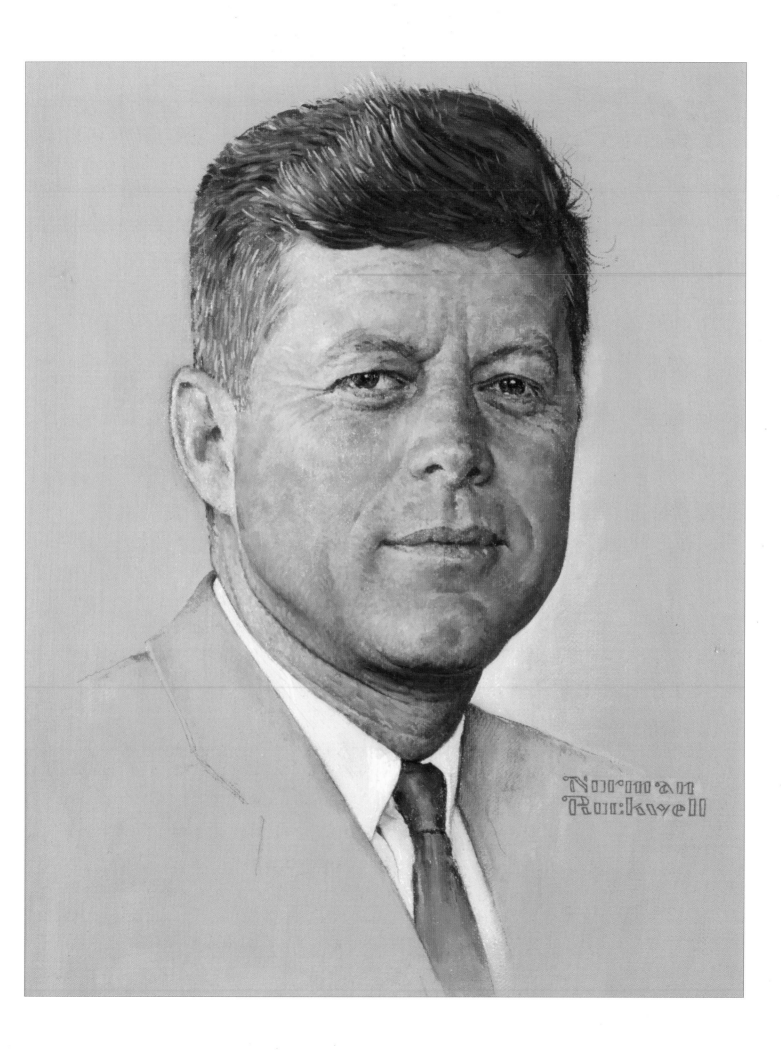

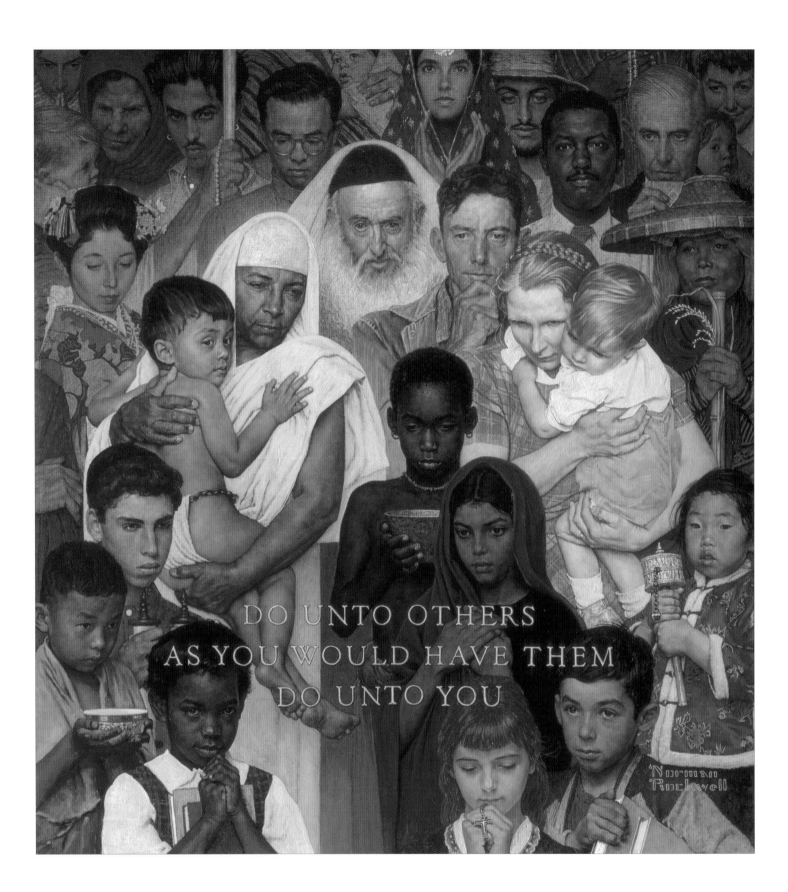

Golden Rule 1961

Norman Rockwell (1894–1978)

Oil on canvas

In the 1960s, the mood of the country was changing, and Norman Rockwell's opportunity to be rid of the art intelligentsia's claim that he was old-fashioned was on the horizon. His 1961 *Golden Rule* was a precursor to the type of subject he would soon illustrate. A group of people of different religions, races, and ethnicities served as the backdrop for the inscription "Do Unto Others as You Would Have Them Do Unto You." Rockwell was a compassionate and liberal man, and this simple phrase reflected his philosophy. Having traveled all his life and having been welcomed wherever he went, Rockwell felt like a citizen of the world, and his politics reflected that value system.

From photographs he'd taken on his 1955 round-the-world Pan Am trip, Rockwell referenced native costumes and accessories and how they were worn. He picked up a few costumes and devised some from ordinary objects in his studio, such as a lampshade used as a fez. Many of Rockwell's models were local exchange students and visitors. In a 1961 interview, indicating the man wearing a wide-brimmed hat in the upper right corner, Rockwell said, "He's part Brazilian, part Hungarian, I think. Then there is Choi, a Korean. He's a student at Ohio State University. Here is a Japanese student at Bennington College, and here is a Jewish student. He was taking summer school courses at the Indian Hill Museum School." Pointing to the rabbi, he continued, "He's the retired postmaster of Stockbridge. He made a pretty good rabbi, in real life, a devout Catholic. I got all my Middle East faces from Abdalla who runs the Elm Street market, just one block from my house." Some of the models were from Rockwell's earlier painting *United Nations*. Though it was never finished, it was going to be "a mass of people," he said, "representing the people of the world, waiting for the delegates to straighten out the world, so that they might live in peace and without fear."

Painting for *The Saturday Evening Post* cover, April 1, 1961
44.5 x 39.5 inches
Norman Rockwell Art Collection Trust, NRACT.1973.10

Lubalin Redesigning the Post 1961
Norman Rockwell (1894–1978)
Oil on canvas

Hoping to lure back advertisers who had switched their attention to television, *Saturday Evening Post* designer Herbert Lubalin was assigned to create a new, more contemporary, logotype. To help readers accept the change, Rockwell was hired to create the first *Post* cover with the new design. In the 1961 cover, also known as *Modernizing the Post*, Lubalin is shown creating the logotype. Strewn over his drawing table are logos dating back to the beginning of the century. Instead of its position in the upper left corner, the new "Post" spread across the width of the page. Reporting on the Savoy Hilton presentation of the cover to more than two hundred advertisers, the *Wall Street Journal* announced, "*Saturday Evening Post*'s New Format Appears to Impress Advertisers." Just six months later, the magazine returned to its old format.

ODDS & ENDS:

Rockwell's choice of Plycraft's bent-plywood chair makes a contemporary statement, as does his simplified signature. Unlike most artists, Rockwell changed his signature to suit the style of each of his paintings.

Painting for *The Saturday Evening Post* cover, September 16, 1961
34 x 26.5 inches
Norman Rockwell Art Collection Trust, NRACT.1973.13

Lincoln for the Defense 1961
Norman Rockwell (1894–1978)
Oil on canvas

No other statesman appears more in Rockwell's work than Abraham Lincoln, who is included in eight of Rockwell's paintings between 1927 and 1964. Rockwell enjoyed painting Lincoln, not only as an affirmation of his private views but also because of the complexity of painting Lincoln's face. In later years, Rockwell publicly stated that he thought Lincoln was the greatest American.

In 1959, discussing the use of photography in preparing an illustration, he told students of the Famous Artists Schools, "If you want to exalt a subject, you shoot up at him. To humiliate him, shoot down." Two years later, Rockwell welcomed the opportunity to paint Lincoln for Elisa Bialk's story, *Lincoln for the Defense*, about the trial of accused murderer William "Duff" Armstrong. The prosecution's case was based on a witness testifying that he saw Armstrong commit the murder between ten and eleven at night. When Lincoln asked the witness how he could see him so clearly at that hour, the witness said it was a bright moonlit night. Lincoln won the case using an almanac to prove there was no moonlight on the night of the murder.

The groundwork for the painting—posing and photographing models and props—was done in Hollywood shortly after Rockwell's marriage to Molly Punderson on October 10, 1961. After a brief stay at New York's Plaza Hotel, the honeymooners traveled to Hollywood, where Rockwell's addiction to work compelled him to begin his assignment. Taking advantage of Hollywood's abundance of actors, he hired four men to pose as Lincoln, two for Armstrong, and a middle-aged couple as onlookers (later omitted from the painting). Returning to his studio, he referenced thirty different magazine photos of Lincoln for the head and for period clothing. Then he proceeded with his painting.

Odds & Ends:

The impressionistic brushwork and combining of different colors to achieve the nuances of shading in the whites of Lincoln's clothing remind us that this painting would be reduced to a much smaller size for a reproduction, in which the separate colors and chunky brushstrokes would blend.

Painting for *The Saturday Evening Post* story
"Lincoln for the Defense" by Elisa Bialk, February 10, 1962
49.75 x 17.5 inches
Norman Rockwell Art Collection Trust, NRACT.1973.77

The Problem We All Live With 1963

Norman Rockwell (1894–1978)

Oil on canvas

Rockwell's first assignment for *Look* magazine was an illustration of a six-year-old African-American schoolgirl being escorted by four U.S. marshals to her first day at an all-white school in New Orleans. Ordered to proceed with school desegregation after the 1954 Brown v. Board of Education ruling, Louisiana lagged behind until pressure from Federal Judge Skelly Wright forced the school board to begin desegregation on November 14, 1960.

Letters to the editor were a mix of praise and criticism. One Florida reader wrote, "Rockwell's picture is worth a thousand words. . . . I am saving this issue for my children with the hope that by the time they become old enough to comprehend its meaning, the subject matter will have become history." Other readers objected to Rockwell's image. A man from Texas wrote, "Just where does Norman Rockwell live? Just where does your editor live? Probably both of these men live in all-white, highly expensive, highly exclusive neighborhoods. Oh, what hypocrites all of you are!" The most shocking letter came from a man in New Orleans who called Rockwell's work "just some more vicious, lying propaganda being used for the crime of racial integration by such black journals as *Look*, *Life*, etc." But irate opinions did not stop Rockwell from pursuing his course. In 1965, he illustrated the murder of civil rights workers in Philadelphia, Mississippi, and in 1967, he chose children, once again, to illustrate desegregation, this time in the suburbs.

In an interview later in his life, Rockwell recalled that he once had to paint out an African-American person in a group picture since *The Saturday Evening Post* policy dictated showing African-Americans in service industry jobs only. Freed from such restraints, Rockwell seemed to look for opportunities to correct the editorial prejudices reflected in his previous work. *The Problem We All Live With* and *Murder in Mississippi* ushered in that new era for Rockwell.

Painting for *Look* illustration, January 14, 1964
36 x 58 inches
Norman Rockwell Museum Collection, NRM.1975.1

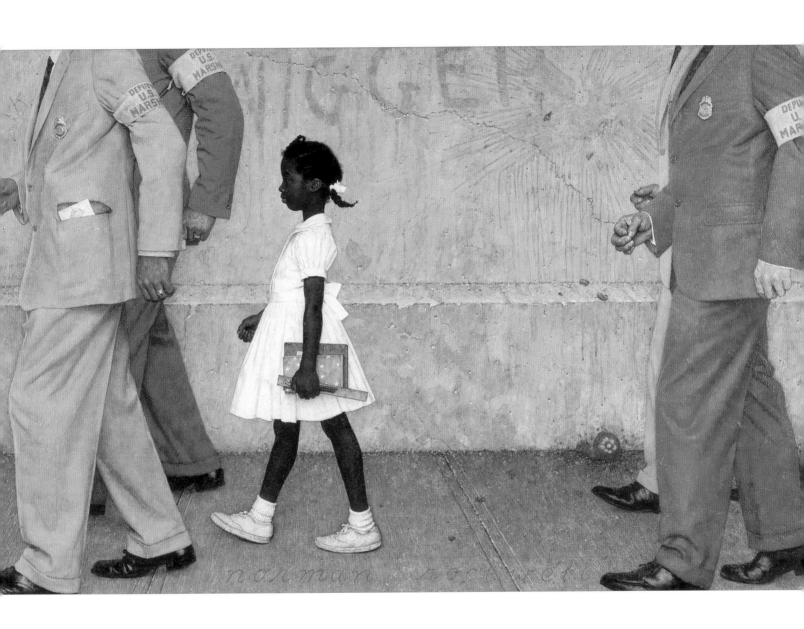

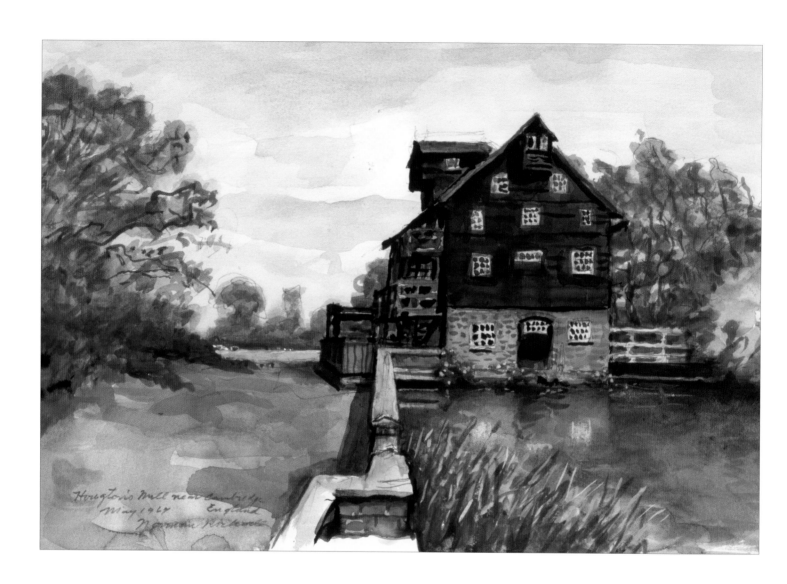

Houghton's Mill near Cambridge
May 1964 England
Norman Kirkwood

Houghton Mill 1964
Norman Rockwell (1894–1978)
Watercolor on paper

Sparked by an early adventure to South America, Norman Rockwell's love of travel continued through his lifetime. He made three trips to Europe in the 1920s, and shortly after his first son was born in 1931, the family lived in Paris for eight months. Rockwell often traveled on assignment, but as he got older, he used travel to relax and rest from his demanding work schedule. In 1963, Rockwell and his wife Molly began a twelve-year period in which they traveled on painting assignments, for rest and recreation, and to visit Rockwell's son Peter and his family in Rome. They traveled to more than seventeen countries, with many return visits to Italy, Greece, Holland, and Mexico. A pastime they both enjoyed, travel became essential for Rockwell's quota of rest. If he stayed in Stockbridge, nothing could keep him from his studio.

Rockwell's maternal grandparents came to the United States from England in 1862; his paternal grandparents descended from sixteenth- and seventeenth-century English settlers. Rockwell visited England a number of times. In 1964, he painted this watercolor of Houghton Mill in Cambridgeshire, England. Recorded history of the mill began in 974. The present building dates from the eighteenth century. In 1923, it was the setting for the American movie *The Typhoon*; in 1939 it became a property of the National Trust; and in 1983 Houghton Mill was opened to the public.

Painting for unpublished travel sketch
9.25 x 14 inches
Norman Rockwell Art Collection Trust, NRACT.1973.126

The Peace Corps (JFK's Bold Legacy) 1966
Norman Rockwell (1894–1978)
Oil on canvas

Rockwell repeated the simple and powerful style used in *Freedom of Worship* to lend impact to this painting. Knowing his strength lay in communicating ideas and feelings through facial expressions, Rockwell chose to portray faces rather than situations to commemorate the fifth anniversary of the Peace Corps. During his 1960 presidential campaign, John F. Kennedy proposed the idea of a volunteer organization of trained people who would be sent to developing nations in Africa and Asia to assist villagers in educational and agricultural projects. In 1961, the program, which Kennedy hoped would promote understanding between nations, was officially instated.

Rockwell's portrait of Kennedy is based on a Jacques Lowe photograph from his book, *The Kennedy Years*. Former Peace Corps workers posed for most of the figures. "In this sordid world of power struggles, politics and national rivalries the Peace Corps seems to stand almost alone," wrote Rockwell to art director Allen Hurlburt, when he sent the picture to *Look* magazine.

Painting for *Look* cover and story illustration, June 14, 1966
45.5 x 36.5 inches
Norman Rockwell Art Collection Trust, NRACT.1973.83

The Saturday People 1966
Norman Rockwell (1894–1978)
Oil on canvas

In May 1966, Rockwell began an illustration for *The Saturday People*, a short piece of fiction for *McCall's* magazine. The story, written by Rita Madocs, relates the observations and fantasies of thirteen-year-old Leslie, who lives with her widowed mother in midtown Manhattan. The stress of losing her father and ambivalence toward her mother's suitor inspire fantasies, as well as fears, which are given form in Rockwell's painting. Saturday visits by the mother's suitor are announced by the presence of his hat left on a hall table. The hat, which Leslie describes as "like some velvety underground animal, a dark-green Tyrolean mole, perhaps, a blushing feather behind one of its concealed ears," appears twice in Rockwell's painting. Eleven celebrities who occupy Leslie's imaginative fantasies are pictured with Leslie. The wide, 24 x 41–inch painting was published as a two-page spread in *McCall's,* large enough for readers to identify the many celebrities who move through Rockwell's picture from left to right. The not-so-famous, including Rockwell (understating his own celebrity) and his wife Molly, walk from right to left.

Moving from left to right:

Actor David McCallum

New York City Mayor John Lindsay

Soprano Maria Callas

Actor Sean Connery

Pianist Van Cliburn

Drummer Ringo Starr

Prince Philip of England

New York Governor Nelson Rockefeller

Comedian Jonathan Winters

Composer/Conductor Leonard Bernstein

Actor Tallulah Bankhead

Painting for *McCall's* story illustration, October 1966
24.5 x 41.5 inches
Norman Rockwell Art Collection Trust, NRACT.1973.88

New Kids in the Neighborhood 1967
Norman Rockwell (1894–1978)
Oil on canvas

At seventy-three, Rockwell had lost the energy to develop his work in the painstaking way of the previous half-century. Now he would often omit the intermediary step of preparing a detailed charcoal drawing before proceeding to paint in oil. In addition, his color perception was diminishing due to cataracts. Still, his work continued to reach an appreciative audience.

In his illustration of suburban integration in Chicago's Park Forest community, Rockwell was secure in expressing his philosophy of tolerance. It appears likely that the children will soon be playing with each other, but the face peering from behind a window curtain makes us wonder how the adults will fare.

Painting for "Negro in the Suburbs" by Jack Star, *Look*, May 16, 1967
36.5 x 57.5 inches
Norman Rockwell Art Collection Trust, NRACT.1973.81

Home for Christmas (Stockbridge Main Street at Christmas) 1967
Norman Rockwell (1894–1978)
Oil and acrylic on board

Norman Rockwell's painting *Home for Christmas* has come to symbolize Christmas in America, just as Rockwell intended in 1967. Rockwell wanted the editors at *McCall's* to identify the location as Stockbridge in the text—and they did.

> *Norman Rockwell takes you on a Christmas Eve walk along Stockbridge's main street—past the public library, the antiques and gift shops, the insurance office, the supermarket behind its Greek-revival facade; past the barbershop, the old town office, the new town bank and down the rambling Victorian hotel, beyond which is Rockwell's own studio.*

McCall's reached out to its national audience by adding, "Wherever you happen to hail from—city, suburb, farm or ranch—we hope you will have, for a moment, the feeling of coming home for Christmas."

In addition to photographs taken of the buildings on Main Street, Rockwell drew on a variety of references to create his snowy winter scene. For sky and mountains, Rockwell used photos of snow-draped mountains in the Berkshire Hills, Vermont, and Switzerland. Prints of Siberian winter scenes provided examples of snow-covered streets. For the warm interior glows, he studied magazine images of candlelit country homes. For clothing styles, especially women's coats, he relied on illustrations in a Sears & Roebuck catalogue. Rockwell's assistant, Louie Lamone, photographed each building individually, and since Rockwell painted them individually, the result is a scene that lacks perspective.

Established in 1773 as a stagecoach stop, the Red Lion Inn has always been the social hub of town. Rockwell's South Street home and studio appear at the far right border. In a window above the market, a Christmas tree glows in a room that was Rockwell's studio from 1953 to 1957. The Old Corner House, which became the home of the first Norman Rockwell Museum two years after the painting was completed, stands at the left border of the painting.

Detail of *Home for Christmas*

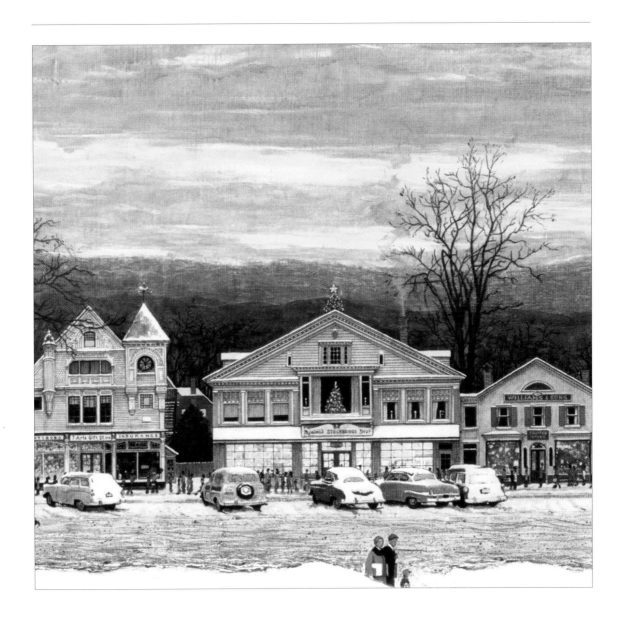

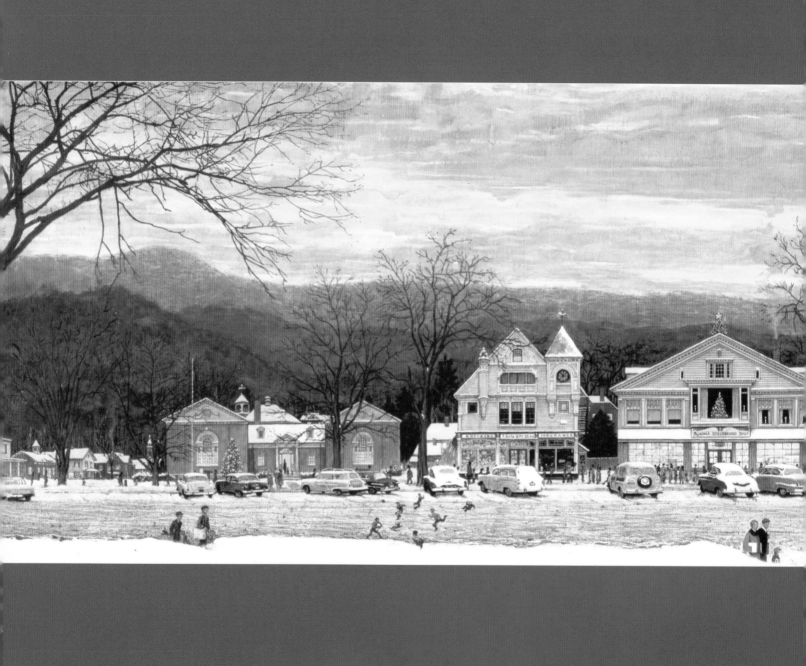

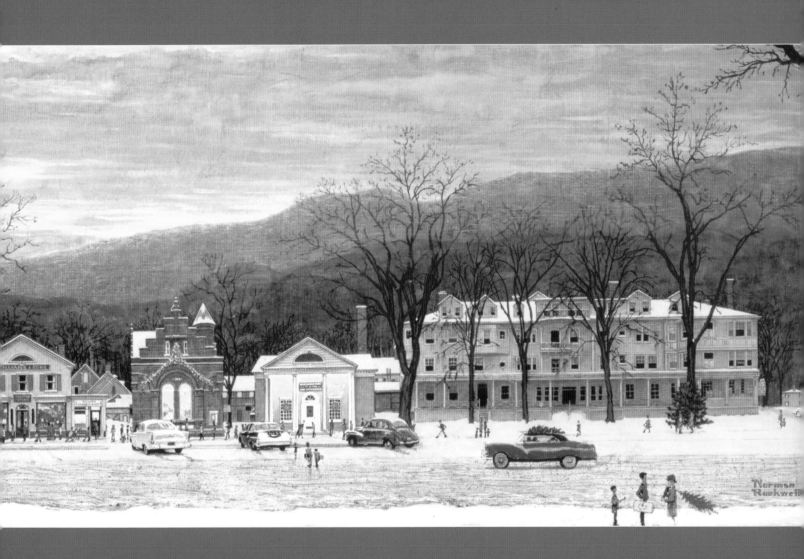

Painting for *McCall's* story illustration, December 1967
26.5 x 95.5 inches
Norman Rockwell Art Collection Trust, NRACT.1973.78

Uneasy Christmas in the Birthplace of Christ 1970

Norman Rockwell (1894–1978)

Oil on canvas

The Basilica of the Nativity, built from 527 to 565 AD, stands where it is claimed Jesus was born. On December 9, 1969, Rockwell decided to go to Bethlehem to paint a Christmas scene. Two weeks later, accompanied by his wife Molly and his photographer, Brad Herzog, he flew to Jerusalem. On Christmas Eve, from the roof of a Bethlehem hotel, he gathered impressions for his painting and directed photography. He was particularly moved by the "sumptuous" presentation of the high priests, cardinals, and bishops as they proceeded to the Basilica. "The high priests carry large crucifixes and banners," he said, "and wear white and scarlet robes, some of them with their red bishop's caps. . . . It is indeed a tremendous spectacle and, although I am not a religious man, I was greatly impressed."

Rockwell's early version of the rooftop onlookers included "devout native Israeli, Christian, Jewish and Mohammedan." The picture was a compromise between Rockwell and *Look*'s art director, who wanted him to omit the Arab and one soldier. But Rockwell kept both soldiers, "They never seem to go singly about the streets of Bethlehem," he said. Another compromise was made when, at the art director's request, he removed the tourist family's souvenirs and guidebook from the painting.

Look wanted Rockwell to do portraits of Prime Minister Golda Meir, Jerusalem Mayor Teddy Kollek, and General Moshe Dayan during his five-day stay in Jerusalem. Rockwell met with Meir at her home and with Kollek. Dayan, however, would not meet with him. Rockwell later did a portrait of Mayor Kollek based on photos taken during the visit, but *Look* decided against the project and never published the portrait.

ODDS & ENDS:

The entrance to the Basilica, seen in the lower left corner of the painting, is narrow and low. The most popular opinion is that the unusual design protected the church from invaders on horseback. Another is that Muslims used it during their rule to remind Christians they were guests and must bow to their hosts. A third is that it protected Christians from hostile neighbors.

Painting for *Look* story illustration
"Uneasy Christmas in the Birthplace of Christ," December 29, 1970
33 x 51 inches
Norman Rockwell Art Collection Trust, NRACT.1973.75

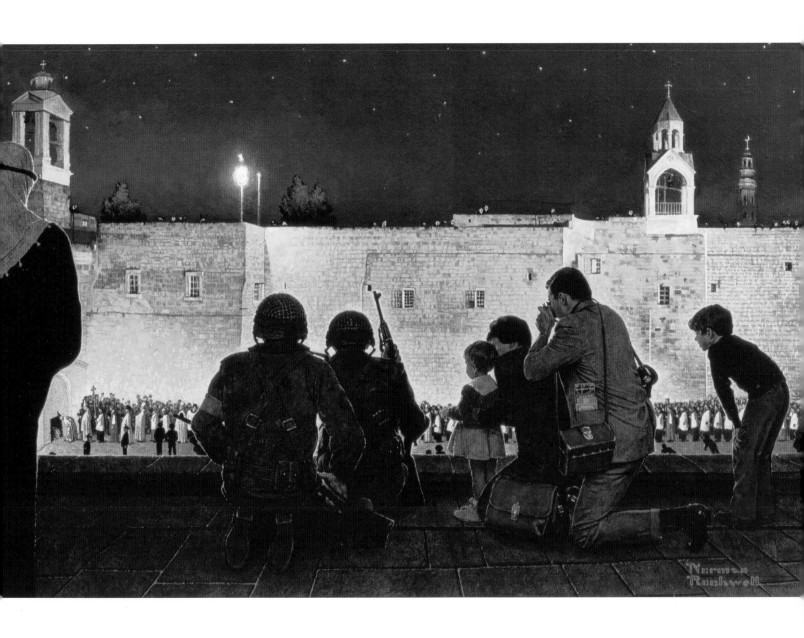

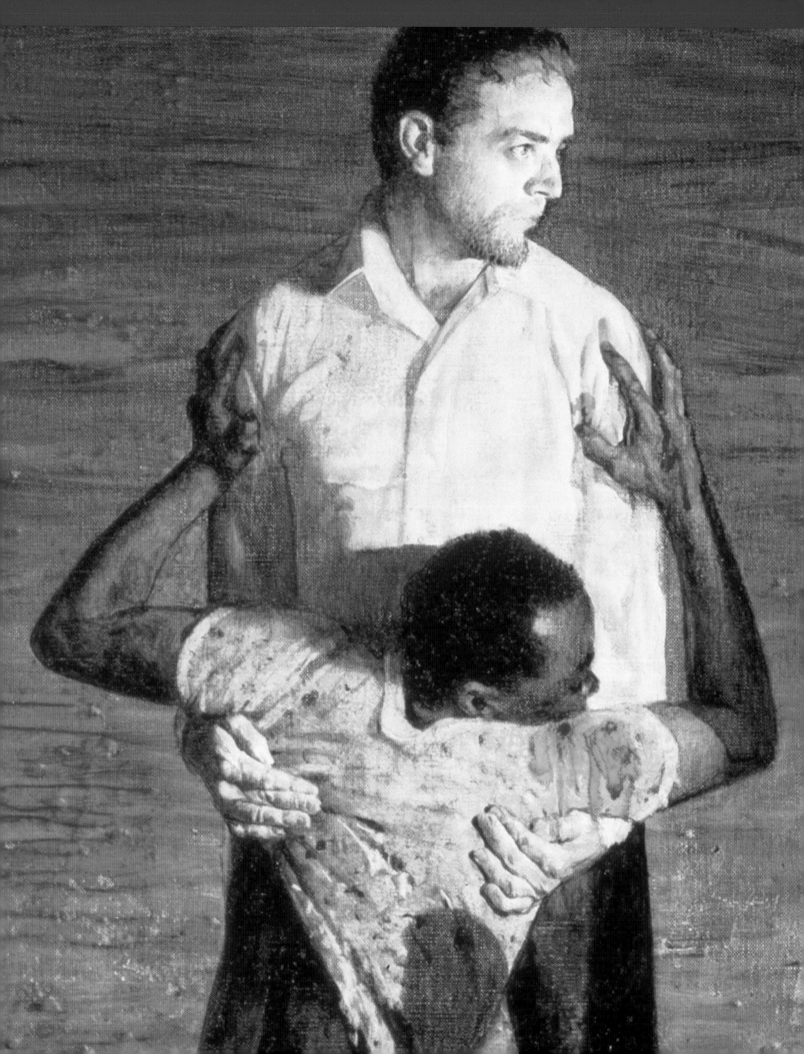

THE ARTIST'S PROCESS:
ANATOMY OF MURDER IN MISSISSIPPI

In 1964, after *The Problem We All Live With* ran in *Look* magazine, Norman Rockwell received many letters criticizing his choice of subject, but irate opinions did not stop him from pursuing his course. In the 1965 painting *Murder in Mississippi*, he illustrated the Philadelphia, Mississippi, slaying of civil rights workers Michael Schwerner, Andrew Goodman, and James Chaney.

The anatomy of this particular work illuminates Rockwell's process. Veering from his habit of working on five or six projects at a time, Rockwell ignored other commissions. The result was an intensive five-week session in which he produced charcoal preliminaries, an oil color study, and the large final painting.

In an interview later in his life, Rockwell recalled earlier having been directed by *The Saturday Evening Post* to remove a black person from a group picture because the magazine's policy dictated showing black people only in service industry jobs. Later, freed from such restraints, Rockwell seemed to look for opportunities to correct editorial prejudices inadvertently reflected in previous work. The *Problem We All Live With* and *Murder in Mississippi* ushered in that new era.

Detail of *Murder in Mississippi*

Murder in Mississippi study, March 5, 1965
Norman Rockwell (1894–1978)
Digital print from archival negative of oil on board

In the beginning of 1965, Rockwell began work on an illustration for *Look* about the June 21, 1964, murders of three young civil rights workers in Philadelphia, Mississippi. Michael Schwerner and his chief aide, James Chaney, were in Philadelphia to assist with training summer volunteers, one of whom was Andrew Goodman. Schwerner had been targeted by the Klan for his organization of a black boycott of white-owned businesses and for his attempts to register blacks in Meridian.

Hearing of a Klan attack against blacks and of arson at Mount Zion Church, the three men drove to the site. On their return to the Meridian office of Congress of Racial Equality (CORE), they were taken into custody by Deputy Sheriff Price, by some accounts for speeding and by others for supposedly setting the fire. After releasing them later that night, Price tailed them. Once outside of town, Klansmen intercepted them and hustled them into Price's car. They were driven to a remote location and shot point blank. Their bodies were then taken to the farm of one of the Klansmen, dumped into a dam site, and covered by tons of dirt pushed over them by tractor.

Rockwell conceived *Murder in Mississippi* as a horizontal composition to run across two pages. The young men would be pictured on the left page and Philadelphia Deputy Price and the posse of Klansmen wielding sticks (we later learned all were armed with rifles and shotguns) on the right. His next idea was to do two separate vertical pictures—the first showing the civil rights workers and the second showing the Mount Zion Church. Rockwell hired local architect Tom Arienti to draft a church steeple, but later decided against including the church.

Study for *Southern Justice*, by Charles Morgan, Jr., *Look*, June 29, 1965
15 x 24.5 inches
Norman Rockwell Museum Collection

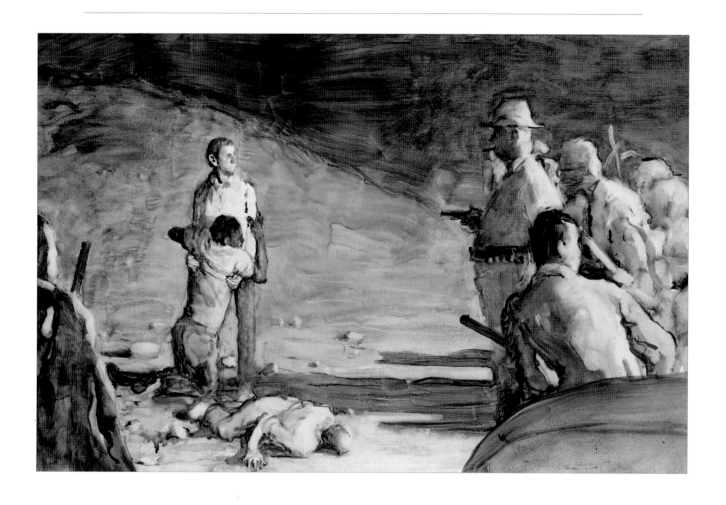

A 2nd Body Is Found in the Mississippi 1964

Tear sheet

On July 14, 1964, *The New York Times* ran a story titled "A 2nd Body Is Found in the Mississippi." A saved copy of the story, found among Rockwell's reference materials, establishes that he had the June 21, 1964, murders in mind long before beginning work on his painting in March 1965.

The New York Times, July 14, 1964
22 x 14.75 inches
Norman Rockwell Art Collection Trust, Studio Collection

16 C

A 2D BODY IS FOUND IN THE MISSISSIPPI

No Link Seen to 3 Missing Civil Rights Workers

By JOHN HERBERS

Special to The New York Times

JACKSON, Miss., July 13 — The Mississippi River yielded a second body today. The discovery indicated a previously undisclosed racial killing in southwest Mississippi, the center of terrorist activity in recent months.

Both bodies were tentatively identified as those of Negro males from Meadville, a small town in the Homochito National Forest 25 miles east of Natchez.

Authorities said their deaths apparently had no connection with the civil rights workers who have been missing since June 21 and are presumed dead.

A Tenative Identification

The body discovered today was believed to be that of Henry Dee, of whom little was known. It was found five miles downstream from the point where the partial remains of a youth believed to be Charles E. Moore, a 20-year-old college student, were found yesterday.

At the same time, Adams County atuhorties announced that two more Negro churches were burned by arsonists early Sunday morning near Natchez, and that night riders attempted to set fire to the home of a Negro contractor in Natchez.

The body believed to be Dee was discovered at midday on the Louisiana side of the river near Vicksburg by one of the local authorities participating in the search. It was Decapitate and badly deteriorated, but fully clothed.

The Federal Bureau of Investigation was to bring it to Jackson to make a positive identification.

The lower half of the first body, also badly deteriorated, was found by fishermen. Authorities at Alcorn A. and M. College said they were sure it was the body of Mr. Moore, a freshman who was expelled for participating in a campus demonstration.

Alcorn is a state-supported Negro institution in rural Claiborne County 25 miles north of Natchez and 50 miles northwest of Meadville. It is in this area that white terrorist groups have been active. Negroes say that members of their race have been killed and others flogged or run out of town in the past months.

'Left School' in April

Dr. J. D. Boyd, a Negro who is the president of Alcorn, said Mr. Moore "left school" in late April. Dr. Boyd said he had been told that the young man's mother, Mrs. Maisey Moore of Meadville, had said her son went to Louisiana to visit relatives and she had not heard from him since.

Mr. Moore's roommate, Robert Haynes, had a different story. He said in a telephone interview that Moore was "sent home by the president" after a campus riot on April 20.

Little was known about the disturbances on the campus April 20. Students, as they had done in the past, staged demonstrations in protest of what they called lack of social activities on the campus, which is 10 miles from the nearest small town.

The State Highway Patrol was sent to restore order and the next day the school dismissed a number of students who had participated.

The body was identified as Moore by a key in the pocket of the jeans. It bore the number of the key assigned to Moore by the college. A buckle with the initial "M" found on the body also was identical to one Moore owned.

When the body was first dis-covered it was believed it might be one of the three missing civil rights workers. The missing men are Michael Schwerner, 24 years old, of Brooklyn; Andrew Goodman, 20, of New York, both white, and James E. Chaney, 21, of Meridian, Miss., a Negro.

They were last seen near Philadelphia, Miss., where they had been arrested and held for several hours. The area where the two bodies were found in more than 100 miles southwest of Philadelphia.

In Natchez, Sheriff Odell Anders of Adams County said two rural Negro churches in the Kingston community, 18 miles south of Natchez, were burned about 3 A.M. Sunday. They were the Jerusalem Baptist and the Bethel Methodist churches.

The State Fire Marshals office found conclusive evidence of arson, Sheriff Anders said. White residents of the area, he added, had begun a drive to raise money to rebuild the churches.

Willie Washington, a 57-year-old Negro contractor, told the Natchez police a white man stopped a car in front of his home early today and tossed a fire bomb into the building, but it failed to ignite.

Kingsborough College Fills 2 Post

Dr. Edward K. Graham

Jack P. Hudnall

Arthur Avedon

Kingsborough Community College has named Dr. Edward K. Graham dean of the faculty and Jack P. Hudnall director of administration.

Dr. Jacob I. Hartstein, president of the new two-year college in Brooklyn, said yesterday that both men had assumed their posts.

Dr. Graham, a graduate of the University of North Carolina, has for the last year been president and consultant of the College Center of the Finger Lakes, Corning, N.Y. Before that he held numerous university administration posts, including vice chancellor for academic affairs of the University of Denver, dean of the College of Liberal Arts and the Graduate School of Boston University, secretary of Cornell University and chancellor of the University of North Carolina at Greensboro. He holds a doctorate in history from Cornell.

Mr. Hudnall, who was dean of Hibbing Junior College in Minnesota from 1959 to 1963, has been a research assistant in the junior college leadership training program at Teachers College, Columbia University, while completing study for a doctorate.

TWO NEW ROCKETS TO GET FLIGHT TEST

WASHINGTON, July 13 (AP) —Two rockets—forerunners of electrified - gas power plants that some day map propel astronauts through space at 100,-000 miles an hour—will get their first flight test, perhaps Saturday.

The National Aeronautics and Space Administration said today that the ion electric engines will be launched from Wallops Island, Va., no earlier than Saturday on a looping ballistic flight to an altitude of 2,500 miles.

During the 50-minute flight, two different types of the engines—which spit out electrified gas as they propel — will be fired. The first engine will fire for 20 minutes.

They will be aboard a 375-pound Sert I spacecraft, and will be launched by a four-stage solid-fuel Scout rocket. Sert stands for space electric rocket test.

PUT

Aid from the Padre June 2, 1962
Photo by Hector Rondon 1933–1984
Tear sheet of photograph

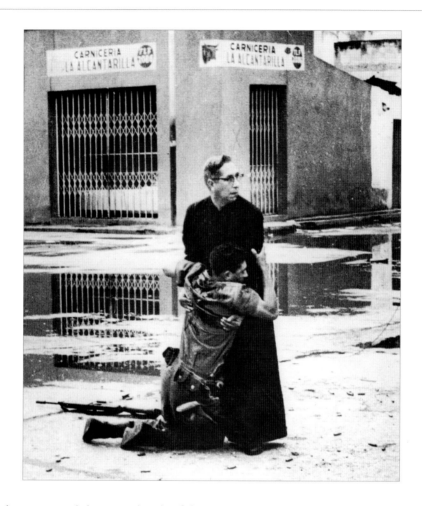

As no one had yet reported the exact details of the murder when Rockwell began his painting, he borrowed from Hector Rondon's 1963 Pulitzer Prize–winning news photo "Aid from the Padre" for the pose of Michael Schwerner holding James Chaney. Rockwell later wrote a note to himself to remember to tell *Look* art director Allen Hurlburt he had used Rondon's photo.

ODDS & ENDS

First published in 1962 in the newspaper *La Republica*, this photo of Father Manuel Padilla holding a wounded soldier was taken by photo-journalist Rondon during a revolt against the Venezuelan government at Puerto Cabello Naval Base, Caracas.

13.875 x 9.625 inches
Norman Rockwell Museum Collection

Expressionist Painting c.1964
Artist Unknown
Tear sheet

Rockwell found inspiration for the shadowy background from this reproduction of an expressionist painting, discovered among his reference materials.

Publication unknown
12.5 x 9.25 inches
Norman Rockwell Art Collection Trust, Studio Collection

Murder in Mississippi preliminary sketch, 1965
Norman Rockwell (1894–1978)
Oil on board

Deputy Price and his stick-wielding posse were removed and represented only by menacing shadows in this quick color sketch, the left half of the original painting. Rockwell received the go-ahead to proceed with his final painting based on this sketch, but *Look* art director Allen Hurlburt, after receiving the final, chose to publish the sketch.

Preliminary sketch published as the final illustration for
Southern Justice, by Charles Morgan, Jr., *Look,* June 29, 1965
15 x 12.75 inches
Norman Rockwell Art Collection Trust, NRACT.1973.79

Victims 1965

Norman Rockwell (1894–1978)

Handwritten pencil notes on paper

Before he began work on his painting, Rockwell compiled notes on the physical traits and clothing of the three young men, the circumstances of their abduction, and the brutal details of their murders. Additional details about the day and the place the three men were murdered were recorded.

9.25 x 6.12525 inches

Norman Rockwell Art Collection Trust, Studio Collection

9.25 x 6.12525 inches
Norman Rockwell Art Collection Trust, Studio Collection

Victims 1965, Event 1965
Norman Rockwell (1894–1978)
Typewritten notes on Norman Rockwell stationery

Abbreviated versions of Rockwell's handwritten notes were typed. The parenthetical remark, "I have not tried to make absolute likenesses," and the use of stationery indicates they were probably intended for *Look* art director Allen Hurlburt.

```
                STOCKBRIDGE
                MASSACHUSETTS

                  VICTIMS

    (I have not tried to make absolute likenesses)
MICHAEL SCHWERNER

    24 YEAR OLD FROM BROOKLYN
    JEWISH
    RATHER HEAVY SET
    BEATNIK BEARD
    WHITE SNEAKERS
    BLUE JEANS
    KILLED WITH SINGLE BULLET IN THE HEART
    WHEN BODY WAS FOUND HIS CLOTHES WERE NOT MESSED UP

JAMES CHANEY
    21 YEARS OLD
    NEGRO OF MERIDIAN, MISS.
    TALL AND SLENDER
    DARK SKIN
    WORE T SHIRT
    BLUE JEANS
    WHITE SNEAKERS
    RIGHT SHOULDER AND HAND CRUSHED BY BEATING
    HE WAS SHOT THREE TIMES
    CLOTHES MESSED.

ANDREW GOODMAN
    20 YEARS OLD, FROM NEW YORK
    WHITE
    ATHEIST
    DARK-HAIRED AND SLENDER
    T SHIRT
    BLUE JEANS
    WHITE SNEAKERS
    SHOT ONCE IN HEART
    CLOTHES NOT MESSED UP

    (They had, all three, had haircuts the day before)
```

```
                STOCKBRIDGE
                MASSACHUSETTS

                  EVENT

    JUNE 21, 1964
    SOMEWHERE NORTH OF PHILADELPHIA, MISS.
    SOMETIME AROUND MIDNIGHT
    NO MOON
    SWAMPS, RED CLAY AND FLAT COUNTRY

    TEMPERATURE DURING THE DAY OF JUNE 21
       HAD BEEN OVER 100 DEGREES.
```

10.25 x 7.25 inches
Norman Rockwell Art Collection Trust, Studio Collection

Charges These nine men—and Deputy Price—were named as members of the lynch mob, Date unknown

Photographer unknown

Digital print from archival negative

Found among his references, this news clip reveals that Rockwell originally considered showing the Klansmen as individuals. Just as he had compiled notes about the victims, these photos provided him with information about the Klansmen's physical traits.

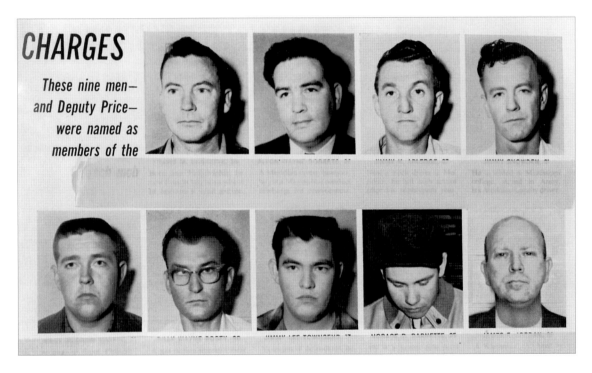

Publication unknown

8 x 10 inches

Norman Rockwell Museum Collection

Jarvis Rockwell poses as Michael Schwerner
Oliver McCary poses as James Chaney, March 20, 1965
Reference photo by Louie Lamone (1918–2007)
Gelatin silver print

Rockwell's son Jarvis served as one of his models. Rockwell's studio, ordinarily bathed in north light, was darkened with shades. Spotlights were brought in to create a nighttime effect.

13.75 x 7.5 inches
Norman Rockwell Art Collection Trust, Studio Collection

Kittridge (Kit) Hudson poses as Andrew Goodman, March 20, 1965
Reference photo by Louie Lamone (1918–2007)
Gelatin silver print

4.5 x 11 inches
Norman Rockwell Art Collection Trust
Studio Collection

Jarvis Rockwell poses as Michael Schwerner
Oliver McCary poses as James Chaney, March 22, 1965
Reference photo by Louie Lamone (1918–2007)
Gelatin silver print

Additional photos were taken of Jarvis Rockwell and Oliver McCary with McCary appearing more wounded.

12.75 x 8.25 inches
Norman Rockwell Art Collection Trust, Studio Collection

Norman Rockwell poses his hand for Murder in Mississippi, March 1965
Reference photo by Louie Lamone (1918–2007)
Polaroid photo

Blood—human blood, at Rockwell's insistence—
was procured from a concealed source and
applied to a shirt that represented the shirt
Michael Schwerner was wearing when he was
killed. Rockwell himself wore the shirt for the
posing, probably not wanting to ask anyone else
to wear it.

4.5 x 3.5 inches
Norman Rockwell Art Collection Trust, Studio Collection

Moments After Saigon Bomb, a Torn Flag Flies 1965
Double-page tear sheet

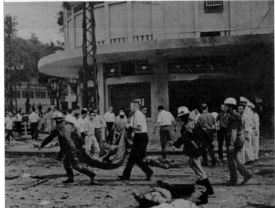

Rockwell removed this page from *Life* magazine to study the appearance of a blood-soaked shirt. By 1965, America was well into the Vietnam War and images such as this one of the bombing of Saigon on March 30, 1965, were starting to flood the media.

Life, April 9, 1965
13.25 x 21 inches
Norman Rockwell Art Collection Trust, Studio Collection

Murder in Mississippi preliminary drawing, March 24–26, 1965
Norman Rockwell (1894–1978)
Photo by Louie Lamone (1918–2007)
Digital print from archival negative

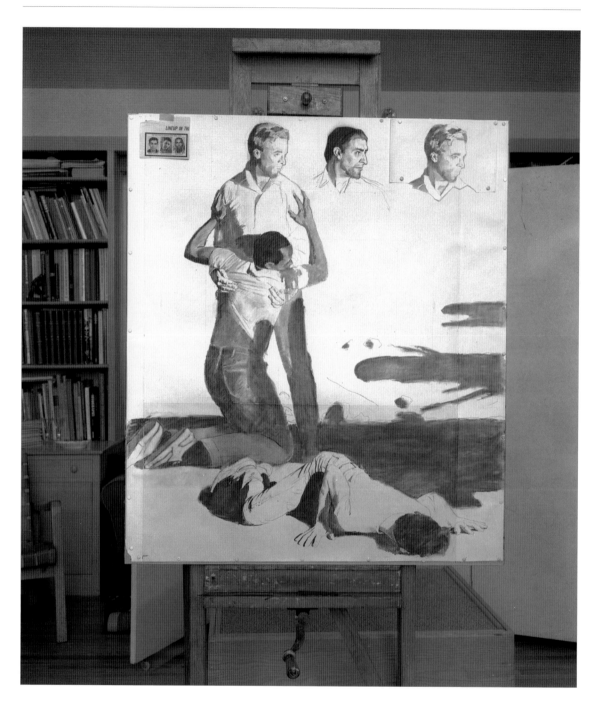

53 x 42 inches
Norman Rockwell Museum Collection

Murder in Mississippi preliminary drawing, March 28–April 5, 1965
Norman Rockwell (1894–1978)
Photo by Louie Lamone (1918–2007)
Digital print from archival negative

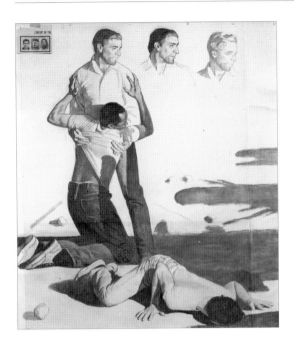

Rockwell prepared this drawing of Schwerner, Chaney, and Goodman for the final version of the painting. He inclined the figure of James Chaney to make him appear more wounded. In the early stage of the drawing, Schwerner strongly resembles Jarvis Rockwell, who posed for the picture. Rockwell gradually made the drawing look more like Schwerner.

53 x 42 inches
Norman Rockwell Museum Collection

Murder in Mississippi section of pencil tracing, 1965
Norman Rockwell (1894–1978)
Pencil on paper

Rockwell said he invoked the style of Michelangelo to impart a more heroic stature to the figures. In this step, paper is placed over the final drawing. Transfer paper is placed between the drawing and the canvas. A basic outline of the image is traced with pencil, transferring the outline onto canvas.

Unpublished
15.5 x 15 inches
Norman Rockwell Art Collection Trust, Studio Collection,
NRACT.1976.365

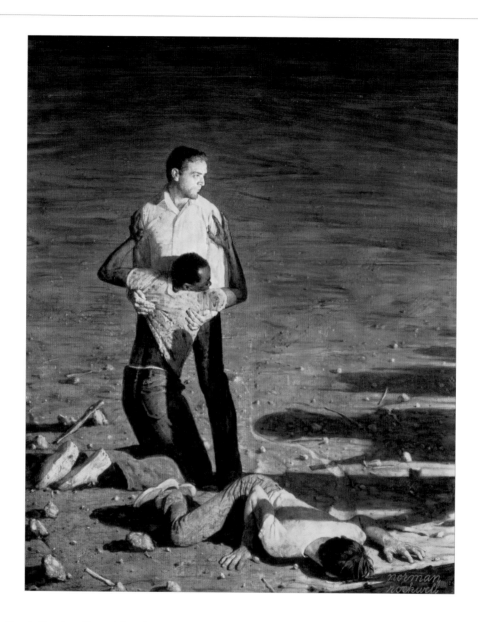

On April 14, Rockwell sent his final painting to *Look*. On the 29th, Rockwell received word that *Look* had decided to use his color study rather than the final painting. Three years later, Rockwell reflected that by the time he had fin- ished the final painting, "all the anger that was in the sketch had gone out of it."

Painting intended as the final illustration for *Southern Justice* by Charles Morgan, Jr., *Look*, June 29, 1965, unpublished
53 x 42 inches
Norman Rockwell Museum Collection, NRM.1978.7

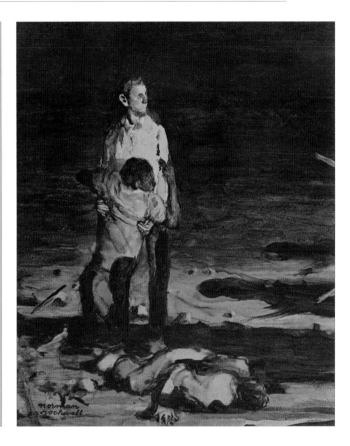

On June 25, Rockwell received his copy of the June 29 issue of *Look*.

Look, June 29, 1965
13.25 x 21 inches
Norman Rockwell Museum Collection

Michael Schwerner James Chaney Andrew Goodman

Those Who Were Killed in U.S. During Civil Rights Movement

MONTGOMERY, Ala., Nov. 3 (AP) — *A civil rights memorial to be dedicated Sunday includes the names of the 40 people killed in the movement. The list, in chronological sequence, gives the date and circumstances of the person's death as described on the memorial.*

LEE, the Rev. George, killed May 7, 1955, for leading a voter registration drive in Belzoni, Miss.

SMITH, Lamar, 63 years old, slain Aug. 13, 1955, for organizing black voters in Brookhaven, Miss.

TILL, Emmett Louis, 14, slain Aug. 28, 1955, for speaking to a white woman in Money, Miss.

REESE, John Earl, 16, slain Oct. 22, 1955, by nightriders opposed to black school improvements in Mayflower, Tex.

EDWARDS, Willie Jr., killed Jan. 23, 1957, by the Ku Klux Klan in Montgomery, Ala.

PARKER, Mack Charles, 23, taken from a jail and lynched April 25, 1959, in Poplarville, Miss.

LEE, Herbert, 50, voter registration worker, killed Sept. 25, 1961, by a white legislator in Liberty, Miss.

DUCKSWORTH, Roman Jr., taken from bus and killed April 9, 1962, by the police in Taylorsville, Miss.

GUIHARD, Paul, a European reporter, killed Sept. 30, 1962, in a riot at University of Mississippi in Oxford, Miss.

MOORE, William Lewis, slain April 23, 1963, in a one-man march against segregation in Attalla, Ala.

EVERS, Medgar, 28, civil rights leader, assassinated June 12, 1963, in Jackson, Miss.

COLLINS, Addie Mae, 14, killed Sept. 15, 1963, in the bombing of the 16th Street Baptist Church in Birmingham, Ala.

MCNAIR, Denise, 11, killed Sept. 15, 1963, in the Birmingham church bombing.

ROBERTSON, Carole, 14, killed Sept. 15, 1963, in the church bombing.

WESLEY, Cynthia, 14, killed Sept. 15, 1963, in the church bombing.

WARE, Virgil Lamar, 13, killed Sept. 15, 1963, in a wave of racist violence in Birmingham, Ala.

ALLEN, Louis, witness to the killing of a civil rights worker, assassinated Jan. 31, 1964, in Liberty, Miss.

KLUNDER, the Rev. Bruce, killed April 7, 1964, protesting the construction of a segregated school in Cleveland.

DEE, Henry Hezekiah, 19, killed May 2, 1964, by the Klan in Meadville, Miss.

MOORE, Charles Eddie, 20, killed May 2, 1964, by the Klan in Meadville, Miss.

CHANEY, James, 21, civil rights worker, abducted and slain June 21, 1964, by the Klan in Philadelphia, Miss.

GOODMAN, Andrew, civil rights worker, abducted and slain June 21, 1964, by the Klan in Philadelphia, Miss.

SCHWERNER, Michael, 24, rights worker, abducted and slain June 21, 1964, by the Klan in Philadelphia, Miss.

PENN, Lemuel, 48, killed July 11, 1964, by the Klan while driving through Colbert, Ga.

JACKSON, Jimmie Lee, civil rights marcher, killed Feb. 26, 1965, by a state trooper in Marion, Ala.

REEB, the Rev. James, march volunteer, beaten to death on March 11, 1965 in Selma, Ala.

LIUZZO, Viola Gregg, 39, killed March 25, 1965, by the Ku Klux Klan while transporting marchers on a highway near Selma, Ala.

MOORE, Oneal, 34, black deputy, killed June 2, 1965, by nightriders in Varnado, La.

BREWSTER, Willie Wallace, 38, killed July 18, 1965, by nightriders in Anniston, Ala.

DANIELS, Jonathan, 26, seminary student, killed Aug. 20, 1965, by a part-time deputy in Hayneville, Ala.

YOUNGE, Samuel Jr., student civil rights worker, killed Jan. 3, 1966, in a dispute over a whites-only restroom in Tuskegee, Ala.

DAHMER, Vernon, black community leader, killed Jan. 10, 1966, in a Klan bombing in Hattiesburg, Miss.

WHITE, Ben Chester, 67, killed June 10, 1966, by the Klan in Natchez, Miss.

TRIGGS, Clarence, slain July 30, 1966, by nightriders in Bogalusa, La.

JACKSON, Wharlest, 37, civil rights leader, killed Feb. 27, 1967, after promotion to "white" job in Natchez, Miss.

BROWN, Benjamin, 22, civil rights worker, killed May 12, 1967, when the police fired on protesters in Jackson, Miss.

HAMMOND, Samuel Jr., 18, killed Feb. 8, 1968, when highway patrolmen fired on protesters in Orangeburg, S.C.

MIDDLETON, Delano, 17, killed Feb. 8, 1968, in the Orangeburg shootings.

SMITH, Henry, student killed Feb. 8, 1968, in the Orangeburg shootings.

KING, the Rev. Dr. Martin Luther Jr., 39, assassinated April 4, 1968 in Memphis.

The New York Times National, November 4, 1989
18.5 x 9 inches
Norman Rockwell Museum Collection

Norman Rockwell with Murder in Mississippi 1965
Photo by Louie Lamone (1918–2007)
Digital print from archival negative

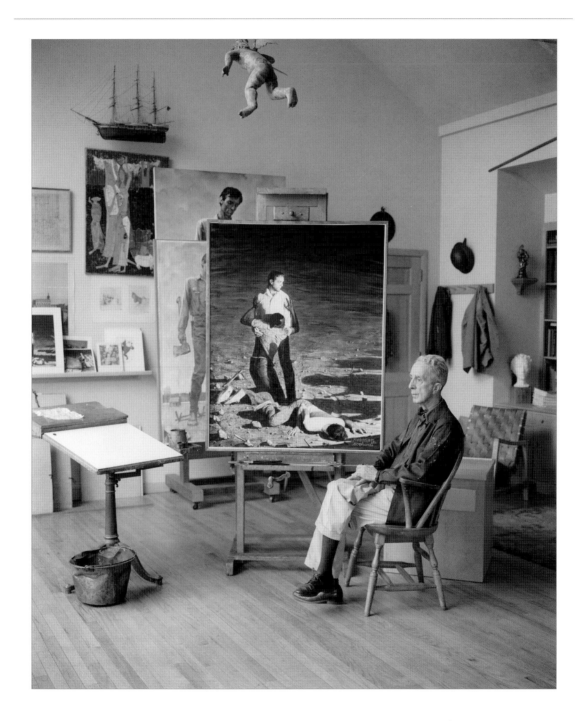

37 x 30 inches
Norman Rockwell Museum Collection

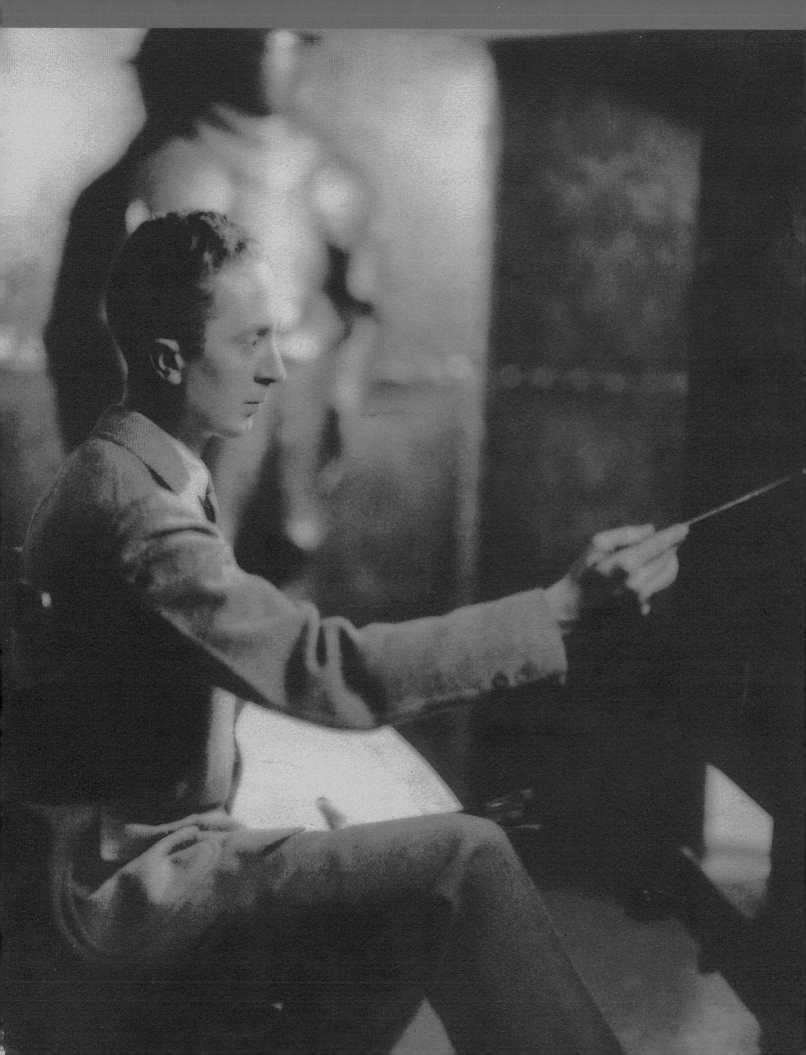

The Artist's Studios

Introduction

During his career, Rockwell occupied approximately seventeen studios and borrowed at least six while away from home. All were arranged in a similar manner. Unlike the stereotypical disheveled artist's studio, Rockwell's were always neat and organized. His creativity and prolific production seemed to depend on a physical environment of tidy organization.

Large north windows supplied steady light. Window seats, with built-in storage space, kept materials out of sight and offered a seating area. A desk provided a space on which to write checks for models after posing sessions. Built-in cabinets with drawers contained charcoal, Wolff pencils, sable and hog bristle brushes, and tools for measuring, cutting, pulling, and hammering. Cupboards were stocked with solvents, varnish and fixatives. Shelves held art books, museum publications, illustrators' annuals, and such reference books as *Anatomy of Animals* and *A Dictionary of Modern Type Faces and Lettering*. Rulers, triangles and T-squares hung with draftsman-like precision. There were always at least two easels and a drawing table. The one in use was positioned "center stage" with north light falling on the work in progress.

Certain decorative objects followed Rockwell to each studio, a Russian samovar perhaps the most striking. These were often mementos of travel, evidence of Rockwell's interest in exploring the world and experiencing foreign cultures. Plaster casts of the human form and a Roman bust, long unnecessary learning aids, served as reminders of student days. Whaling ships captured Rockwell's imagination early, and were prominently displayed. Beautiful in design, they also paid tribute to fellow illustrators who recorded sea-faring adventures. More privately, they represented

Photographic portrait of Norman Rockwell, c.1920. Photo by McManus Studios, New York City.

Rockwell's fascination with travel. Antique firearms, also on display, were featured in some of Rockwell's paintings, and when his collection was destroyed in a 1943 fire, Rockwell began a new one. He seemed to turn a corner in his subject matter, however, painting far fewer historical subjects that required such props.

Of all the objects in Rockwell's studio the most famous is the shiny brass helmet atop his easel. The story goes (The Reference Center doesn't have it in his own words) that Rockwell purchased the helmet in a Paris antique shop from a dealer who said it had been worn by a French soldier during the Napoleonic Wars. Later, during a fire near his hotel, Rockwell discovered, while looking out the window, that the helmets worn by the Paris firemen were identical to his "antique."

In addition to holding curiosities acquired on travels, Rockwell's studios served as continuous gallery spaces for prints of his favorite artists' work. Bruegel and Rembrandt commanded the most important focal points. In his Vermont studio a Rembrandt self-portrait hung directly in front of him, as if he might gain inspiration whenever his eye left his own canvas. When Rockwell occupied a studio temporarily, such as when he shared space with artist Joe Mugnaini at the Otis Art Institute in Los Angeles in 1948, Rembrandt's *Bathsheba* occupied wall space in his view.

Over time there were a few basic changes in Rockwell's environment. In the beginning of his sixty-year-career, he painted with a hand-held wooden palette. In the mid-1920s it was replaced by a palette table with a milk-glass surface. This was a standard piece of artists' equipment, preferred for its accurate representation of how colors would translate to the white ground of canvas and how easily it could be cleaned—a razor quickly removed hardened paint. Rockwell used an office-style swivel chair until his studio fire in 1943, after which he switched to a stationary Windsor chair that he continued to use until the end of his career.

Norman Rockwell in the South Street, Stockbridge, studio, c. 1957. Photo by Bill Scovill.

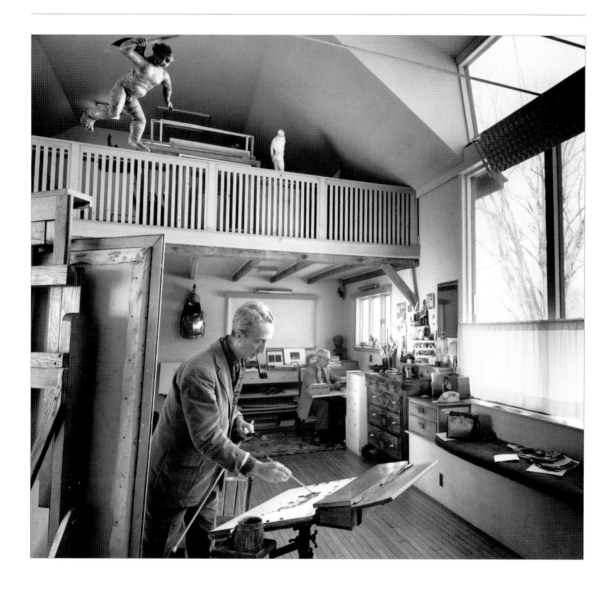

Norman Rockwell and Pitter looking betwen rulers in the South Street, Stockbridge, studio, c. 1964. Photo by Louie Lamone.

THE ARTIST'S STUDIOS

Norman Rockwell at his drawing table in the South Street, Stockbridge, studio, 1962. Photo by Louie Lamone.

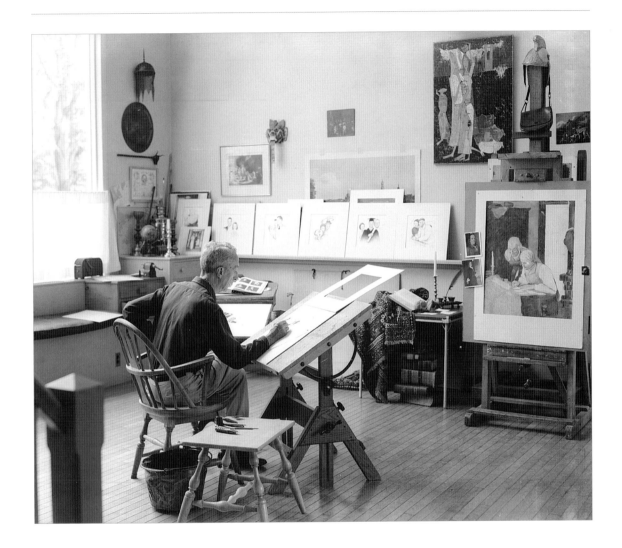

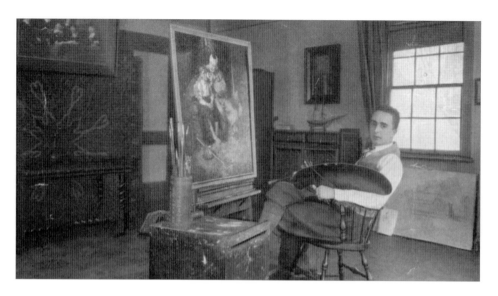

During a difficult period in his first marriage, Rockwell rented a room at the Salmagundi Club and worked at the Beaux Arts Studios, also known as the Bryant Studios because they overlooked Bryant Park, at 80 West 40th Street in New York City. Note the samovar and the ship model, objects Rockwell had in each of his studios from then on. His brother Jarvis crafted the miniature from detailed plans that converted the ship's original dimensions for model builders.

In 1927, Rockwell and his first wife, Irene, bought a home in New Rochelle,

New York, and Rockwell commissioned his friend, architect Dean Parmelee, to design a studio next door. For inspiration, Rockwell and Parmelee traveled to the Wayside Inn in South Sudbury, Massachusetts. The studio was

Norman Rockwell in the Prospect Street, New Rochelle, studio, 1922. Photographer unidentified.
Norman Rockwell's West 40th Street, New York, studio, 1925. Photographer unidentified.

EARLY STUDIOS

Norman Rockwell and model in the Lord Kitchener Road, New Rochelle, studio, c. 1939. Photo by Richard Wyrley Birch.

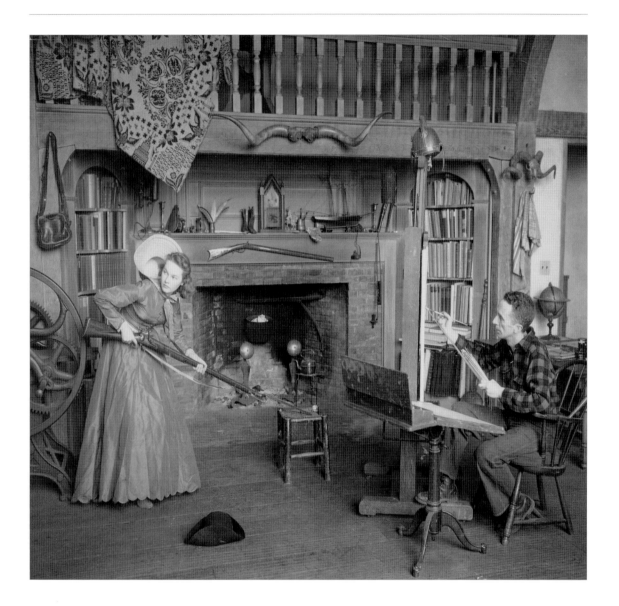

Norman and Mary Rockwell sitting on the step of the Lord Kitchener Road,
New Rochelle, studio, c. 1931. Photographer unidentified.

furnished at great expense, with authentic and reproduction American antiques, which, according to Rockwell, was the current craze in decorating.

When Irene and Norman divorced three years later, he rented their Lord Kitchener Road house to the family of his model Muriel Bliss. At the urging of Clyde Forsythe, Rockwell traveled to southern California where he met and married Mary Barstow. The couple returned to New York and lived for three months at the Hotel des Artistes, until the Lord Kitchener Road home was again available.

In 1932, Rockwell, Mary, and son Jarvis traveled to Paris, where Rockwell worked in rented studios for eight months. His first, on the Avenue de Saxe, had direct north light, gray walls and a coal stove. A sofa covered in deep, wine-colored velvet was the *pièce de résistance*, according to Mary. A few months later the Rockwells moved to an apartment with a larger studio.

Norman Rockwell's Lord Kitchener Road, New Rochelle, studio. Photographer unidentified.

In 1938, the Rockwells purchased a summer home—an eighty-year-old farmhouse with two cow barns in Arlington, Vermont. After one summer, they decided to make it their year-round home and arranged for necessary renovations. The smaller barn was converted into a studio, reminiscent of the Dean Parmelee–designed New Rochelle studio.

Norman Rockwell's Arlington studio and all of its contents were destroyed by fire the night of May 14, 1943. Rather than rebuild, Rockwell decided to buy a home in West Arlington, Vermont, a more settled area with neighbors nearby, and build a new studio next to the house. Plans were drawn by architect Payson Rex Webber and, like the Arlington studio, followed the basic layout of his New Rochelle studio.

In 1948, Rockwell took an extended leave with his family to live in Los Angeles,

Thomas and Peter Rockwell playing near their father's Arlington, Vermont, studio, c. 1940. Photo by Gene Pelham.

Norman Rockwell illustrating a pose for *Bartender's Birthday* in the Arlington, Vermont, studio, 1940.
Photo by Gene Pelham.

California, where he taught at the Otis Art Institute. He shared studio space with artist Joe Mugnaini who also taught at the school. Back in Vermont in 1950, Rockwell worked on his *Post* cover, *The Toss*. In the background is the etching press he bought in England in the 1920s; above it is his drawing documenting the disastrous studio fire.

Peter Rockwell, John Atherton, Mary Rockwell and Norman Rockwell outside the West Arlington, Vermont, studio, c. 1949. Photographer unidentified.
Norman Rockwell with *The Toss* in his West Arlington, Vermont, studio, 1950.
Photo by Victor Keppler, New York City.

THE VERMONT STUDIOS

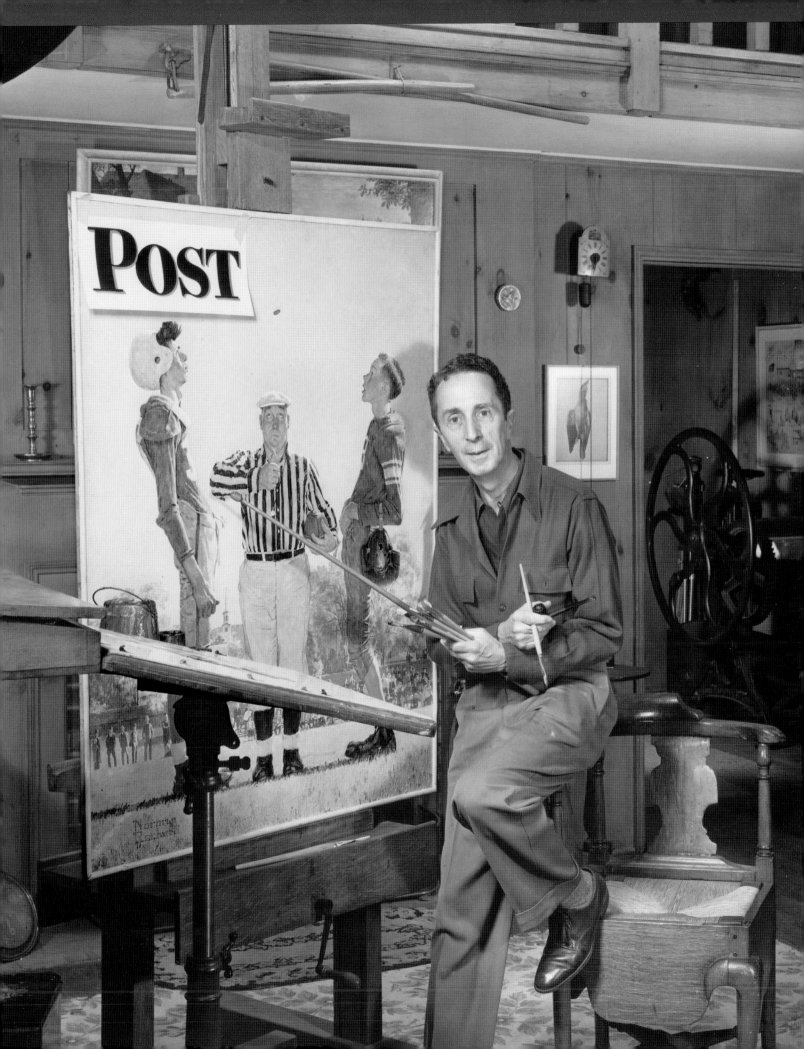

Norman Rockwell in his temporary studio at the Otis Art Institute in Los Angeles, California, 1949. Photographer unidentified.

THE VERMONT STUDIOS

Norman and Mary Rockwell posing for *The Street Was Never the Same* in his West Arlington, Vermont, studio, 1952. Photo by Gene Pelham.

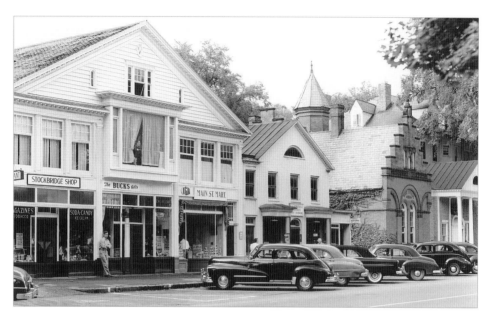

In the fall of 1953, the Rockwells moved to Stockbridge, Massachusetts, where they purchased a home adjacent to the cemetery on west Main Street. For his studio, Rockwell rented a room above a Main Street market. He soon rented the room next to his and, with permission, enlarged its north window and removed the dividing wall to have one large space.

To announce his move to their readers, *The Saturday Evening Post* published pictures of Rockwell looking out from the window of his new studio. During the next three years, twelve *Post* covers were produced in the Main Street studio. The painting that demanded the most time and energy of Rockwell during this period was about a young art student in a gallery. *Art Critic* ("In the Museum" was Rockwell's reference title) was one of a handful of paintings that went through elaborate changes before Rockwell was satisfied enough to submit it for publication.

Although the Main Street studio was small compared to his earlier studios,

View of Norman Rockwell's Main Street, Stockbridge, Massachusetts, studio window from the north side of Main Street, 1954. Photo by Bill Scovill.
Norman Rockwell with preliminary studies for *Art Critic* in his Main Street, Stockbridge, Massachusetts, studio, 1955. Photo by Bill Scovill.

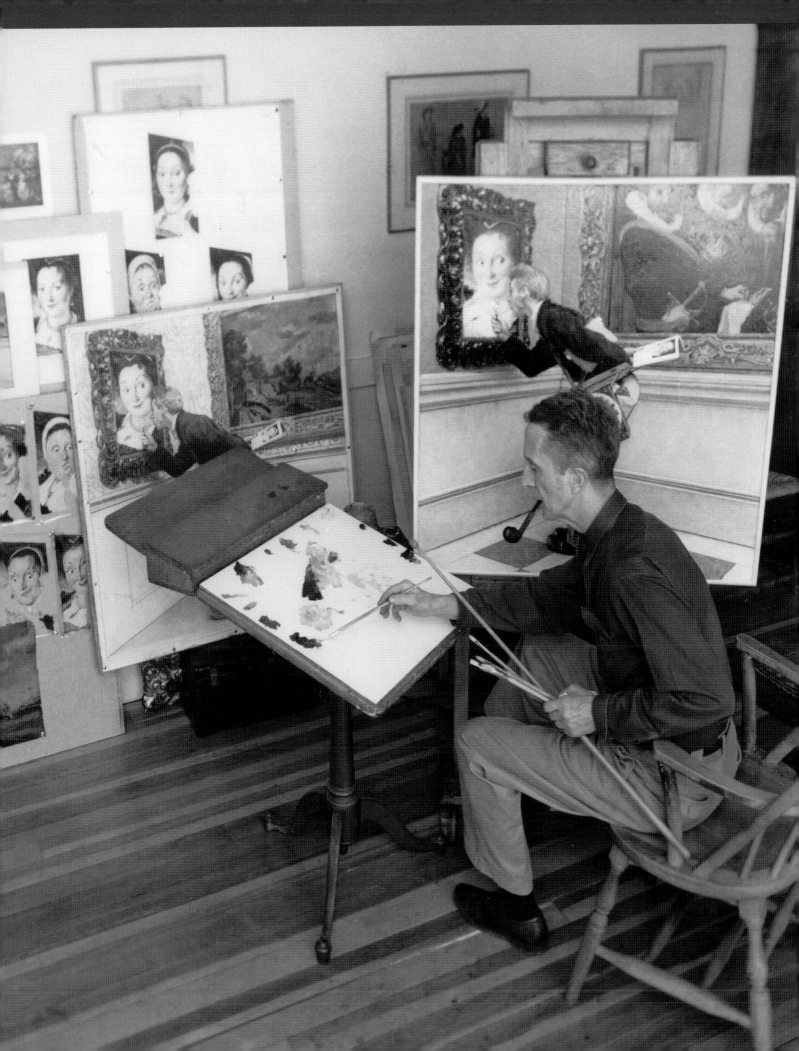

Norman Rockwell "sweeping" *Lunch Break with a Knight* in his South Street,
Stockbridge, Massachusetts, studio, 1962. Photo by Bill Scovill.

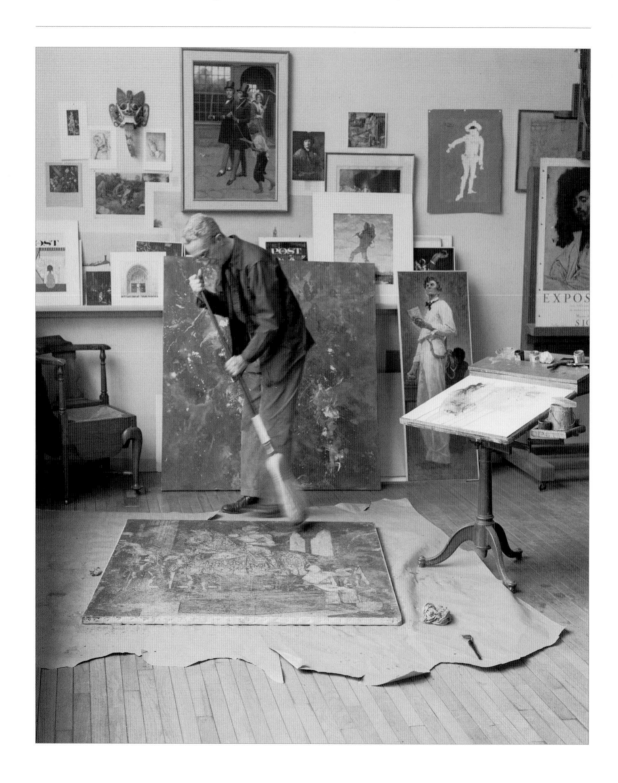

Rockwell could still create sets in which to pose his models. In addition to recreating the interior of an optician's office in 1956, Rockwell installed a lunch counter and stools to pose his 1957 *Post* cover, *After the Prom*.

Rockwell remained on Main Street for four years until August 1957, when he purchased an eighteenth-century house around the corner on South Street. With the help of local cabinetmaker Ejner Handberg, he converted an old carriage barn on the property into a studio. Once again, he based the layout on his Lord Kitchener Road studio, but since Handberg's specialty was Shaker reproduction furniture, the interior referenced the economy and practicality of Shaker design rather than the rustic warmth of his former early-American motif. In addition to the main

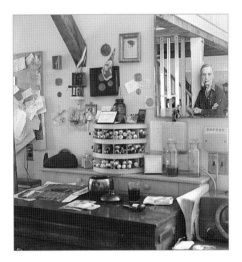

room, there was a bathroom where models could change, and a darkroom where Rockwell's photographer could develop negatives and enlarge prints. In 1961, the second tier of north windows was replaced with larger ones, and in 1962, a storage room was added beyond the darkroom. Rockwell was blissfully happy with the results and said it was his "best studio yet."

Norman Rockwell posing Ken Ingram and Clarence H. Berger in his Main Street, Stockbridge, Massachusetts, studio for *The Optician*, 1956. Photo by Bill Scovill.
Norman Rockwell studying the progress of his painting by looking at its reflection in the north wall mirror in his South Street, Stockbridge, Massachusetts, studio, c. 1962. Photo by Louie Lamone.

Norman Rockwell on the lawn outside the South Street,
Stockbridge, Massachusetts, studio, 1960 (note smaller north windows). Photo by Bill Scovill.

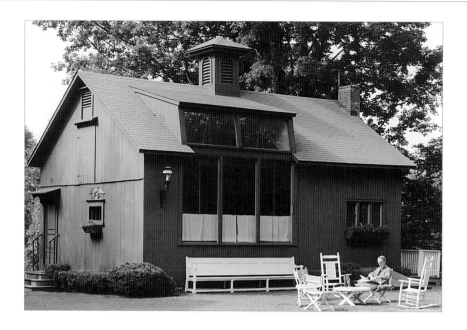

Norman Rockwell's South Street, Stockbridge,
Massachusetts, studio in 1966 (note enlarged north windows). Photographer unidentified.

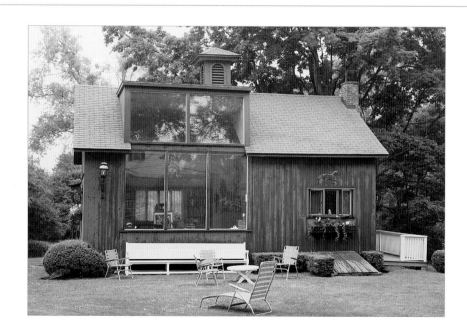

Norman Rockwell and carpenter Ejner Handberg during construction of the addition to the South Street, Stockbridge, Massachusetts, studio, 1962. Photographer unidentified.

Norman Rockwell's assistant Louie Lamone (visible in mirror) photographing Rockwell as he directs a scene to be photographed by Bill Scovill in Rockwell's South Street, Stockbridge, Massachusetts, studio, c. 1962. Photo by Louie Lamone.

Norman Rockwell and Peter Rockwell working on *The Connoisseur* in Rockwell's South Street, Stockbridge, Massachusetts, studio, 1961. Photo by Louie Lamone.

THE STOCKBRIDGE STUDIOS

Norman Rockwell reenacting Jackson Pollock's drip method for *The Connoisseur* in his South Street, Stockbridge, Massachusetts, studio 1961. Photo by Louie Lamone.

Norman Rockwell talking on the telephone in his South Street, Stockbridge, Massachusetts, studio, 1966. Photo by Louie Lamone.

Norman Rockwell entering the South Street,
Stockbridge, Massachusetts, studio, 1966. Photo by Louie Lamone.

Correspondence and memorabilia in the Norman Rockwell archives indicate that Norman Rockwell's artwork was shown in at least sixty group and one-person exhibitions in his lifetime. Since records of just two pre-1937 exhibitions were found, it is safe to assume that this list documents only a fraction of the public exhibitions of Rockwell's work. All known exhibitions from 1914 to 1978, whether major or incidental, are included. In addition, major exhibitions from 1978 to the present are listed.

Host or organizing institutions appear first, followed by opening and closing dates, if known, or n.d. (no date) if specific dates are unknown. In the absence of specific dates, a month may be listed even if the run did not extend the whole month. Subsequent venues and their dates, if the exhibition traveled, are indented. Exhibition titles, if known, appear in italics.

New Rochelle Art Association, May 1914, New Rochelle Public Library, New Rochelle, New York
First exhibition and debut of the Association
Group exhibition

New Rochelle Art Association, February 8, 1916 – n.d., New Rochelle Public Library, New Rochelle, New York
Artwork by Norman Rockwell, Victor C. Forsythe, and Ernest Albert, Jr.
Group exhibition

Mark Twain Museum, July 1937 – n.d., Hannibal, Missouri
One-person exhibition

Bell & Fletcher Gallery, December 1937, Boston, Massachusetts
One-person exhibition

Mark Twain Museum, February 1938 – January 1939, Hannibal, Missouri
One-person exhibition

Portrait Painters Galley, January 30 – February 11, 1939, New York, New York
One-person exhibition

Society of Illustrators, April 1939, New York, New York
Thirty-Seventh Annual Exhibition
Group exhibition

Galleries of Associated American Artists, May 1941, New York, New York
Twentieth Annual Exhibition of the Art Directors Club
Group exhibition

Ferargil Galleries, January 6–20, 1941, New York, New York
One-person exhibition
 n.d, Detroit, Michigan
 April 1941, Hackley Art Gallery, Muskegon, Michigan
 May 1941, Milwaukee Art Institute, Milwaukee, Wisconsin
 July–August 1941, Thayer Art Museum, Lawrence, Kansas
 October 9–26, 1941, Davenport Municipal Art Gallery, Davenport, Iowa
 November 1–25, 1941, Currier Gallery of Art, Manchester, New Hampshire
 December 1–28, 1941, Brooks Memorial Art Gallery, Memphis, Tennessee
 January 1–25, 1942, Beloit College, Beloit, Wisconsin
 April 13–25, 1942, Higbee Auditorium, Cleveland, Ohio
 May 3–23, 1942 , Academy of Arts, Newark, New Jersey

Art Students League, February 7–28, 1943, New York, New York
Fifty Years on 57th Street
Group exhibition

Curtis Publishing Co. and U.S. Treasury
Four Freedoms War Bond Show
Group exhibition
 April 27 – May 8, 1943, The Hecht Company, Washington, District of Columbia
 May 15–22, 1943, Strawbridge and Clothier, Philadelphia, Pennsylvania
 June 4–13, 1943, Rockefeller Center, New York, New York
 June 19–26, 1943, William Filene's Sons and Company, Boston, Massachusetts
 July 14–21, 1943, The William Hengerer Company, Buffalo, New York
 August 2–7, 1943, Sibley, Lindsay & Curr Company, Rochester, New York
 September 8–15, 1943, Kaufman's Department Store, Pittsburgh, Pennsylvania
 September 27 – October 9, 1943, J.L. Hudson Company, Detroit, Michigan
 October 25–28, 1943, May Company, Cleveland, Ohio
 November 11–22, 1943, Carson Pirie Scott & Company, Chicago, Illinois
 December 16–23, 1943, Stix, Baer and Fuller Company, St. Louis, Missouri
 January 17–21, 1944, Municipal Auditorium, New Orleans, Louisiana
 January 27 – February 5, 1944, Tisch-Goettinger Company, Dallas, Texas
 February 12–22, 1944, Bullock's, Los Angeles, California
 March 27 – April 8, 1944, Meier & Frank Company, Portland, Oregon
 May 1–6, 1944, Denver Dry Goods Company, Denver, Colorado

California Palace of the Legion of Honor, May 1945, San Francisco, California
Group exhibition

Society of Illustrators, May 3–20, 1946, International Galleries Rockefeller Center, New York, New York
Group exhibition

Southern Vermont Artists Inc., August 24 – September 3, 1946, Manchester, Vermont
Seventeenth Annual Exhibition
Group exhibition

The Metropolitan Museum of Art, January 7, 1947 – n.d., New York, New York
Art in Motion Picture Advertising
Group exhibition

Curtis Publishing Company, 1947, Philadelphia, Pennsylvania
The Saturday Evening Post Art Exhibition
Group exhibition

Stevens Gross Galleries, May 20 – June 28, 1947, Chicago, Illinois
Paintings by Norman Rockwell and Mead Schaeffer
Group exhibition

Woodbury College, July 12 – August 6, 1948, Los Angeles, California
25 Original Saturday Evening Post Paintings
Group exhibition

Society of Illustrators, December 17, 1948, New York, New York
Group exhibition

Arts and Crafts Festival, August 1–14, 1949, Skyforest, California
Group exhibition

New Rochelle Public Library, January 29 – February 15, 1951, New Rochelle, New York
One-person exhibition

Institute of Commercial Art, Inc., New York, New York
Art America Loves
Group exhibition
 March 4–18, 1951, Parthenon Museum, Nashville, Tennessee
 March – n.d., New England School of Art, Boston, Massachusetts
 n.d., Entwistle Galleries, Ridgewood, New Jersey, and Atlanta, Georgia

The Metropolitan Museum of Art, n.d.– April 29, 1951, New York, New York
The 75th Anniversary Exhibition of Painting & Sculpture by 75 Artists Associated with the Art Students League of New York
Group exhibition

Saint-Gaudens Memorial, August 6, 1951 – n.d., Cornish, New Hampshire
The Saturday Evening Post Art Exhibition
Group exhibition
 October 1951, Cartoonists and Illustrators School, New York, New York
 November 1951, Laguna Beach, California

Berkshire Museum, October 1955, Pittsfield, Massachusetts
Group exhibition

Curtis Publishing Company
Paintings for *The Saturday Evening Post*
One-person exhibition
> June 16, 1955, **Corcoran Gallery**, Washington, District of Columbia
> October 1955, **Asheville Art Museum**, Asheville, North Carolina
> June 1956, **Washington County Museum of Fine Arts**, Hagerstown, Maryland
> n.d., **Calgary Power Ltd.**, Calgary, Alberta, Canada
> February 1957, **William Filene's Sons and Company**, Boston, Massachusetts

Berkshire Museum, August 1–31, 1958, Pittsfield, Massachusetts
Norman Rockwell Retrospective
One-person exhibition

Virginia Beach Convention Center, January 13–25, 1960, Virginia Beach, Virginia
One-person exhibition

Berkshire Museum, February 11, 1960 – n.d., Pittsfield, Massachusetts
Original Drawings and Sketches of Local People
One-person exhibition

Seaman's Savings Bank, n.d. – February 26, 1960, New York, New York
One-person exhibition

Southern Vermont Art Center, June 30 – July 22, 1962, Manchester, Vermont
The Saturday Evening Post Norman Rockwell Show
One-person exhibition

Cooperstown Art Association, July 29 – August 23, 1962, Cooperstown, New York
27th Annual Open Exhibition
Group exhibition
Note: Between 1962 and 1974, Norman Rockwell exhibited artwork at the Annual Art Exhibition of the Cooperstown Art Association every year with the exception of 1964. In 1967 (July 30 – August 24), the Association held a one-man show of his artwork.

National Museum of Sport, Inc., November 1962, I.B.M. Gallery, New York, New York
Fine Art in Sports
Group exhibition

Syracuse University/School of Art, March 6 – April 2, 1963, Syracuse, New York
15 American Illustrators
Group exhibition

Exhibit of Economic Achievements, December 13, 1963 – January 15, 1964, Moscow, USSR
American Graphics
Group exhibition

Akhnaton Gallery, January 23–27, 1964, Cairo, Egypt
One-person exhibition

Bennington Museum, June 19 – October 19, 1964, Bennington, Vermont
Paintings by Norman Rockwell
One-person exhibition

Chesterwood, July 1 – August 31, 1964, Stockbridge, Massachusetts
Exhibition of Paintings and Drawings by Norman Rockwell
One-person exhibition

City and County Savings Bank, June 1965, Albany, New York
Paintings by Norman Rockwell
One-person exhibition

Municipal Art Gallery, January 4 – February 6, 1966, Barnsdall Park, Los Angeles, California
Norman Rockwell
One-person exhibition

Bristol Art Museum, August 4–15, 1966, Bristol, Rhode Island
Paintings by Norman Rockwell
One-person exhibition

Paine Art Center and Arboretum, December 1, 1966 – January 5, 1967, Oshkosh, Wisconsin
One-person exhibition

Society of Illustrators, February 6–24, 1967, Union Carbide Exhibition Area, New York, New York
Group exhibition

Anchorage Gallery, January 31 – February 28, 1967, Syracuse, New York
One-person exhibition

Bernard Danenberg Galleries, October 22, 1968 – November 9, 1968, New York, New York
Major paintings by Norman Rockwell
One-person exhibition

Shaker Museum, August 2, 1969 – n.d., Old Chatham, New York
14th Annual Shaker Museum Festival
One-person exhibition

Society of Illustrators, May 8–18, 1970, New York, New York
Artists Guild of New York, *Artist of the Year* exhibition
One-person exhibition

Lobster Pot Gallery, July 6, 1970 – n.d., Nantucket, Massachusetts
Norman Rockwell
One-person exhibition

First Federal of Hollywood, September 27 – October 29, 1971, Los Angeles, California
Norman Rockwell
One-person exhibition

National Air and Space Museum, Smithsonian Institution, December 1970 – April 1971,
Washington, District of Columbia
Space Artists
Group exhibition

Bamberger's, November 13 – December 30, 1972, Newark, New Jersey
Norman Rockwell
One-person exhibition

Bernard Danenberg Galleries, New York, New York
Norman Rockwell: A Sixty Year Retrospective
One-person exhibition
 February 11 – March 5, 1972, **Ft. Lauderdale Museum of the Arts**, Ft. Lauderdale, Florida
 March 22 – May 14, 1972, **Brooklyn Museum**, Brooklyn, New York
 May 26 – July 16, 1972, **Corcoran Gallery of Art**, Washington, District of Columbia
 August 1–27, 1972, **Marion Koogler McNay Art Institute**, San Antonio, Texas
 September 8 – November 5, 1972, **M.H. De Young Memorial Museum**, San Francisco, California
 November 12 – December 10, 1972, **Oklahoma Art Center**, Oklahoma City, Oklahoma
 December 18, 1972 – January 21, 1973, **Indianapolis Museum of Art**, Indianapolis, Indiana
 January 28 – February 25, 1973, **Joslyn Art Museum**, Omaha, Nebraska
 March 8 – April 15, 1973, **Seattle Art Museum**, Seattle, Washington
 April 27 – May 27, 1973, **Museum of the Philadelphia Civic Center**, Philadelphia, Pennsylvania
 April 4–9, 1975, **Hankyu Department Store**, Tokyo, Japan

Smithsonian Institution Traveling Exhibition Service, October 6, 1973 – November 24, 1974
The American Artist and Water Reclamation, A selection of paintings from the collection of the Bureau of Reclamation
U.S. Department of the Interior
Group exhibition

Gallery 1020, May 20 – June 28, 1975, New York, New York
Norman Rockwell
One-person exhibition

Museum of Arts and Sciences, January 15 – February 15, 1976, Daytona Beach, Florida
Norman Rockwell's America
One-person exhibition
 February 19 – March 15, 1976, **Norton Gallery of Art**, West Palm Beach, Florida

Columbus Gallery of Fine Arts and Allentown Art Museum, 1976–1977, Columbus, Ohio, and Allentown, Pennsylvania
Salute to Norman Rockwell
One-person exhibition

Bennington Museum, May 4 – July 28, 1978, Bennington, Vermont
Norman Rockwell Exhibition
One-person exhibition

Grand Central Art Galleries, Inc., May 8–25, 1979, New York, New York
American Illustrators: The Twenties, Adventure, Suspense, Romance and Humor
Group exhibition

Museum of Fine Arts, June 1, 1979 – n.d., Springfield, Massachusetts
One-person exhibition

Davenport Art Gallery, 1980, Davenport, Iowa
The American Profile: Drawings by Norman Rockwell
One-person exhibition

Museum of Fine Arts, July 1 – August 3, 1980, St. Petersburg, Florida
American Illustrators: Norman Rockwell and His Contemporaries
Group exhibition

Dallas Historical Society, April – August 1981, Dallas, Texas
Norman Rockwell's World of Scouting
One-person exhibition

C.W. Post Art Gallery, Long Island University, March 19 – April 25, 1982, Greenvale, New York
The Great American Illustrators
Group exhibition

Center Art Galleries, July 1983, Honolulu, Hawaii
Norman Rockwell: Americana Collection
One-person exhibition

Judy Goffman Fine Art, December 4, 1985 – January 31, 1986, New York, New York
Norman Rockwell: An American Tradition
One-person exhibition
 March 25 – May 4, 1986, Greenville County Museum of Art, Greenville, South Carolina

Philadelphia Maritime Museum, November 7, 1986 – February 28, 1987, Philadelphia, Pennsylvania
Tales of the Mermaid
Group exhibition
 June 5 – August 16, 1987, The Mariners' Museum, Newport News, Virginia
 September 8 – October 27, 1987, Explorers Hall, National Geographic Society, Washington, District of Columbia

Bennington Museum, 1988, Bennington, Vermont
Paintings by Norman Rockwell
One-person exhibition

Judy Goffman Fine Art, New York, New York
Norman Rockwell: The Great American Storyteller
One-person exhibition
 March 2–15, 1988, Mississippi Museum of Art, Jackson, Mississippi
 June 25 – August 14, 1988, Orlando Museum of Art, Orlando, Florida
 September 11 – October 30, 1988, Woods Art Gallery, U. of Southern Mississippi, Hattiesburg, Mississippi
 November 20, 1988 – January 9, 1989, Hunter Museum of Art, Chattanooga, Tennessee
 January 30 – March 5, 1989, Center for the Arts, Vero Beach, Florida
 March 26 – May 14, 1989, Lakeview Museum of Arts and Sciences, Peoria, Illinois
 June 8–14, 1989, Judy Goffman Fine Art, New York, New York

American Illustrators Gallery, New York, New York
Norman Rockwell
One-person exhibition
 August 3 – September 16, 1990, Cortina d'Ampezzo, Museo "Ciasa de ra Regoles," Rome, Italy

American Illustrators Gallery and Brain Trust, Inc., New York, New York, and Tokyo, Japan
Norman Rockwell
One-person exhibition
 February 20 – March 31, 1992, Isetan Museum of Art, Tokyo, Japan
 May 7–17, 1992, Daimaru Museum, Umeda-Osaka, Osaka, Japan
 July 23 – August 23, 1992, Matsuzakaya Art Museum, Nagoya, Japan

Galleria Prova, 1992, Tokyo, Japan
Heart Warming
Group exhibition

American Illustrators Gallery and Brain Trust, Inc., New York, New York, and Tokyo, Japan
The Great American Illustrators
Group exhibition
 April 21 – May 9, 1993, Odakyu Museum, Tokyo, Japan
 June 12 – July 11, 1993, Fukushima Prefectual Museum of Art, Fukushima, Japan
 October 20 – November 8, 1993, Daimaru Museum, Umeda-Osaka, Osaka, Japan

Norman Rockwell Museum at Stockbridge and Printemps, Stockbridge, Massachusetts, and Paris, France
Norman Rockwell's New England
One-person exhibition
 November 17 – December 31, 1993, Printemps, Paris, France

Society of Illustrators and The Wagnalls Memorial Foundation, New York, New York, and Columbus, Ohio
Ten Works from the Literary Digest Collection
Group exhibition
 October 25 – November 18, 1995, Columbus College of Art & Design, Columbus, Ohio

Connecticut Valley Historical Museum, 1995, Springfield, Massachusetts
Norman Rockwell Drawing the American Dream
One-person exhibition

Marietta/Cobb Museum of Art, Summer 1996, Marietta, Georgia
Norman Rockwell: Portrait of America
One-person exhibition

Norman Rockwell Museum and Brain Trust, Inc., Stockbridge, Massachusetts, and Tokyo, Japan
Norman Rockwell
One-person exhibition
 December 4–28, 1997, Isetan Museum of Art, Tokyo, Japan
 January 3–25, 1998, Matsuzakaya Art Museum, Nagoya, Japan
 January 29 – March 1, 1998, Chiba Sogo Museum of Art, Chiba, Japan
 March 4–17, 1998, Niigata Isetan Art Hall, Niigata, Japan
 March 25 – April 13, 1998, Daimaru Museum, Umeda-Osaka, Osaka, Japan
 April 18 – May 17, 1998, Hiroshima Museum of Art, Hiroshima, Japan

Norman Rockwell Museum and High Museum of Art, Stockbridge, Massachusetts, and Atlanta, Georgia
Pictures for the American People
One-person exhibition
 November 6, 1999 – January 30, 2000, High Museum of Art, Atlanta, Georgia
 February 26 – May 21, 2000, Chicago Historical Society, Chicago, Illinois
 June 17 – September 24, 2000, Corcoran Gallery, Washington, District of Columbia
 October 28 – December 31, 2000, San Diego Museum of Art, San Diego, California
 January 27 – May 6, 2001, Phoenix Art Museum, Phoenix, Arizona
 June 9 – October 8, 2001, Norman Rockwell Museum, Stockbridge, Massachusetts
 November 16, 2001 – March 3, 2002, Solomon R. Guggenheim Museum, New York, New York

I love to tell stories in pictures. For me, the story is the first thing and the last thing.

Norman Rockwell

For many, Norman Rockwell's icons of living culture were first experienced in the most unassuming of places, in the comfort of home or on the train ride at the end of a long day. Created for the covers and pages of our nation's periodicals rather than for the walls of galleries and museums, Rockwell's images were intimately understood by a vast and eager audience who saw the best in themselves reflected in his art and in the stories that he chose to tell. His intricately conceived narratives imbued ordinary activities with a sense of historical importance, seizing the moment almost as it was about to fade.

Ephemeral though often unforgettable, Rockwell's published imagery was replaced at the turn of a page by a succession of magazine issues and illustrations, but his original paintings were made to last. Bearing the mark of history, his large scale canvases offered far more than was necessary even by the standards of his profession. By virtue of his training and his inclination, he called the history of European art into play, employing classical painting methodology to weave contemporary tales inspired by everyday people and places. A cast of affable, exquisitely painted characters and a plethora of supporting details kept him and his audience engaged, and inspired belief by millions in the uniquely American vision that he conceived and continued to refine.

The ongoing focus of visual artists, filmmakers, and photographers, storytelling in pictures predates verbal language. Narrative picture makers were employed for centuries to display the wealth and power of their patrons, first gaining access to mass audiences during the nineteenth century, when the publishing industry emerged as a leading employer of artists and a prominent showcase for their work. In today's digital age, it is almost impossible to imagine the role that magazines played in a society quite different from our own, when periodicals served as the primary source of information and entertainment.